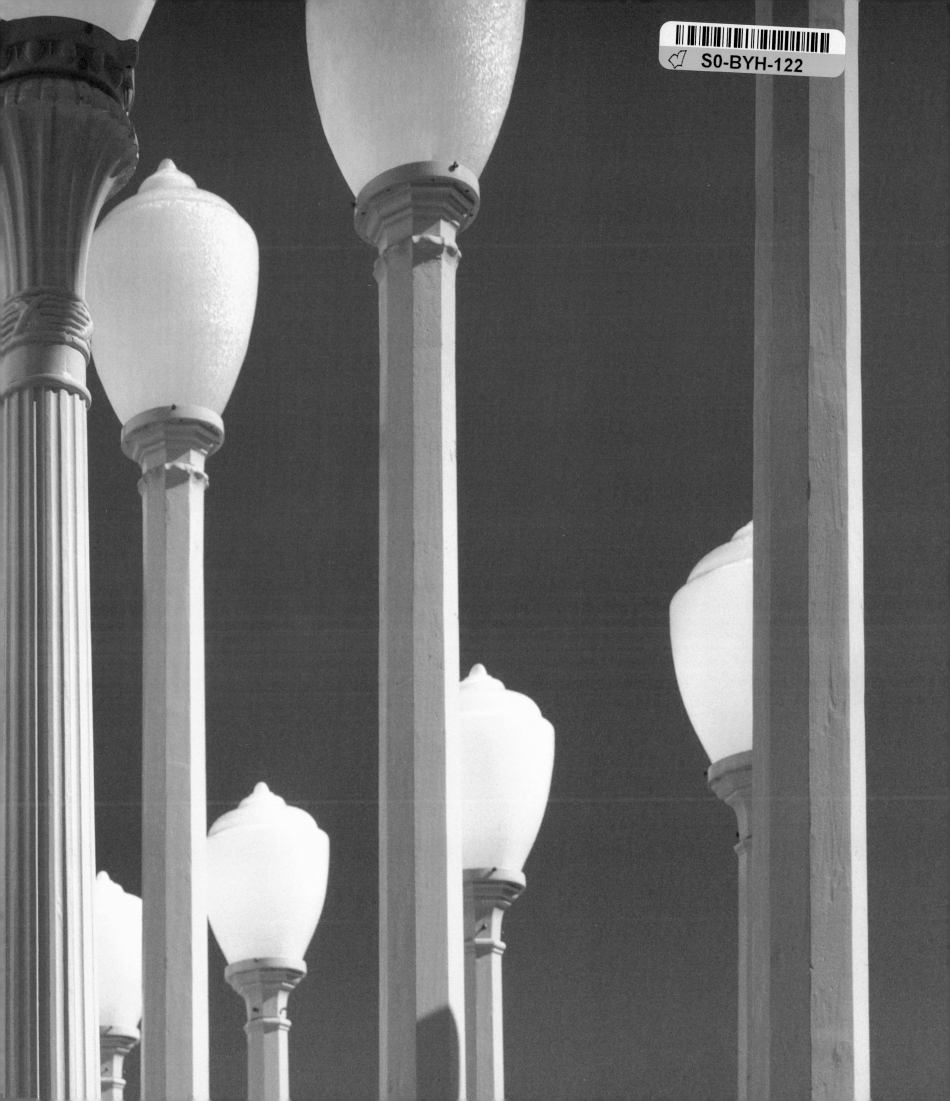

BCAM/LACMA/2008

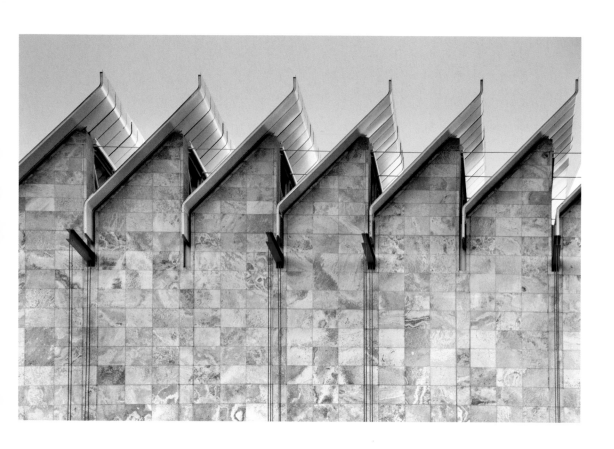

THE BROAD CONTEMPORARY
ART MUSEUM

at the LOS ANGELES COUNTY MUSEUM OF ART,
2008

BCAM/LACMA/2008

LOS ANGELES COUNTY MUSEUM OF ART

This book is published on the occasion of the opening of the Broad Contemporary Art Museum
at the Los Angeles County Museum of Art, February 2008.

Directors of Publications, LACMA
NOLA BUTLER
THOMAS FRICK

Editors
JENNIFER MACNAIR
THOMAS FRICK
NOLA BUTLER

Editorial assistant
CAITLIN ROCKLEN

Designers
LORRAINE WILD WITH **VICTOR HU** AND **VICTORIA LAM,**
GREEN DRAGON OFFICE

Photography supervisor
PETER BRENNER

Rights and reproductions manager
CHERYLE T. ROBERTSON

Note to the reader:
Not every work of art included in this book will be on view
at the museum at all times.

The first group of digits in the LACMA acquisition numbers
(found at the end of entries in the list of illustrated artworks)
indicates the year the work was acquired by the museum.

PUBLISHED BY
Los Angeles County Museum of Art
5905 Wilshire Boulevard
Los Angeles, CA 90036
lacma.org

DISTRIBUTED BY
D.A.P./Distributed Art Publishers, Inc.
155 6th Avenue
New York, NY 10013
(800) 338 2665
artbook.com

Library of Congress Control Number: 2007942217

ISBN: 978-0-87587-197-4

Printed and bound in Massachusetts

Cover: Anthony Hernandez, *BCAM #4* (detail), 2007; endsheets: Chris Burden,
Urban Light (details), 2000–2007; pp. 2–3, 4: BCAM, November 2007

CONTENTS

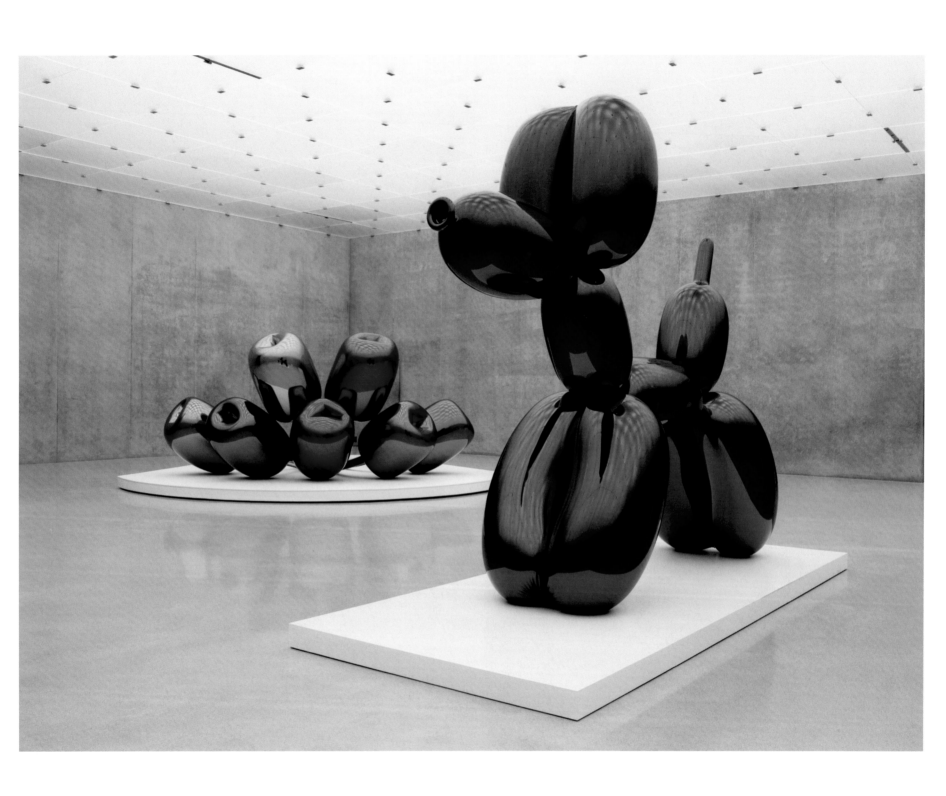

JEFF KOONS *Tulips*, 1995–2004, and *Balloon Dog (Blue)*, 1994–2000

WHERE WE ARE

MICHAEL GOVAN

There is something special about the light in Los Angeles, where the desert, the mountains, and the ocean meet. As Southern California artist Robert Irwin has noted, "The haze . . . fractures the light, scattering it in such a way that on many days the world has almost *no* shadows." There is a stillness to the light, captured by plein-air painters, and an unchanging quality that attracted the early filmmakers. It is also no coincidence that so many significant astronomical discoveries were made from Southern California: the clear, still atmosphere caused by the cool ocean air trapped beneath that of the desert creates the environment of undifferentiated, often meditative, light that Irwin describes. Perhaps it is because of this light, inspiring and attractive as it is, that so much art originates here.

As an art student on the East Coast, I knew Los Angeles largely from the art that it had produced. Art historians and cultural critics, perhaps most notably Reyner Banham, had mapped out a distinctive aesthetic philosophy emanating from the region. Banham described the "four ecologies" of Los Angeles: beach, plains, foothills, and—an ecology all their own—freeways. He recognized a city spread out over several terrains and knitted together by the automobile, for all that was good and all that was bad—both the sunshine and the noir, to borrow a phrase from a Los Angeles–themed exhibition in Europe.

The modern world was invented (or reinvented) here. Contemporary cities no longer look like the villages of Europe. Seoul, Beijing, Mexico City: the cities of the future look like Los Angeles. L.A. is a man-made utopia built on chamber-of-commerce boosterism, brought on by a combination of good weather and great marketing. Images of light abound. And darkness: L.A.'s freeways speak of the freedom represented by the automobile, but equally of the segregation of communities, and by extension the riots that have rocked this city in

the past. Everything gets reinvented in California, including massive pollution and traffic jams, migrant exploitation, and urban sprawl in proportions never imagined.

No matter how far the city spreads, however, it is hard to escape some kind of civic identity, at various times conveyed by nicknames such as Eden, the Pastel City, Tinsel Town, Hollywood, the Creative Capital. But, perhaps as with any really big city, increasingly there is no longer *one* L.A. In three hundred years Los Angeles has evolved from a modest Spanish pueblo to the second-largest city in America, a vast, complex, fast-growing urban metropolis that is now the nation's largest port city, whose communities speak more than a hundred languages. Amid this kind of rhizomic urbanism, it is probably only a museum—an encyclopedic museum—that could represent a multitude of cultures, providing some sense of center in response to so much diversity. Acting as a kind of town square, the Los Angeles County Museum of Art, at the geographic center of the city, has the potential to be a shared space for its public, providing on any day something of importance for everyone.

Encyclopedic art museums like LACMA were created, and maintain their status as educational institutions, on the premise that much can be learned about a place and time by the finest art that it has produced. Art from every region and era not only documents history, embodies aesthetic inventions, and constitutes the highest of human achievements; it is also a proxy for a worldview (or cosmology, in ancient terms). The general art museum as we know it was born in Europe as an adjunct of the philosophy of the Enlightenment, which privileged a rational, taxonomic, but obviously Eurocentric perspective. The traditional art museum presents a unified narrative of artistic and cultural history from ancient Egyptian, Greek, and Roman times through the achievements of the Renaissance, the advent of modernism, and finally to the present.

But Los Angeles—situated at the western edge of Western expansion, looking out to the Pacific Rim, thriving under the huge cultural influence of Latin America—is a vastly different place than the European and, later, East Coast cities whose institutions embody and perpetuate the ideas behind the general art museum. From this perspective it is increasingly possible to see that the historic artistic achievements of Latin America are parallel to, and in many ways quite distinct from, the achievements of European artists. Similarly, in Asian culture—where the concept of the general museum does not even

exist—the lasting influence of ancient Chinese art is equal to that of Greece and Rome in the West.

This museum, as it grows, will reflect that difference of worldview in its presentation of the art of all times, ages, and places. Renzo Piano's master plan for LACMA's campus aims at that end, and the Broad Contemporary Art Museum is its cornerstone. In one central respect contemporary art is a pursuit no different from that of art dating back to antiquity—to understand and reflect on the issues of the culture that created it. BCAM allows us not only to exhibit contemporary art but also to embrace contemporary thinking about all art, to consider the conventions of previous eras and explore the questions of our own. The history of art will be examined in a new light. The light of Los Angeles.

Art history can be broken into distinctions of time, but also of place. Even within the narrow band of a Western aesthetic, one can discern differences of style and influence: for instance, between seventeenth-century French painting and that of Italy; or more narrowly, among Florentine, Roman, Neapolitan, and Venetian artists. So, too, have distinctions in American art become apparent in the twentieth century when looking at the artists of New York and those of California. Beyond California's late-nineteenth-century plein-air school and the influence of Mexican artists like José Clemente Orozco and David Alfaro Siqueiros in the first half of the twentieth century, Los Angeles has also given birth to a distinct moment in art history during the last forty years—a development aided in part by LACMA, as Lynn Zelevansky's essay in this book illustrates. That history is beginning to gain world attention, as exhibitions like *Sunshine & Noir* in 1997, at the Louisiana Museum of Modern Art in Denmark, or *Los Angeles 1955–1985: The Birth of an Art Capital* in 2006, at the Pompidou Center in Paris, have shown.

The character of contemporary art in Los Angeles couldn't help but be shaped in part by artistic temperaments responding to the great openness of the light and still air in Southern California. Lawrence Weschler captured this sense in *Seeing Is Forgetting the Name of the Thing One Sees,* his now-classic tale of the coming of age of a quintessentially Los Angeles artist, Robert Irwin. In contrast to the archetypal European story conjured by James Joyce's nearly century-old *Portrait of the Artist as a Young Man,* which celebrated

an individual's angst-ridden struggle against God and the establishment and helped define the bohemian archetype, Weschler draws a character literally dancing his way to a deep and historical perceptual awareness under the bright postwar suburban California sun.

The trajectory of Irwin's work between the late 1950s and 1974—from abstract expressionist canvases to paintings of lines, then dots, then glowing discs, to nearly invisible prismatic columns, and finally to what at first appears very simply as an empty room—is a parable of the power of Southern California's light to dissolve the dominant Eurocentric New York aesthetic into a kind of pure, objectless experience, one that creates a phenomenology of self-awareness as much as an art awareness. Of some of his paintings during this period Irwin said, "They have no existence beyond your participation."

Irwin brought his new vision to New York in 1974, to the Pace Gallery, where he installed his landmark *Soft Wall*—an empty room in which, if you spent the time to look, one wall didn't seem quite right; it was a bit blurry, as if glowing with a depth that defied expectations. Irwin had stretched a white translucent scrim eighteen inches in front of an entire wall of the gallery. Was it an ultimate abstraction made of light itself? A logical and metaphorical endpoint of the European-born modernism that had intellectually colonized the New World in the twentieth century? Or, perhaps, a pure product of the Western physical and cultural trajectory through the American frontier to the light of Los Angeles, a new ground zero for art?

Irwin was only one of a group of artists in Southern California now loosely and somewhat misleadingly called the "light and space" movement, which included Maria Nordman, James Turrell, and Doug Wheeler, among others. All of them pioneered not just the use of light, but pure experience, as their medium. They made manifest that art is important to us not just because of what we see "out there," but also what we take with us. For the light and space artists, this inner reality became a fundamental component of their work. After modernism seemed to leave nothing left to do on canvas, *experience* became important: to have the truth of our perception embodied in art.

The light and space artists were at one (somewhat dematerialized) edge of the wide-ranging use of new, industrially produced materials (especially plastics and treated glass), prized for their ability not only to convey a futuristic feel but also to uniquely hold light and

color, as seen in works by Larry Bell and Peter Alexander. Industrial colors and materials were combined with handwork by "finish fetish" artists like Craig Kauffman and Billy Al Bengston. The refined and particularly Southern Californian look of customized surfboards and hot rods—where the vibrant colors of the materials achieved a special glow in the intense native light—was easily adopted into art-making practice, notably by John McCracken. The obsession with color carries over into every medium, from the late Norman Zammitt's sunset-induced abstract paintings to the exquisitely layered surreal-looking abstract ceramics of Ken Price.

Much of the work being made in New York at this time was heavy and gray by comparison. Artists such as Carl Andre and Robert Morris used metals, felt, and uncolored fiberglass as their material, while New York conceptual art and photography were insistently black and white. When the intense, industrially produced colors of Day-Glo plastics or bright fluorescent light were employed in the east—for example in the work of minimalists Dan Flavin and Donald Judd—they were left purely as made in the factory or bought in the hardware store. And while color was abundant in New York in both abstract and pop painting, it was flat and painterly. In contrast to the light and space of 1960s Los Angeles, the image of New York was grime and grit, dim, deep canyons of stone devoid of sunlight or even moonlight.

Los Angeles, meanwhile, had its own variety of darkness: noir. Perhaps precisely because of L.A.'s unmediated, almost primeval daylight, it had to invent a psychological counterpoint. Hollywood, especially, has deployed noir in the backstreets of the inner city, in the murky depths of private homes, in the supposedly vacant desert surrounding the city; or more recently in the Lynchian darkness beneath the manicured lawns of suburban sprawl. In art, emblematic visions of this underlying darkness can be found in Edward Kienholz's socially and politically charged *Illegal Operation*, and in his *Back Seat Dodge '38*, which almost shut LACMA down when it was exhibited in 1966, for its depiction of a couple having sex in a car, radio playing—an image that is distinctly American, and iconically Southern Californian. The assemblage tradition, embodied in this way by Kienholz, but also by Betye Saar, George Herms, Wallace Berman, and John Outterbridge, has carried on in Los Angeles in the ensuing decades, particularly in the assemblage

installation-events of the late Jason Rhoades, who filled his spaces with the chaos and clutter of urban life.

Contemporary art has a strong foundation in Los Angeles, and continues to thrive. Much of its growth was built on the back of educational institutions, including CalArts, Otis College of Art and Design, UCLA, and Art Center College of Design, which have bred generation after generation of artists. From the 1960s through the early 1980s, when the international art world had easily identifiable hubs, many artists who were educated in Los Angeles left to develop their careers in New York, Europe, or otherwise outside of Southern California. In the 1970s, John Baldessari counseled his students to consider going to New York to have the best chance of being recognized. Sometime in the mid-1980s, however, it became clear to him that such migration was no longer necessary or even advisable. Artist Mike Kelley recently said that he chose to stay in L.A. thirty years ago not because the institutions or the audiences were so well developed, but because of the growing artists' community. The world of contemporary art was spreading out globally, de-emphasizing any one point of concentrated activity. It had become polycentric, and Los Angeles (itself a polycentric city) was emerging as one of those important centers.

LACMA and a handful of local organizations—the Pasadena Art Museum, the Ferus Gallery, and LACE (Los Angeles Contemporary Exhibitions), among others—were the original loci for Southern California's contemporary artists. In the last thirty years—not coincidentally, the same period in which Kelley, Baldessari, and others affirmed their allegiance to the city—additional institutions have come to nurture Los Angeles artists. A crucial one was the Museum of Contemporary Art, founded in 1979 (with much support from Eli Broad, among many others), which provided a platform for this burgeoning group, as well as an internationally recognized exhibition program, and grew to become one of the finest museums of contemporary art in the nation. More recently, the Hammer Museum has emerged as a major cultural force in contemporary art, and in the past decade the J. Paul Getty Museum, with its adjunct institutes, has devoted significant resources to documenting art history of the last thirty years, and begun programs to work with living artists.

Into this already vibrant cultural environment, the Broad Contemporary Art Museum is born. Containing a world-class collection, designed by an architect of stellar reputation for museums, and possessing the highest international aspirations, BCAM is the most recent and largest sign of the steady growth of the arts in L.A. This and other landmark projects—most notably Frank Gehry's Walt Disney Concert Hall, one of the world's most important works of contemporary architecture—have been attainable thanks to a new wave of cultural patronage, including, of course, Eli and Edythe Broad, whose collections will be the foundation of BCAM's six large, open galleries. Arguably among the most notable collections in the world, defined by their great depth and sustained commitment to individual artists throughout their careers, the Broad collections (the Broads' private collection and that of The Broad Art Foundation) are also among the best representations of contemporary art *collecting* as a global phenomenon in itself, perfectly in sync with the explosive growth of museums that began in the 1980s and continues to this day. At that time, just as modernism ran into an identity crisis heralded as "postmodernism," the avant-garde became popularized. Especially in Germany, the final phase of the postwar rebuilding effort turned toward cultural projects, expressing itself in a surge of exhibitions, galleries, museums—and artists to fill them. Having swallowed the European avant-garde in New York, which was also rapidly becoming a magnet for the growing market for new art, the United States kept pace, as cities commissioned star architects to create tourist-attracting cultural anchors to redevelop city centers as much as to house great works of art.

Chronologically, the Broad collections begin not with the New York school's dominant brand of abstract expressionism, which consolidated and reinvented European modernism on a physical and ideological scale to match America's landscape and (perhaps temporary) postwar political and economic dominance. Rather, they begin with eccentric variations on abstraction and the flattened modern picture plane: Cy Twombly's poetically and historically attenuated scribbles; Robert Rauschenberg's accumulated and collaged surfaces, and surfaces of images; Jasper Johns's thickly elaborated and obscured signs and symbols; and Ellsworth Kelly's extremely minimal, often dreamlike floating planes of pure color. The Broads' collecting comes into sharp focus with many examples of Andy Warhol's and Roy Lichtenstein's wry and graphic appropriations of popular culture—the seeming

antithesis of the ultraserious, almost sacred qualities of nature-infused abstract expressionism. The Los Angeles king of the pop sensibility, Ed Ruscha, has become another foundation of the collections. However, except for the brilliant intellectual/artistic prank-sterism of John Baldessari, nearly absent from the Broad collections are early conceptual art and photography—not to mention the huge influence of so-called minimal art, except in the later spectacular and monumental sculptures by Richard Serra, which were never easily accessible to collectors or the market until very recently. The character of the collections is clarified when it is understood that a majority of these historical works were acquired not as they were made but rather since the 1980s—and especially in the last ten or twelve years, when the depth of the collections truly matured. The Broad collections first took their direction from the perspective of the 1980s, when the Broads' tastes ran toward the huge new wave of figurative painting and a bold and public brand of conceptual and feminist art that held sway, and when the epicenter of the art world was in the galleries of Manhattan's SoHo and scattered through a network of German cities, particularly Cologne.

Andy Warhol (the person, if not always his paintings) was a dominant presence in New York and in the media. His seemingly unabashed love of money and celebrity paved the way, along with sustained peacetime economic prosperity, for the invention of the "big, beautiful art market," as art critic Dave Hickey described it. Contemporary art, which in the 1960s and early 1970s often took an anti-institutional stance, was largely given status through art journals, international exhibitions, and museums, and sifted through a relatively small network of galleries. As the plethora of conceptual, performance, and earth art proved, commercial viability was not necessarily a major consideration. In contrast, with figurative painting back in fashion, and salable objects plentiful, the 1980s saw the rising power of the market, and of dealers and collectors who had the power to make (and sometimes break) artists' careers outside the domain of museums or academies. It was not the market alone that opened the art system to a broader public. Art of the 1970s that pushed outside the gallery led in the 1980s to a surge in large-scale art in civic spaces, bringing more contemporary art into contact, and sometimes conflict, with the public. Since then, contemporary art has become the domain of an ever-larger public and an increasing number of collectors of all ages.

The growing accessibility of contemporary art is exemplified in the visual clarity running throughout the Broad collections, whether in bright abstraction, pop icons, provocative photographs, or bold words. It can be seen in the large-scale figurative painting of New York stars Julian Schnabel, David Salle, Eric Fischl, Ross Bleckner, Jean-Michel Basquiat, Leon Golub, Philip Taaffe, and Susan Rothenberg, among others; or in the more politically and socially challenging work of Jenny Holzer and Barbara Kruger; or in Cindy Sherman's insistent confrontation with the lens of the camera in multifarious guises. In recent years the Broads have also seized upon the physically provocative, mostly sculptural, theatrical scale of Los Angeles artists Mike Kelley, Chris Burden, and Charles Ray.

For a time, the stock market crash of 1987 and, more pervasively, the AIDS epidemic that claimed so many artists, critics, and curators greatly diminished the growing market exuberance. AIDS in particular provoked a sense of mortality that can be seen in vanitas motifs in work by artists such as Ross Bleckner and Robert Mapplethorpe, much of which is prefigured and explored contemporaneously by Warhol. Perhaps by its tragic presence the AIDS crisis also nurtured a broader philanthropy and a common cause within the growing community that called itself the "art world."

The downturn in market exuberance was only temporary. As the Broad Contemporary Art Museum nears its opening in 2008, the growth of the market, accompanied by the presence of contemporary art in fashion, commerce, and popular culture, has far exceeded the highest expectations of the 1980s, despite predictions of another crash. In fact it is since the mid-1990s that the Broads have made their largest investment in the collection, including perhaps their largest commitment to any single artist—Jeff Koons. Koons emerged in the 1980s as an eccentric conceptual standout of the East Village scene and, unlike many of his colleagues, has blossomed into a bona fide international superstar, a true heir to the Warhol legacy, who along with his British colleague Damien Hirst produces and sells art on a scale unmatched in history. Through it all, including market ups and downs and ups, the Broads continued to acquire significant and plentiful examples of work that struck them as both appealing to the eye and relevant to its time in history. They were not deterred by untested names or provocative statements. Once committed to an artist's vision, they usually remained committed. This has resulted in some of the most in-depth groupings of some of

the most widely recognized artists of the last decades. It is an astounding collection, and certainly has always been destined for the public. With great foresight throughout their years of buying (and almost never selling), their intention has been to create a cultural resource. The Broad Art Foundation was created in 1984 with the express mission of lending its renowned, in-depth collections to museums around the world. With the inauguration of the Broad Contemporary Art Museum, LACMA will now become the chief recipient of the foundation's loan program. That such a resource is now first and foremost for Angelenos is a testament to the Broads' civic-mindedness. Eli Broad has been a driving force behind MOCA, the Walt Disney Concert Hall, and the proposed redevelopment of Grand Avenue. But the ambition of these local initiatives is to become international cultural resources. Los Angeles is home to more artists than ever before in its history, and its cultural infrastructure is gaining critical mass and worldwide recognition.

With the addition of the Broad Contemporary Art Museum, LACMA has taken steps to assume anew its role as one of those resources. Contemporary artists create things as ways of seeing the world. Nurtured in a museum, their work will become the way that people look at our time; art will be the context—if not the content—by which future generations understand us. A marvelous thing about this encyclopedic museum is that Renzo Piano's master plan calls for the new BP Grand Entrance to be directly linked with BCAM. The museum can begin its historical narrative from the present and proceed in reverse.

Contemporary art often communicates immediately and clearly. In fact, perhaps it only becomes esoteric or obscure if you must first march through the history of art to get there. It takes years of training to learn that art is paintings in frames or sculptures on pedestals. That certainly wasn't necessary to grasp in ancient times, and it's not necessary now.

Los Angeles is a city that privileges the present, and from this particular vantage point we might make the journey from BCAM through the modern era and early-twentieth-century Mexican art, to the masterpieces of seventeenth- and eighteenth-century Europe, to the Mughal courts of India, to older works from pre-Columbian, Islamic, Japanese, and Chinese cultures. Visitors would be able to make connections between the light and space of 1960s Venice, California, and the exquisitely detailed treatment of light in the paintings

of seventeenth-century Venice, Italy. The Broad Contemporary Art Museum, positioned within the Los Angeles County Museum of Art, suggests many such possibilities.

Renzo Piano has created a campus for LACMA that rationalizes its organization in a new way and utilizes the light of Southern California as it should be, whether inside BCAM, where the glass ceiling allows the carefully buffered sunlight to suffuse the third-floor galleries, or by inviting visitors to enjoy the outdoor piazzas, complemented by ambitious works from two of L.A.'s most important artists, Robert Irwin and Chris Burden. Those artists will be joined in the near future by others, including perhaps Jeff Koons, whose *Train*, a seemingly absurd, surrealist object—an actual-size 1940s steam engine suspended from a 161-foot crane, dramatically marking time throughout the day—could serve as the central campanile, if you will, for LACMA's town square.

It is fitting that an architect so identified with light and with space would have his building complemented by Robert Irwin, who has planted palm trees—a carefully curated grouping of exotic and tropical species from far and wide—around BCAM and the BP Grand Entrance, and will continue to plant more in the coming years. The palm tree, despite not being native to Southern California, is a powerful cultural object, an iconic image that has drawn legions of people to a beguiling version of paradise. In this case they have been scrutinized as fantastic sculptural objects, collected and organized as a museum should, by an artist who has had these minimal, almost metaphysical trees very much in mind.

As Irwin's palms hold the sunlight, Burden's *Urban Light*, a collection of more than two hundred streetlamps, illuminates the darkness. Burden has collected these cast-iron lamps, dating back to the 1930s and before, from various cities within Los Angeles County. They are in effect a kind of history of L.A.'s civic identity; each city designed their own with great pride (a stylized "A" in Anaheim, for instance). In bringing them together Burden draws out their distinctions within the larger overall culture that is Los Angeles.

Seeing Burden's collection for the first time and imagining it as a foundational marker for LACMA's new campus, I recalled one of the legends of the founding of Rome, in which pieces of earth from surrounding locales were ceremonially collected to create the city center. Burden's streetlamps, brought to LACMA from throughout L.A. county, symbolize a kind of "refounding" of its center—fittingly, anointed with light.

THE BROAD COLLECTIONS: A PORTFOLIO

DAVID SMITH *Cubi XXVIII*, 1965

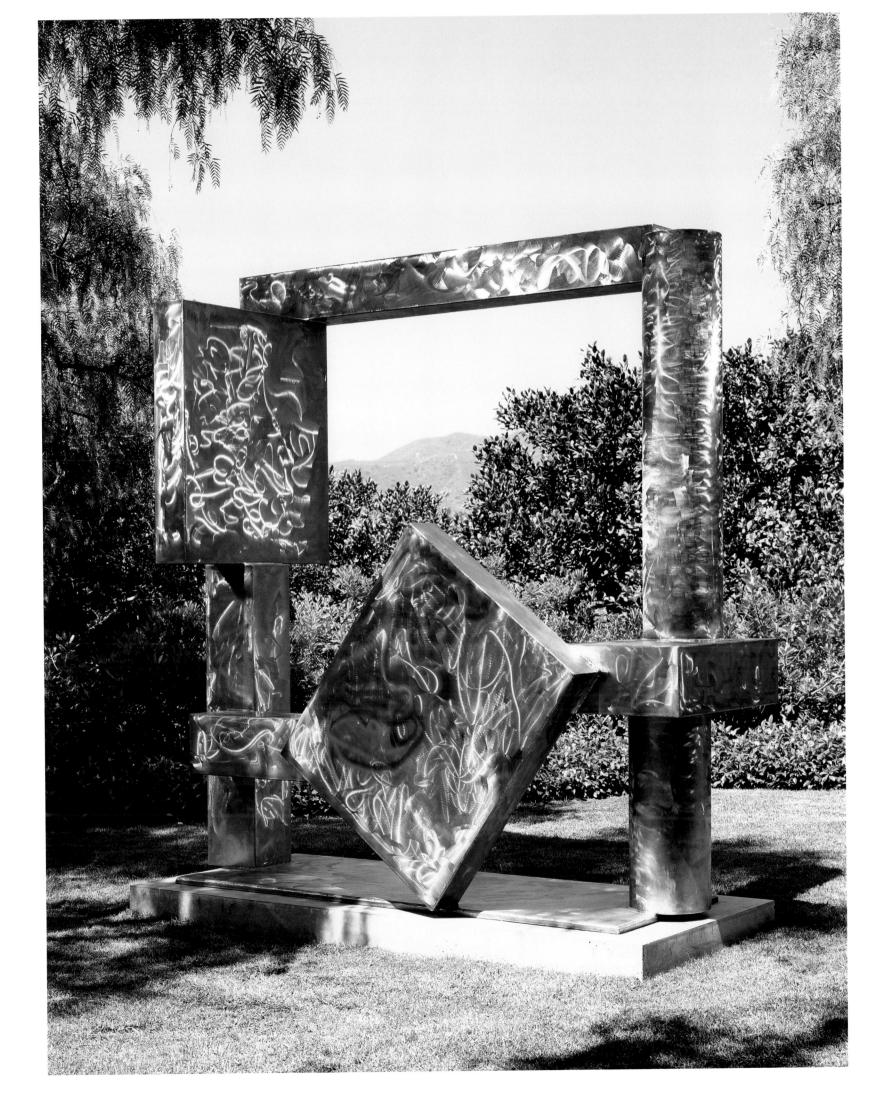

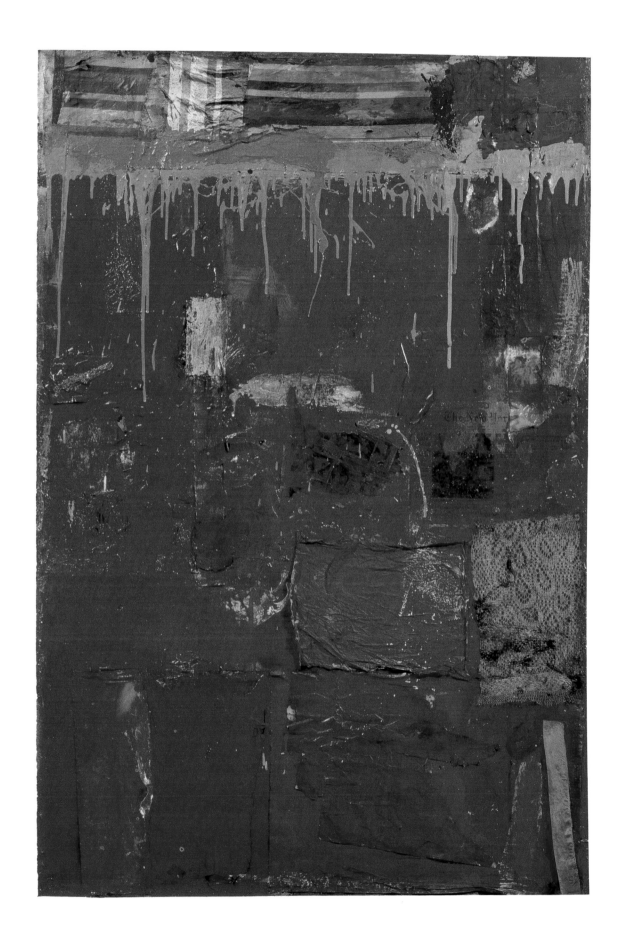

ROBERT RAUSCHENBERG *Untitled (Red Painting),* 1954

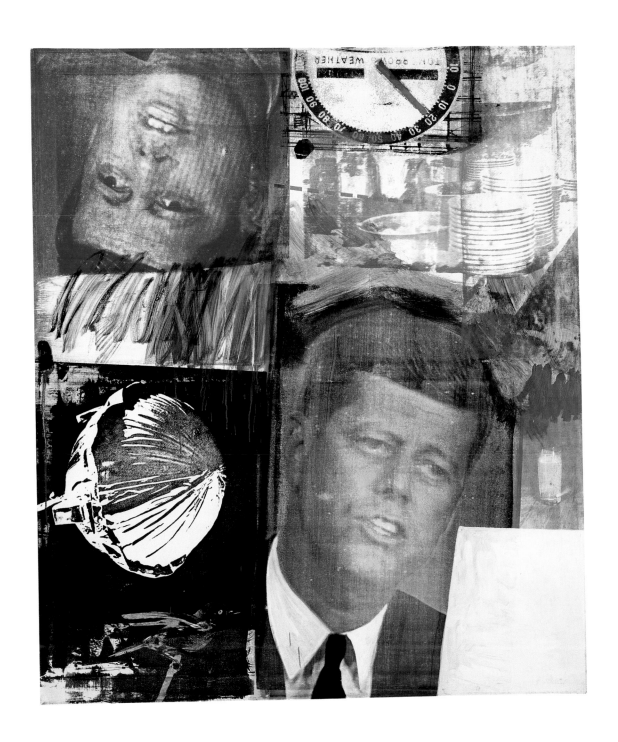

ROBERT RAUSCHENBERG *Untitled*, 1963

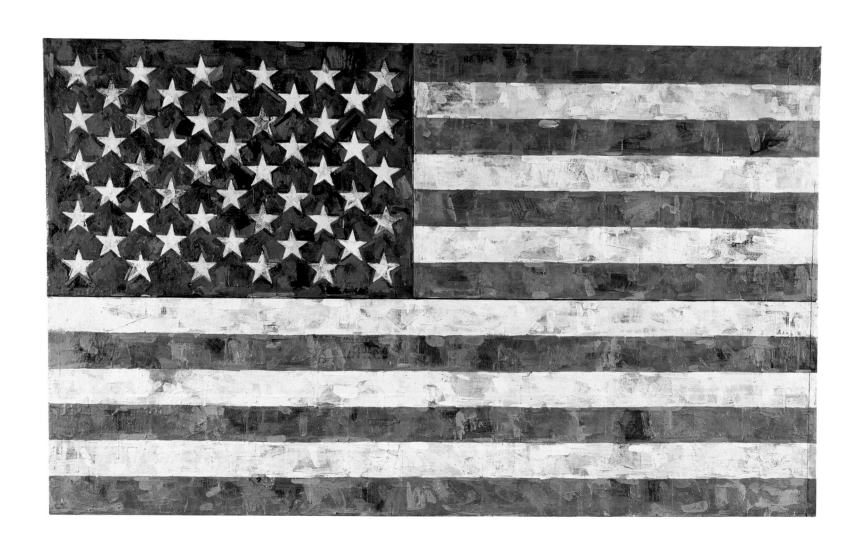

JASPER JOHNS *Flag*, 1967

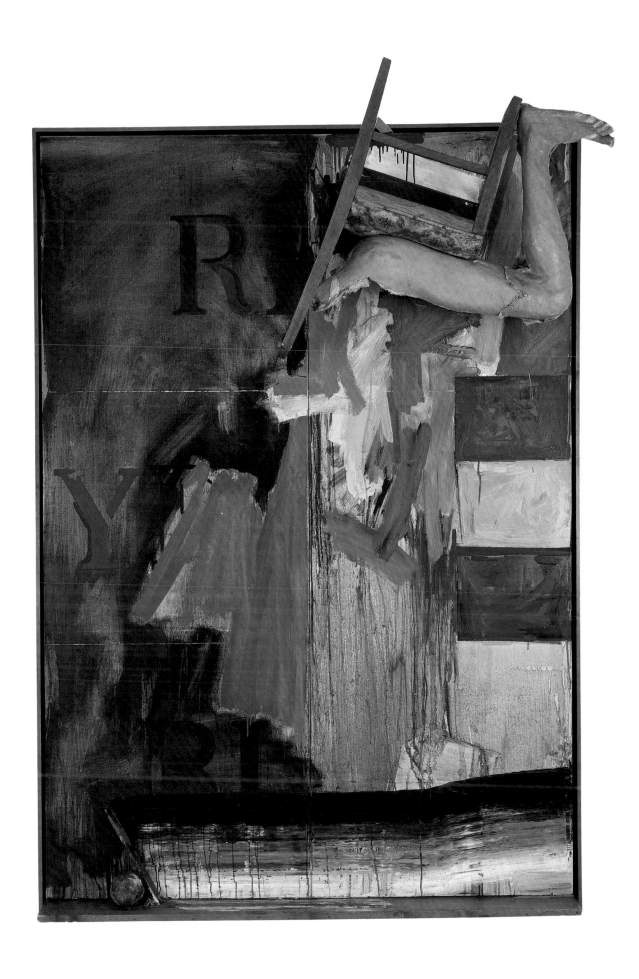

JASPER JOHNS *Watchman*, 1964

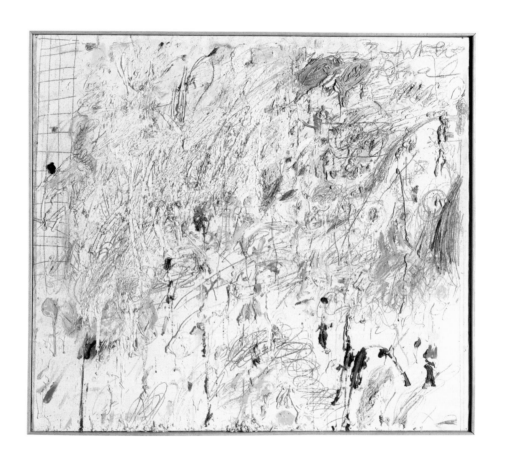

CY TWOMBLY *Untitled (Rome),* 1961

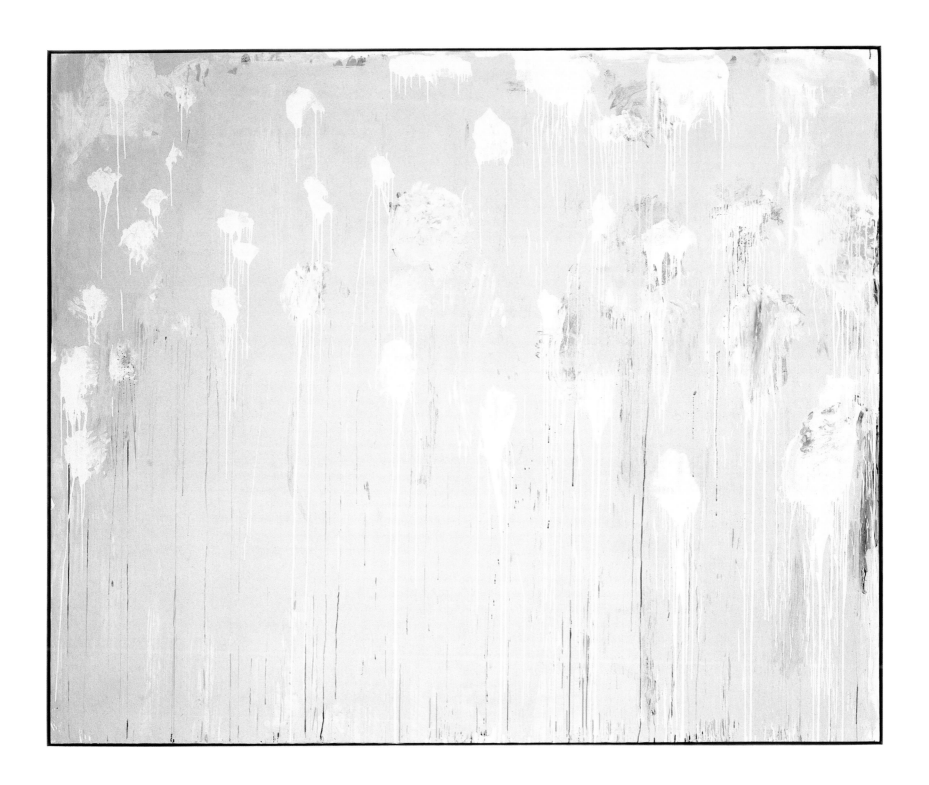

CY TWOMBLY *Untitled*, 2003

ROY LICHTENSTEIN *Black Flowers*, 1961

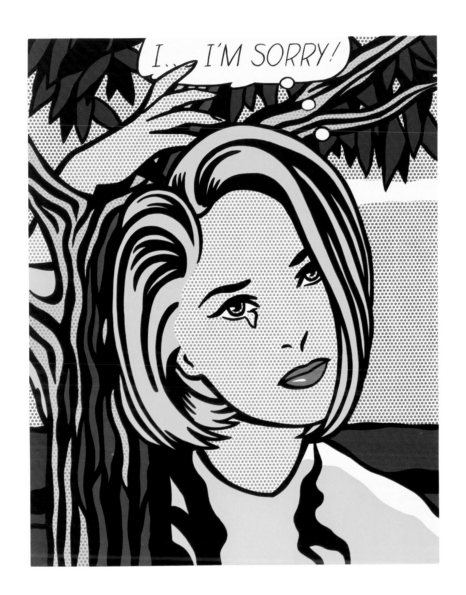

ROY LICHTENSTEIN *I . . . I'm Sorry!*, 1965–66

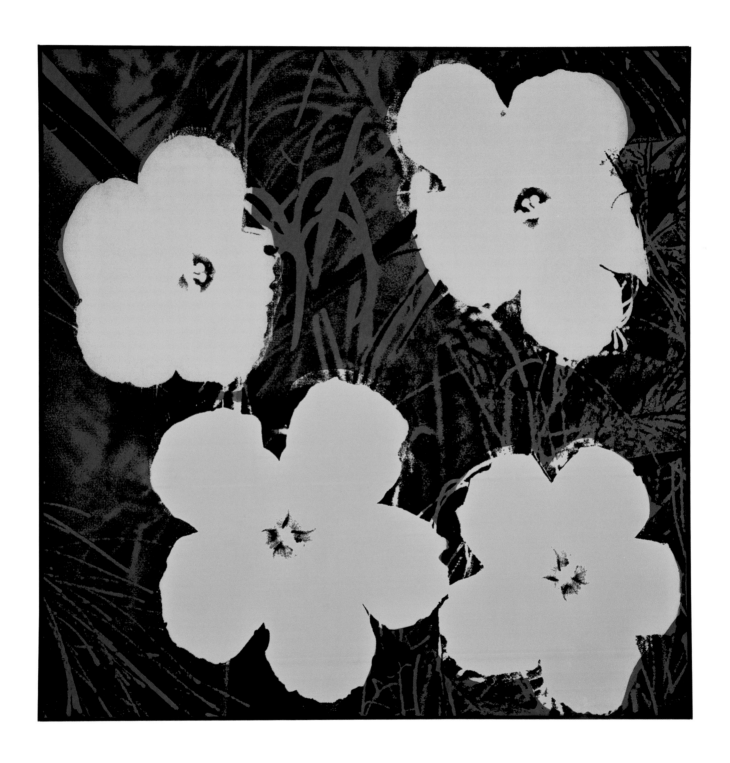

ANDY WARHOL *Flowers*, 1964

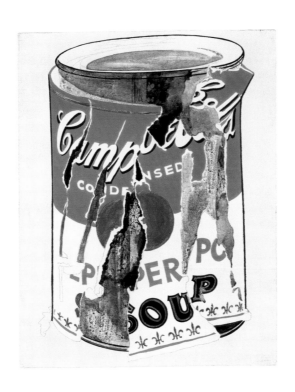

ANDY WARHOL *Small Torn Campbell's Soup Can (Pepper Pot),* 1962

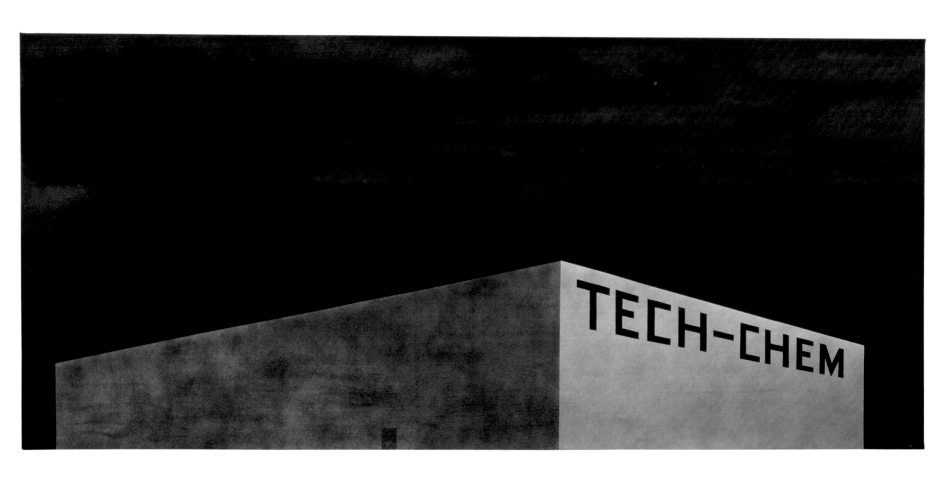

ED RUSCHA *BLUE COLLAR TECH-CHEM,* 1992

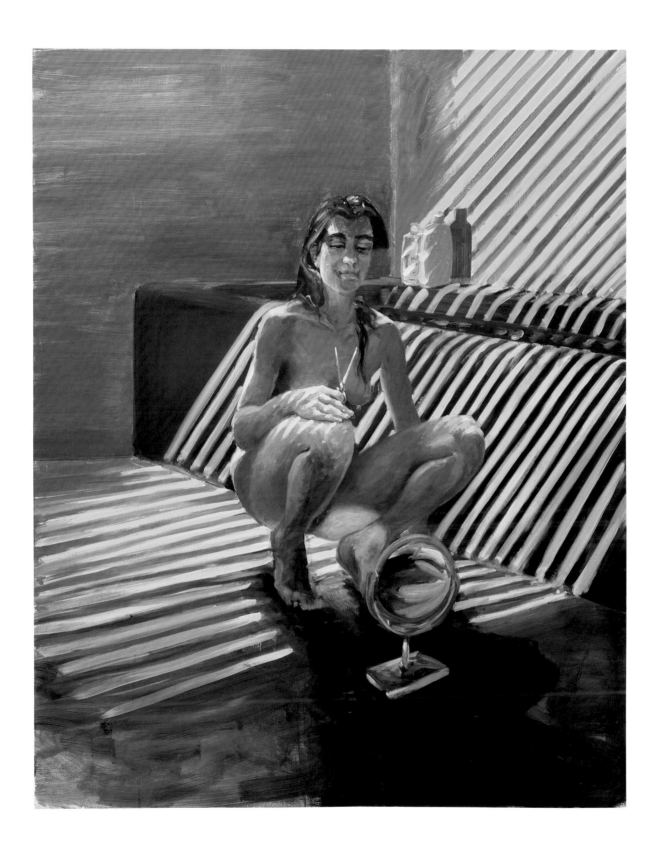

ERIC FISCHL *Haircut*, 1985

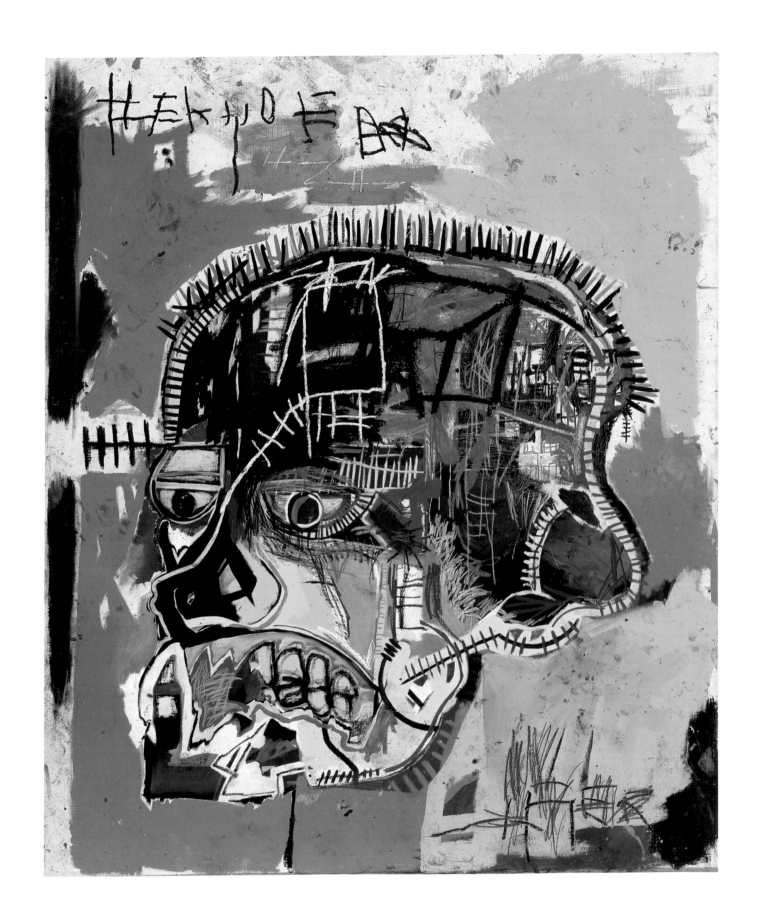

JEAN-MICHEL BASQUIAT *Untitled*, 1981

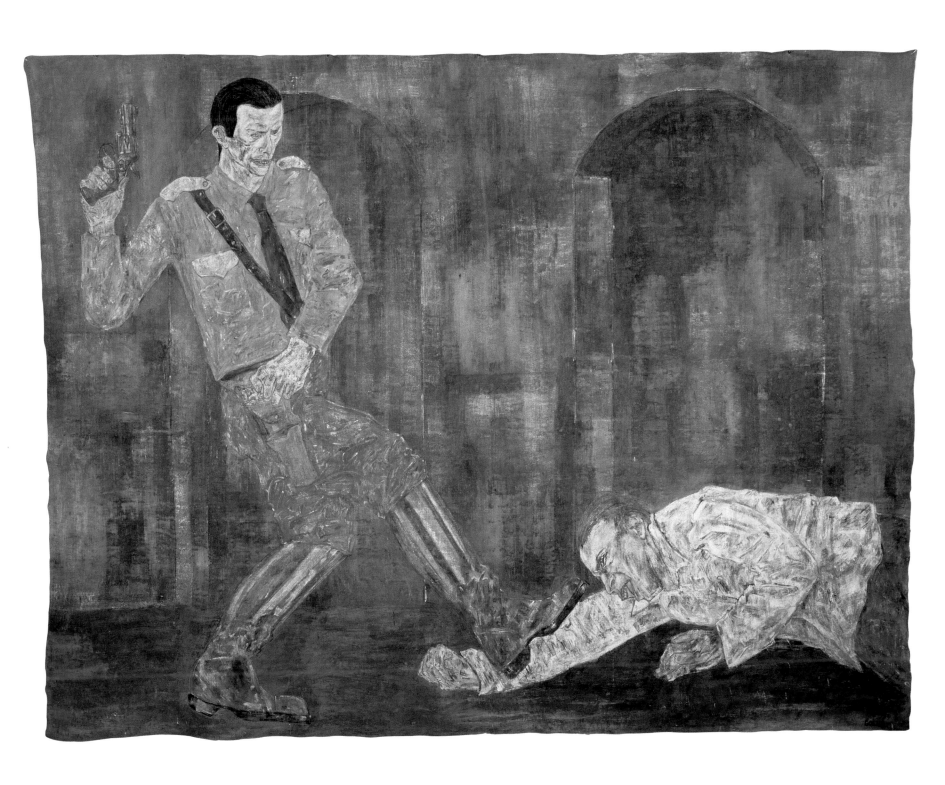

LEON GOLUB *White Squad V*, 1984

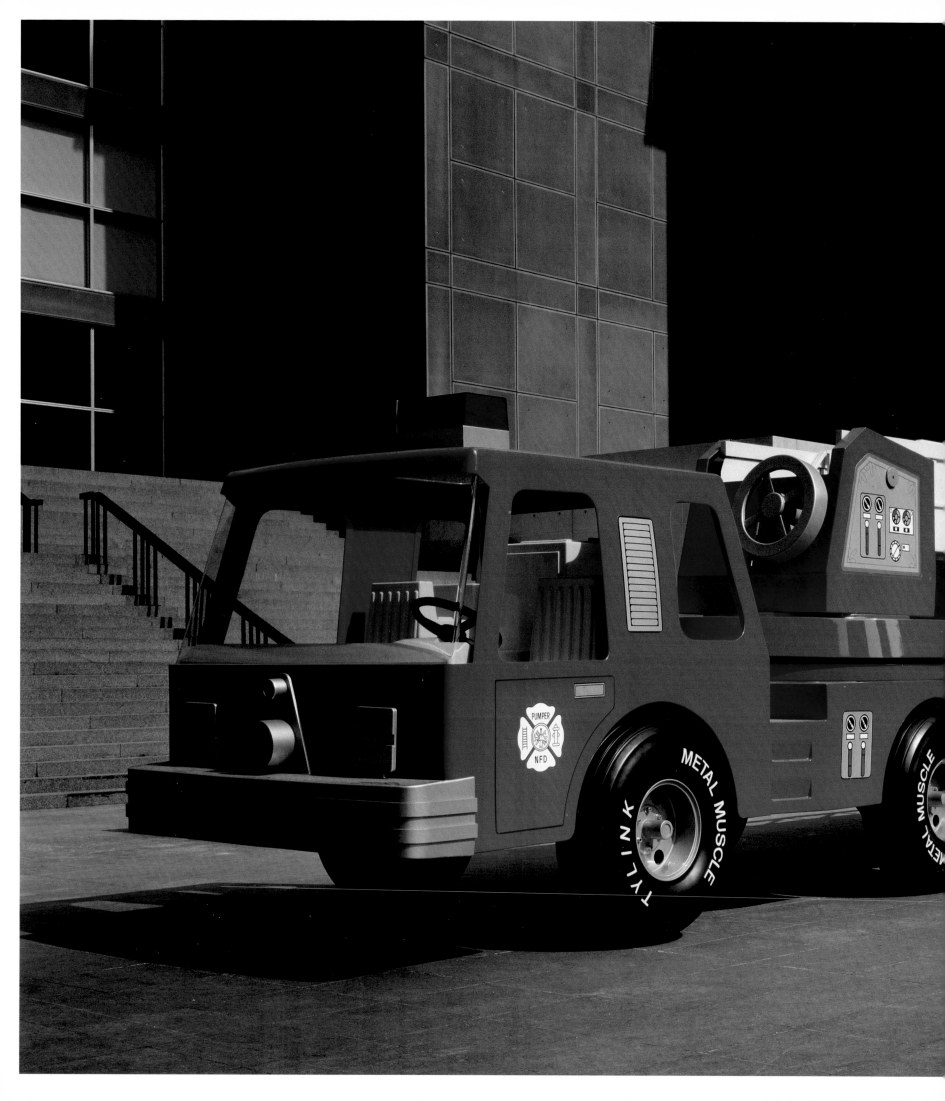

CHARLES RAY *Firetruck*, 1993

MIKE KELLEY *Gym Interior*, 2005

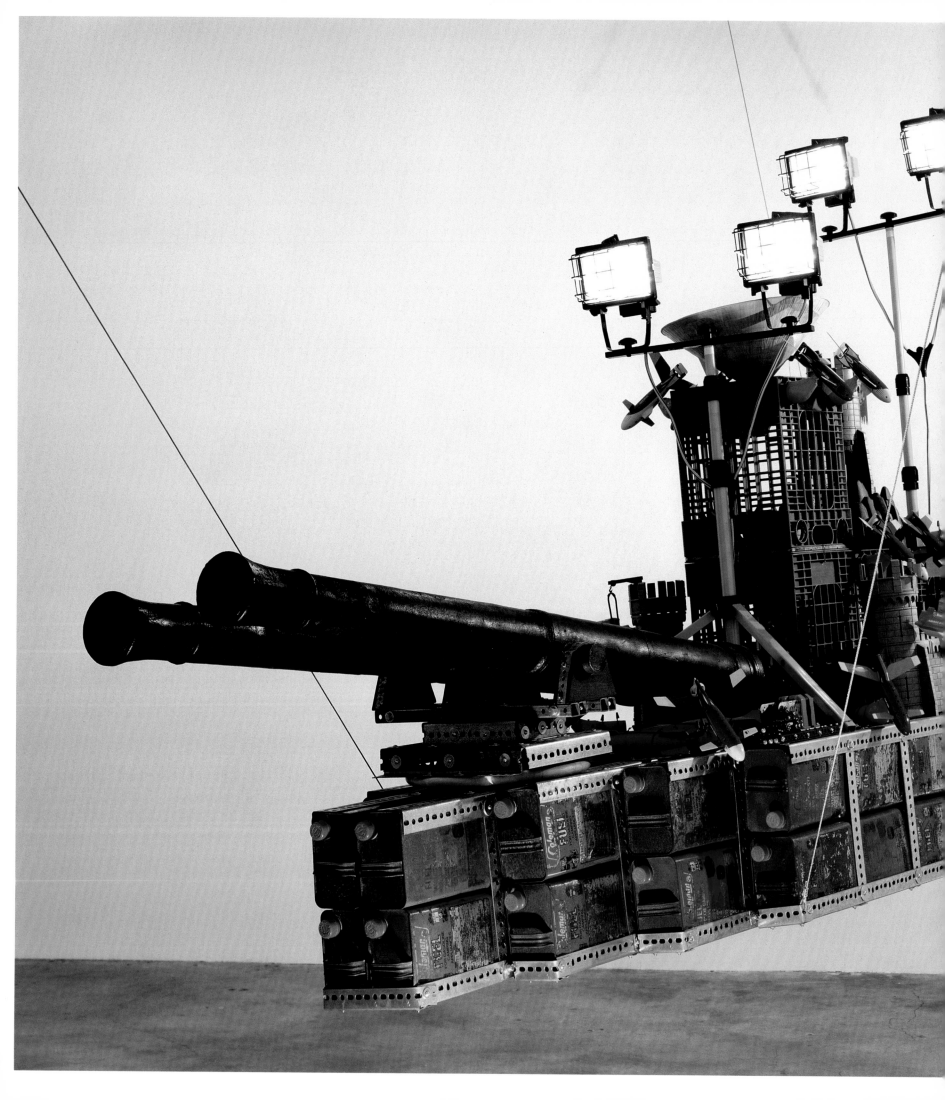

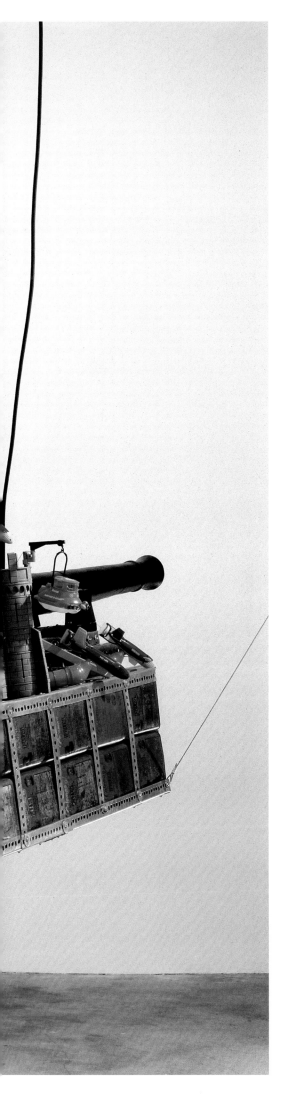

CHRIS BURDEN *Bateau de Guerre,* 2001

DAMIEN HIRST *The Kingdom of the Father*, 2007

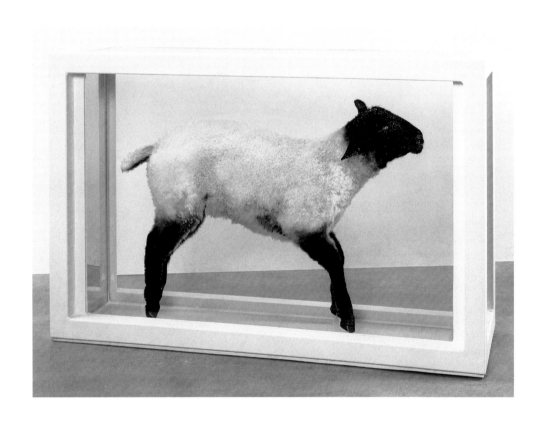

DAMIEN HIRST *Away from the Flock*, 1994

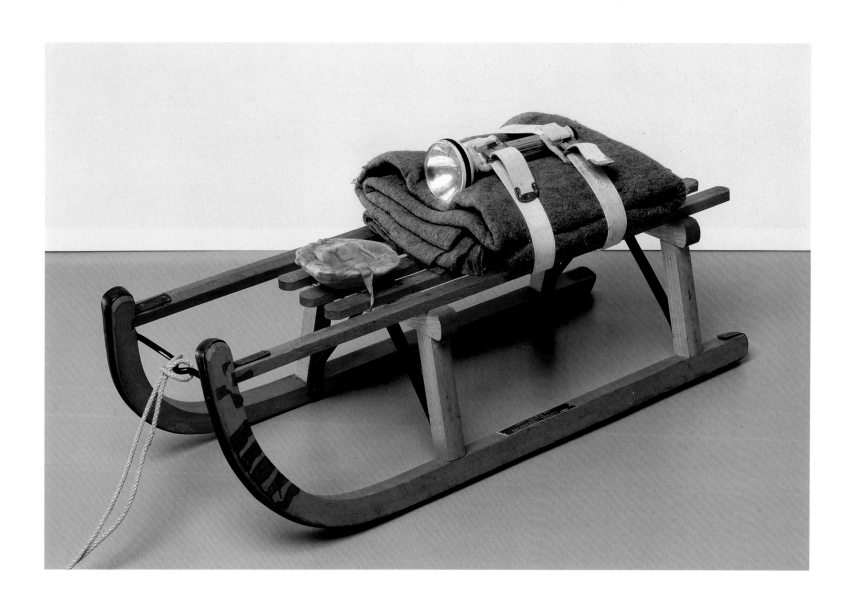

JOSEPH BEUYS *Sled*, 1969

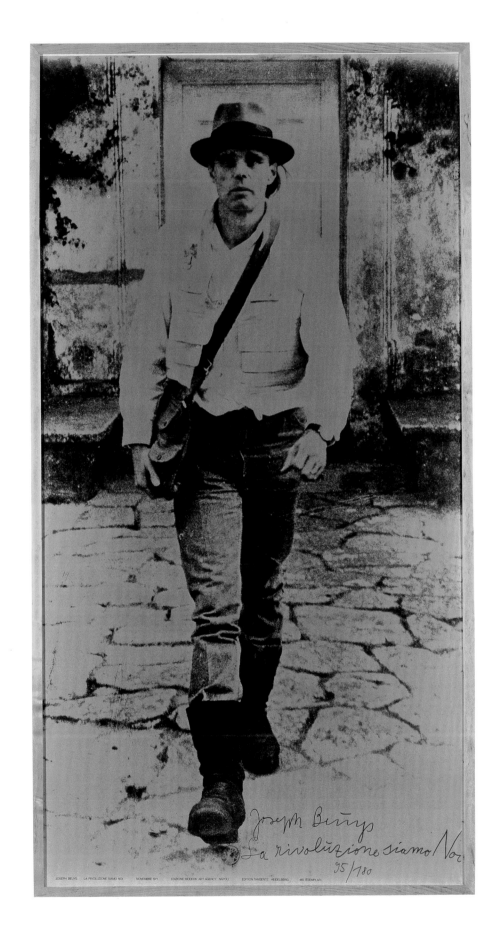

JOSEPH BEUYS *La rivoluzione siamo noi*, 1972

RICHARD SERRA *Band*, 2006
Los Angeles County Museum of Art, purchased with funds
provided by The Broad Contemporary Art Museum Foundation

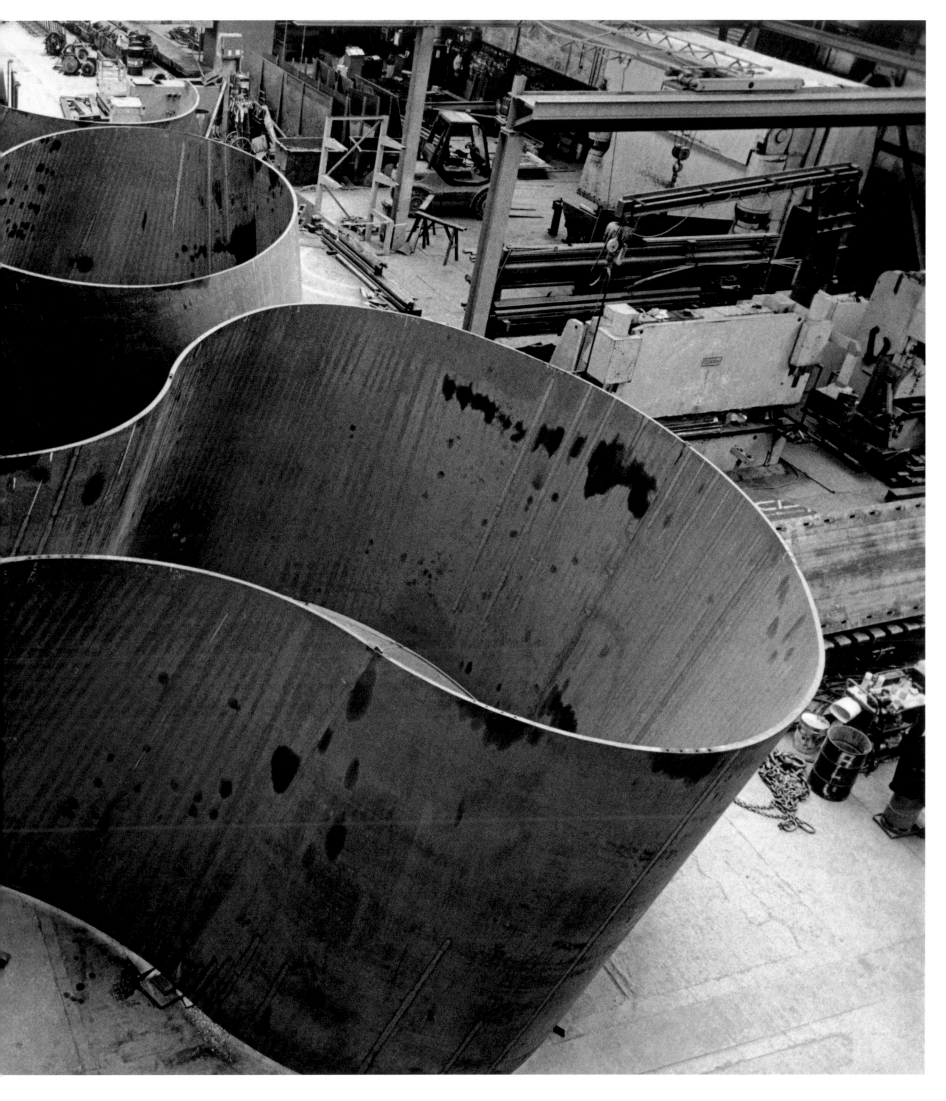

UTA BARTH

UNDER THE SURFACE

MICHAEL GOVAN IN CONVERSATION WITH ELI BROAD AND RENZO PIANO

MICHAEL GOVAN Eli, as far back as 2000 there was an understanding that the LACMA campus needed to change. What was the feeling? Was it just more space?

ELI BROAD For many years a lot of us were concerned with the architecture. I didn't mind telling the press we had an architectural mess on our hands, and something had to be done. Plus, we did need more gallery space, especially for contemporary art. So as a result of those discussions, during 2001 the board of trustees finally said, "Let's have a competition." We took a trip around Europe to visit museums and came up with a list of architects, including Renzo Piano. At that time Renzo said, "Thank you, but no thank you." So we ended up with Rem Koolhaas, Jean Nouvel, Daniel Libeskind, Thom Mayne, and Steven Holl. The board of trustees selection committee cut the list down to Koolhaas and Nouvel. In the end, we were intoxicated with what Rem had in mind, which was taking all the buildings, other than LACMA West and the Pavilion for Japanese Art, and slicing them off. Then he would build a huge tentlike structure on the site. He had schemes on how to show the various collections in this building. It was fascinating, so we said, "Let's go ahead." We asked, "Rem, can you build this in stages? Because we can't close the museum for three years, and we can't raise all that money at once." He said, "Yes, of course, you can build it in stages." As it turned out, you couldn't really build it in stages. In November 2002, the board decided we

would try to raise $100 million in bond financing from the taxpayers to finance a portion of the Koolhaas project. Well, it needed a two-thirds vote, and we got 63 percent. So that was the end of that. I was frustrated that our expansion plans had stalled, so in June 2003 I went to Europe to see Renzo and said, "I really want you to do this building for me, a freestanding museum for contemporary art." And he said, "Why should I do it? I've got all this other work." I said, "You only have to deal with me and LACMA's director." He said, "Let me think about it. I'm going sailing tomorrow." I asked, "Well, where are you going to be when you come home?" He said, "I'll be in London." A bit later we met in London, and Renzo said, "Okay. Let me have a look at the site." So the conversation started. After looking at the site he said, "I can't do just your building. We have to redo everything on the LACMA campus. We have to find a solution for the whole thing."

RENZO PIANO I wasn't that bad!

MG I have a letter in front of me written on June 19th, 2003:

Dear Eli,
As I already told you, it's very frustrating to play a good piece by a string quartet in the middle of three badly played rock concerts.

So tell us, Renzo. What did you really think of the campus when you saw it?

RP It was quite a mess. But my first reaction—to say no—was because of being so busy. Energy is about putting everything into what you do, the way children do. If you do something, you just do that one thing. So my initial reaction was, "No. Never." Not because of arrogance; because I was doing something else. But when you see a monster, you are attracted at the same time as you are pushed away. Monsters are fantastic creatures. This was a bit like that.

MG You mean the Los Angeles County Museum of Art in toto?

RP The entire thing. I will never forget the first time I set foot in what I immediately felt was the kingdom of darkness, the staff offices. "What are you doing here? How can you see the light and the truth? How can you have the perception of truth by staying here in this darkness?" So it was not just about the new building. The entire campus was really a mess. But when something is so messy, you start to be interested, because you think, Oh, I can do something. Also, art excuses many things. When you see the collection, you start to be attracted.

MG At that point you hadn't built in Los Angeles. Was it a place you had thought about?

RP I had been brought to Newport Beach by a little museum, and it didn't work out. But I became more familiar with Los Angeles. I was lecturing here at that time. It's a city that always attracted me for some reason.

EB The first time I saw something of Renzo's was at the opening of the Pompidou Center.

RP January 1977.

EB Another memorable project was the Beyeler Museum. I was at that opening also. I was fascinated by the dialogue that went on between Ernst Beyeler and Renzo. Renzo said, "I'm not the architect; Beyeler's the architect. I'm the director." It came to me clearly that a great building is the product of a great architect and a strong client. So I felt we had to get Renzo engaged.

MG Renzo, you came back and said the project had to be larger than just BCAM.

BCAM excavation, January 2006

SHARON LOCKHART

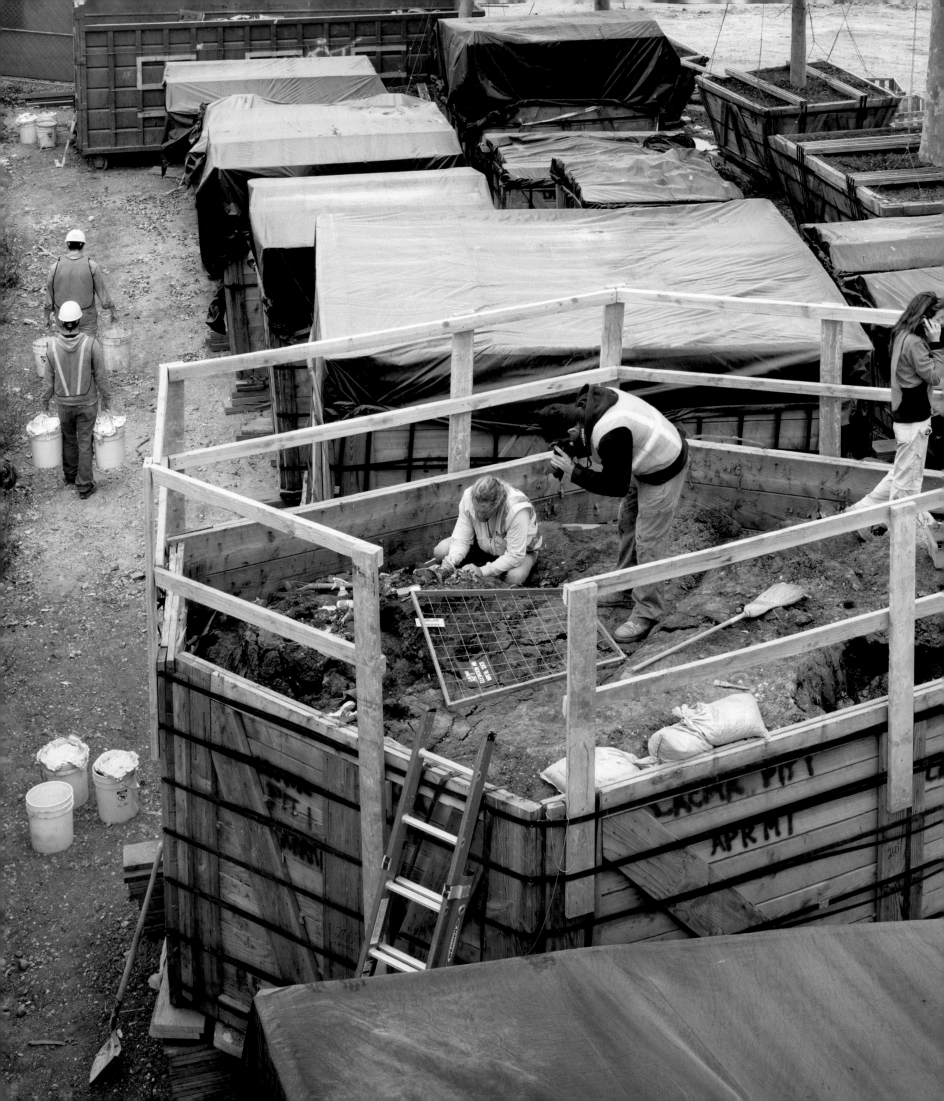

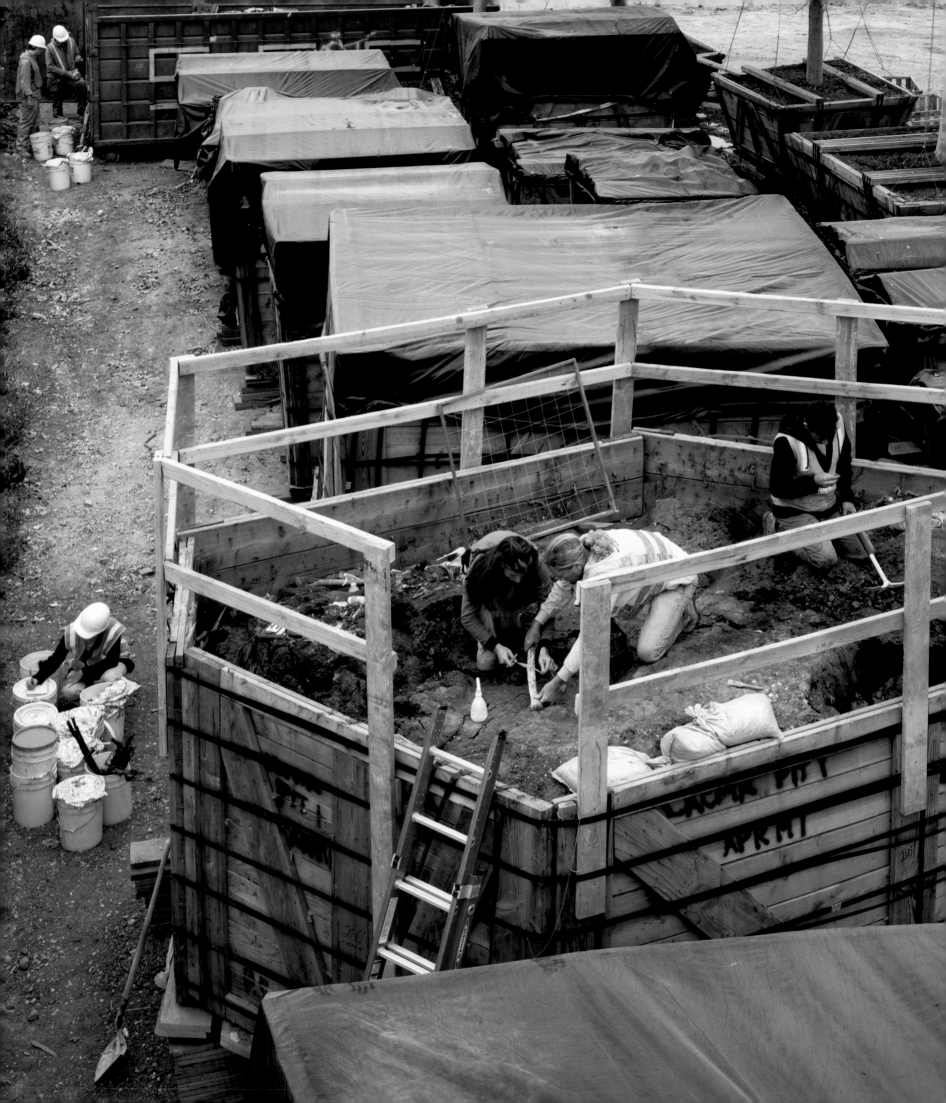

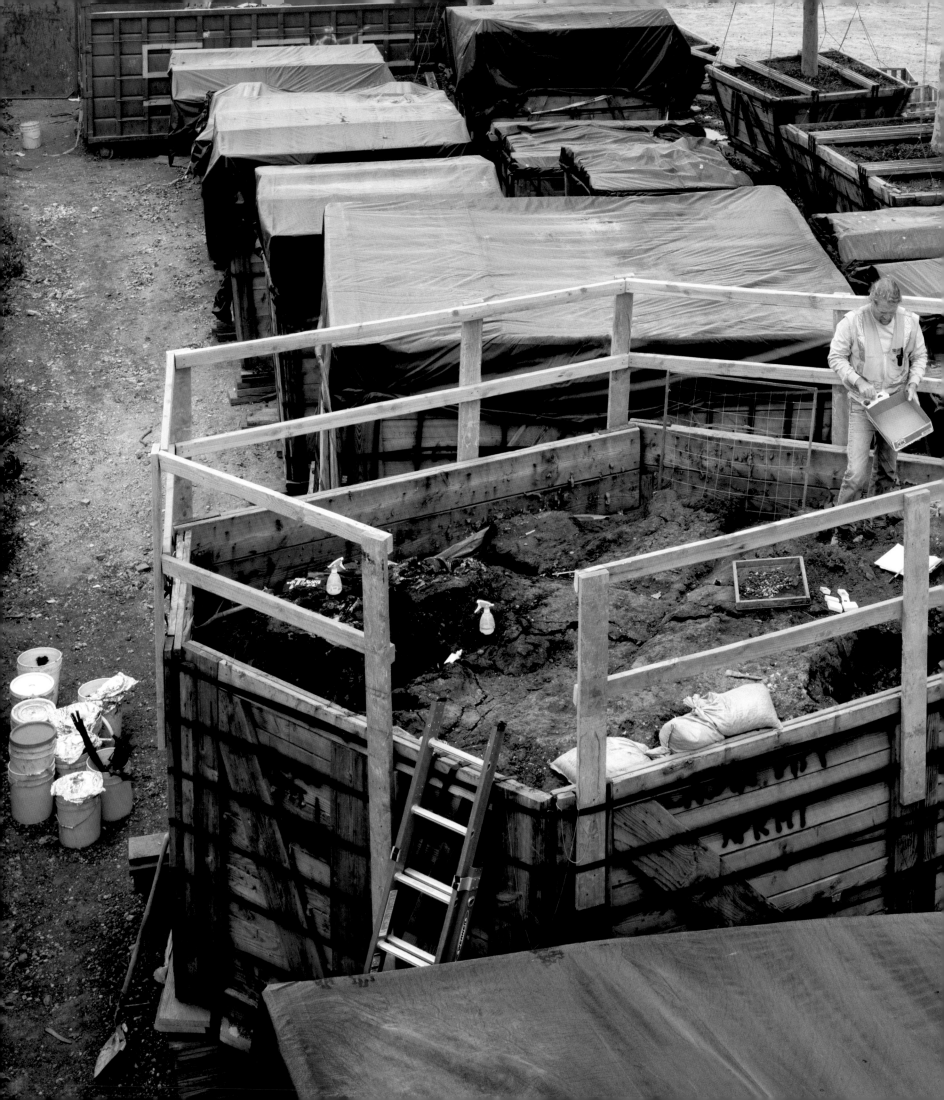

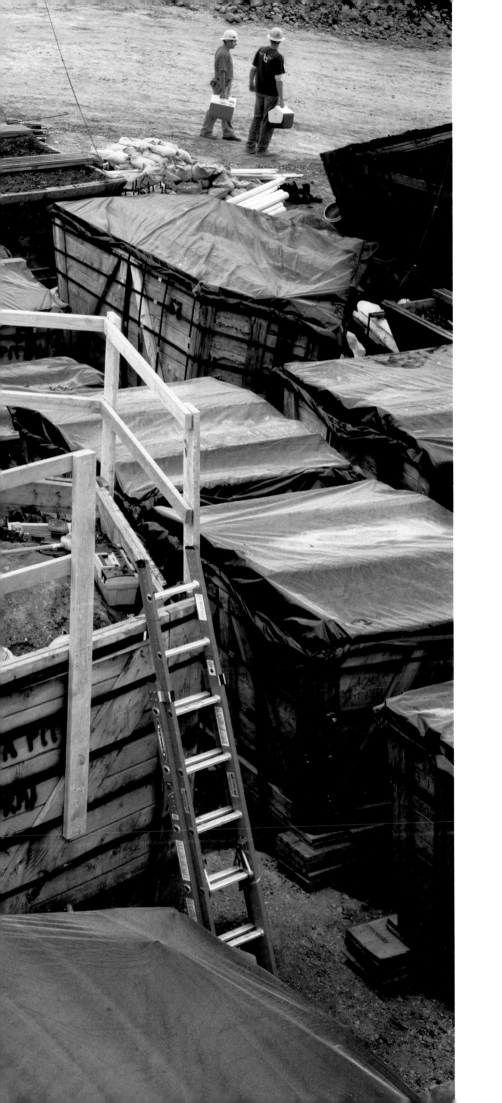

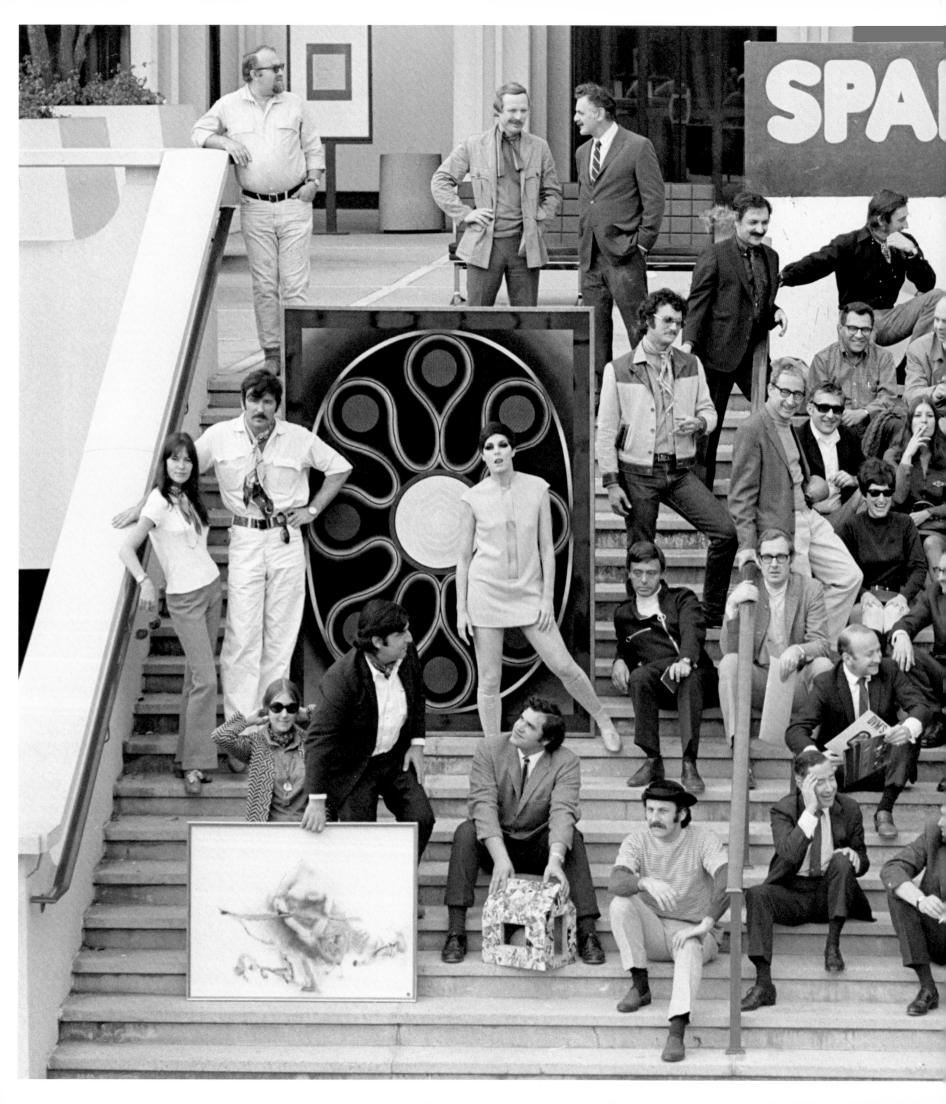

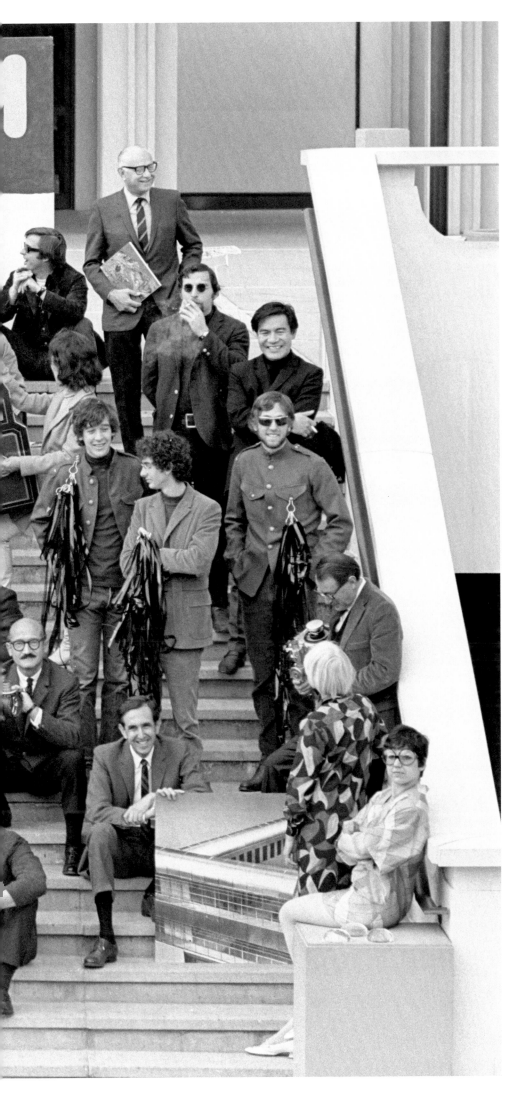

ARS LONGA, VITA BREVIS

CONTEMPORARY ART AT LACMA, 1913–2007

LYNN ZELEVANSKY

A reception for artists, at LACMA, 1968.
Among those pictured (in alphabetical order): Babs Altoon, John Altoon, Larry Bell, Billy Al Bengston, Tony Berlant, Leon Bing, Judy Chicago, John Coplans, Lou Danziger, Jules Engels, Frank Gehry, Rudi Gernreich, Lloyd Hamrol, Craig Kauffman, Edward Kienholz, Thornton Ladd, Penny Little, Claes Oldenburg, Ken Price, Ed Ruscha, Art Seidenbaum, Henry J. Seldis, Deborah Sussman, Kay Tyler, Kenneth Tyler, John Whitney Jr., Mark Whitney, and Michael Whitney

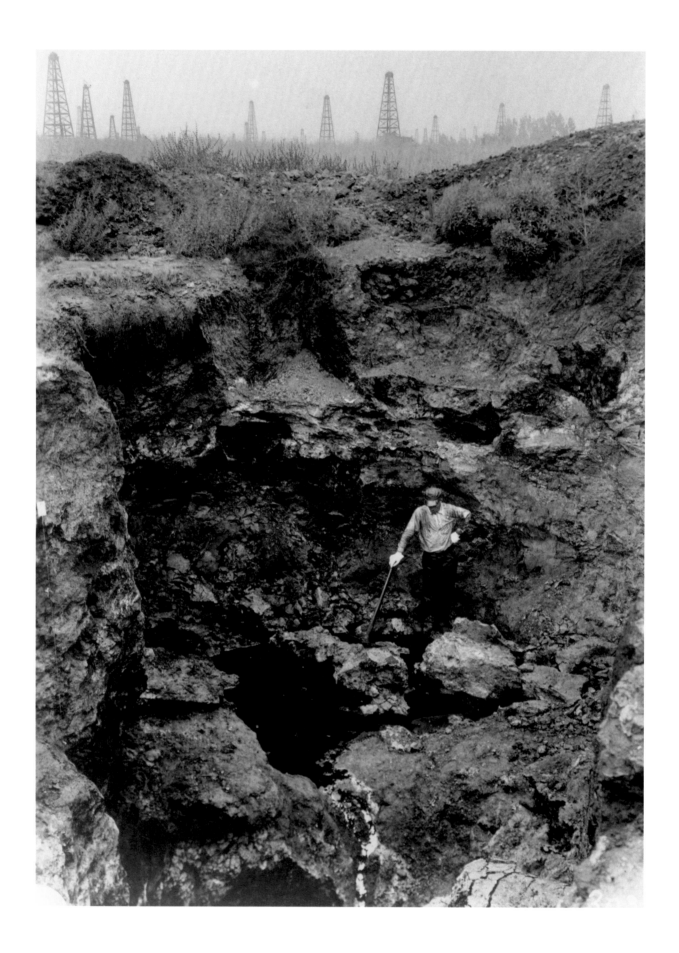

Archaeologist in tar pit in the Miracle Mile area, oil fields in the background, c. 1910

PROLOGUE

Hancock Park, home to the Los Angeles County Museum of Art, also encompasses the George C. Page Museum and the La Brea Tar Pits, which contain the largest and most diverse assortment of ice age fossils in the world.[1] Although it is not immediately evident to the casual visitor, the same muck that thousands of years ago trapped now-extinct mammals still roils under the trees, sidewalks, and buildings of the park and neighborhood. It bubbles up insistently through cracks in the cement, but in a city traversed mostly by automobile, it remains invisible to most everyone except those who live or work in the vicinity.

When construction of the Broad Contemporary Art Museum (BCAM) at LACMA began in 2006 on the grassy expanse between the Ahmanson Building on the east (one of LACMA's three original structures from 1965) and the 1939 art deco May Company department store now known as LACMA West, fossils were found—saber-toothed tigers, mammoths, even a camel.[2] Throughout the excavation, teams of scientists were on hand to monitor each pile of dirt as it came out of the ground. When bones were found, the head paleontologist would briefly take control of the site. The scientists would descend, slowly and carefully brushing away dirt to identify an entire cache of bones that would be dug out, dirt and all, under their supervision. The whole bundle, encased by wood slats, would be lifted from the pit by crane. As I write this, these bones have yet to be transferred to a laboratory, where they will be cleaned, fully examined, and catalogued.

People in the United States are generally intrigued when you tell them the story of the bones; mention it to many Europeans or Latin Americans and they just shrug. They are accustomed to finding relics of long-dead civilizations beneath their feet. Go a little north of Mexico City and there are no major civilizations to discover, but in certain spots there are repositories of bones far older than the Egyptian pyramids or the buildings of imperial Rome. Los Angeles, often seen as lacking historical consciousness—a city focused on the future—has beneath its largest museum the relics of prehistoric times. BCAM, LACMA's first building devoted exclusively to contemporary art, sits on very ancient soil.

The physical situation of the new museum—a clean, modern structure atop the muck of the tar pits—parallels the complex history of contemporary art at LACMA. It is not only that LACMA's contemporary art building is perched on a foundation of fossils. Its great collections, its many memorable and art historically significant exhibitions, and its programs that have steadfastly served L.A.'s museum-going public for more than four decades also obscure from view an often turbulent past. Contemporary art, which elicits passionate responses from supporters and detractors alike, was often at the center of the fray. However, a tumultuous history is to be expected of the first major museum in Los Angeles, whose roots stretch back to when the city was still the Old West.

To my knowledge, what follows is the first attempt to write a history of contemporary art at LACMA. It begins in 1913 with the museum's early days as a division of the Los Angeles Museum of History, Science, and Art in Exposition Park and ends in the present. If it has succeeded, it should shed light on the development of cultural life in the city and inspire further research.

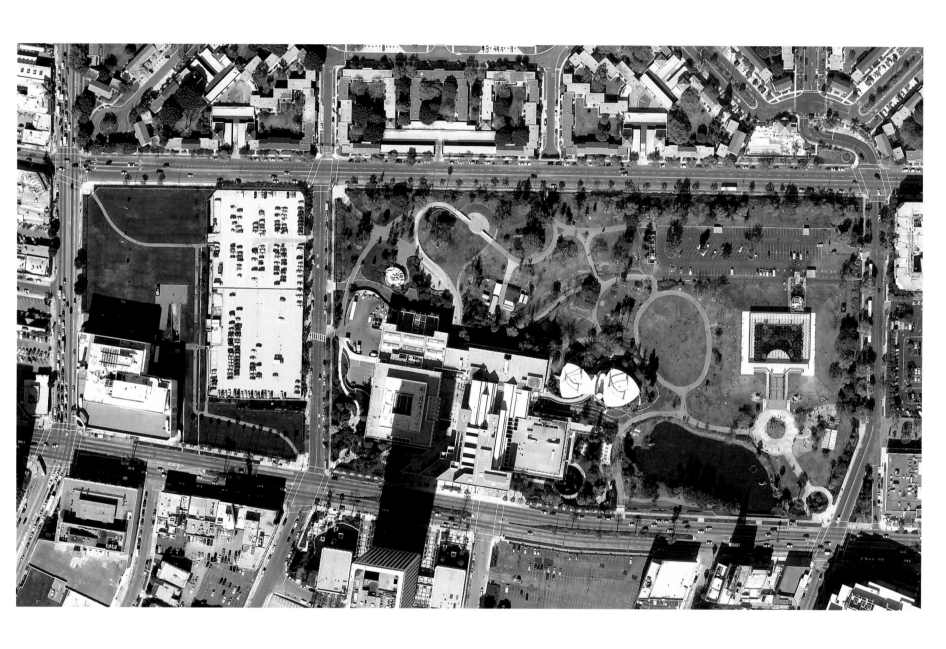

Aerial view of LACMA, the La Brea Tar Pits, the George C. Page Museum, and Hancock Park, 2004

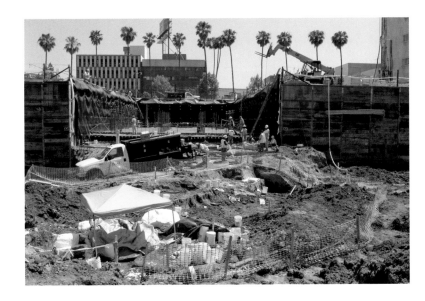

The word *contemporary* is tricky. As philosopher and art critic Arthur C. Danto has noted, when used today in relation to art, it is more than a temporal term. This was not always the case, however. In the first half of the twentieth century, when *modern* signified the art of the day, *contemporary* simply referred to modern art that was made very recently. Danto asserts that somewhere between the late 1940s and the present, a distinction emerged between modern and contemporary art. *Modern* signified a style and a period, while *contemporary* became that which was not modern and came after modernism. Like modernism before it, contemporary art has its own unique "structure of production never . . . seen before in the entire history of art."[3] This essay begins when the art of the day was *modern*, and ends well after it became *contemporary*.

At LACMA, the department responsible for interpreting contemporary work was first called the Modern Art Department. In 1981 it was renamed the Twentieth-Century Art Department, in line with more established institutions such as the Metropolitan Museum of Art in New York and the Art Institute of Chicago. In 1996, with the new century fast approaching, the Twentieth-Century Art Department became the Modern and Contemporary Art Department. In 2005, as modernism receded further into the past and plans for the new Broad Contemporary Art Museum

(which focuses on art created after 1945) solidified, modern and contemporary art were divided into two separate departments. The exact date of the division—the line drawn between the two disciplines—remains elusive. Art made between 1945 and 1960 could find a place in the galleries of either department. These changes in the museum underscore the ambiguities of Danto's contemporary-versus-modern question.

Excavation of the BCAM construction site, 2007

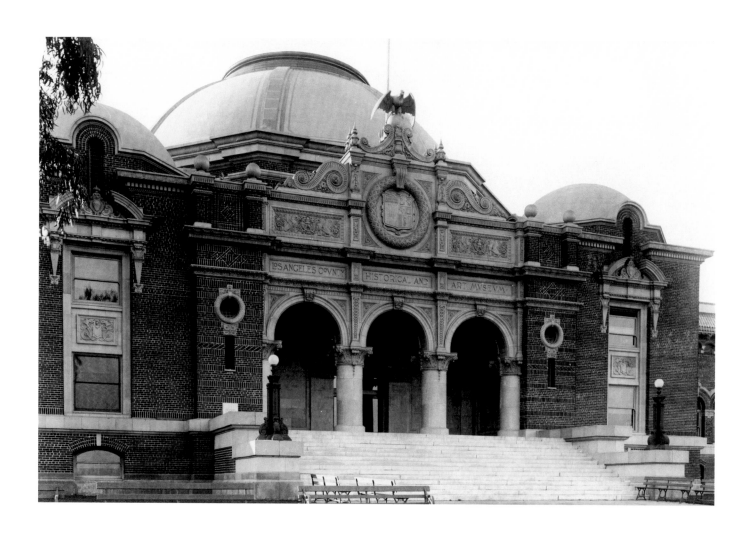

Entrance to the Los Angeles Museum of History, Science, and Art in Exposition Park, c. 1920

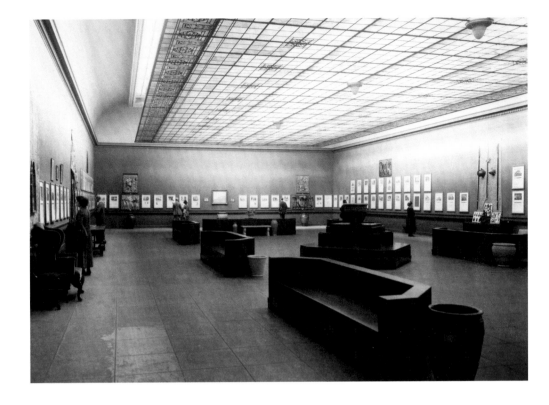

EARLY HISTORY

Los Angeles is associated with the future because it is a young city; it started to fully develop only in the late 1800s. By the early twentieth century, it had become a haven for land speculators who, along with the chamber of commerce, promoted the myth of L.A.'s edenic, primordial past and open-ended future full of promise. Los Angeles was built on a new, non-European model. It sprawls. It has no center. It was constructed for cars. The story is familiar, yet its particulars still have the capacity to surprise. Whereas the great general museums of the East Coast and Midwest, such as the Metropolitan Museum of Art and the Art Institute of Chicago, were founded in the 1870s in long-established urban centers, the Los Angeles Museum of History, Science, and Art (from which LACMA would evolve) was born just as the city began to grow. It opened south of downtown in Exposition Park in 1913, the day after the Owens River Valley aqueduct first brought water to Los Angeles from Northern California. In fact, the cornerstone of the museum building had been christened in 1910 with a goblet of Owens River water. It was the aqueduct that would allow L.A. to become a major metropolis.[4]

The Los Angeles Museum (now the Natural History Museum of Los Angeles County), with its beaux-arts facade and Spanish inflections, sat before a large, formal garden, as grand an edifice as any civic building in the country. Unlike its eastern and midwestern counterparts, however, Los Angeles during the early years of the twentieth century did not have a single significant art collection. Neither the founders of the museum nor its initial board members had fortunes to rival those of robber barons such as Andrew Carnegie or J. Pierpont Morgan, nor did L.A. have the funding infrastructure of cities like New York or Chicago. What it did have were ambitious civic leaders with a vision of what their town could become.

Without a collection, though, and no great art to borrow from local patrons, in the beginning (and for a long time afterward) the museum depended heavily on temporary loan exhibitions to draw crowds. It borrowed primarily from eastern dealers and art associations such as the American Federation of Arts. The result was that from its inception, the Los Angeles Museum's (and later LACMA's) programming was skewed toward contemporary art.

This was unusual. Most general museums in the United States emphasize historical works, organizing their holdings to tell a story in which the cream, in the form of artistic genius, rises to the top. They aspire to present only what is considered the best of what was produced in a given era or culture. Of course, fashions ebb and flow in art history as they do in the rest of culture; one artist or style loses prestige while another gains it depending on the aesthetic values of the moment. In general museums, however, these shifts in attitude usually provoke subtle changes that do not fundamentally disrupt the existing narrative. Historical works have proven their significance over time. Areas of art historical expertise have relatively fixed boundaries and their contents are largely known. Contemporary art, in contrast, is a messy business, a field in which the parameters are constantly shifting. What was contemporary yesterday is historical today.

ARS LONGA, VITA BREVIS

89

Modern art gallery, Los Angeles Museum of History, Science, and Art, c. 1920

Collecting contemporary art means buying more work but knowing that a larger percentage of acquisitions will not find a place in the history of the period.

When New York's Museum of Modern Art (MoMA) was founded in 1929, the term *modern* had stylistic connotations associated with the European avant-garde, but it also simply meant *contemporary*; MoMA was founded as a contemporary art museum. Its first director, Alfred H. Barr, openly acknowledged that contemporary art was a field in constant flux. He saw the fledgling institution in part as an incubator for the Metropolitan Museum of Art. An important precedent for this model was the Musée du Luxembourg in Paris, which housed the work of living artists. Ideally, the best of that institution's holdings eventually found its way to the Musée du Louvre. Barr initially saw MoMA as the Musée du Luxembourg to the Met's Louvre and planned, after a fixed number of decades, to move its most important older art uptown. In this way, the museum's collections would mirror the changing nature of the field. MoMA would be "a torpedo moving through time, its nose the ever-advancing present, its tail the ever-receding past."[5] The plan proved far more palatable when the Modern had no collection, however, than in later years when the administration faced the loss of some of its finest works. In 1953 MoMA officially renounced the arrangement with the Metropolitan, but not before some very significant works from its collection were forfeited, among them Honoré Daumier's *Laundress* (1863), Paul Cézanne's *Man in a Blue Cap* (1866), and Pablo Picasso's *Woman in White* (1923).[6]

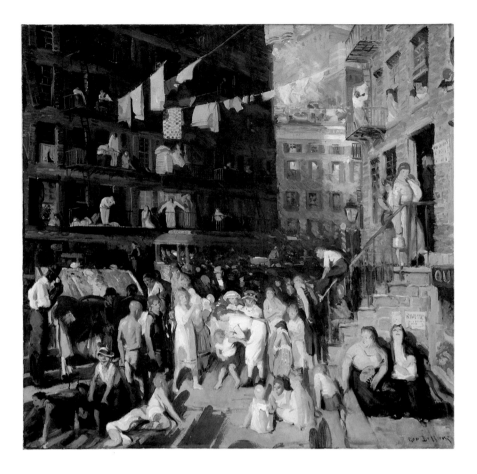

Contemporary art not only requires the acquisition of works that are not time tested but also demands greater resources than other museum disciplines. More staff is needed to stay abreast of a constantly changing field, and more-frequent exhibitions are essential to at least suggest the diversity of artistic activity at any given moment. A general museum with deep and rich historical collections could exist happily for much of the twentieth century without engaging the art of the present. The Art Institute of Chicago and the Met did not create departments of twentieth-century art until 1954 and 1970, respectively, and these departments have generally been overshadowed by their museums' remarkable collections of older works and the activities of the myriad museums devoted exclusively to contemporary art that have sprung up across the country in the last fifty years.

In contrast, and largely out of necessity, the Los Angeles Museum of History, Science, and Art was committed to the art of its

GEORGE BELLOWS *Cliff Dwellers*, 1913

day from the beginning, and not in its exhibition program alone. The museum began to collect contemporary work just three years after its inception with George Bellows's *Cliff Dwellers* (1913), which was bought with public funds. The museum's board and the county supervisors who controlled the museum's budget must have found Bellows's realism acceptable, but the response to so-called modern art would have been very different. Despite a tradition of democratic, utopian radicalism, for much of the last century Los Angeles was a culturally and politically conservative city. L.A. was founded by rugged individualists—cowboys, adventurers, oil and property speculators—and populated over the first half of the twentieth century by large migrations of Middle Americans, many of whom had been farmers rather than urbanites. In the 1910s and 1920s, when the East Coast and Midwest were flooded with poor eastern and southern Europeans looking for a better life, California saw relatively little European immigration, a fact that appealed to some of the U.S. citizens who moved here.[7] For a long time, the resulting community was not predominantly progressive, cosmopolitan, or hungry for the latest developments in the visual arts.

The museum did not make its first stylistically modern acquisition until 1925, with North American artist Andrew Dasburg's *Tulips* (c. 1923–24), a still life rendered in a more naturalistic, less extreme form of cubism than the one defined in France a decade and a half earlier by Pablo Picasso and Georges Braque. The museum's first major work to represent the European avant-garde was by Albert Gleizes, who was known as a "salon cubist." His

Figure (c. 1920)—a thoroughly cubist painting—entered the collection in 1926 as a gift of William Preston Harrison, a trustee and the museum's first major patron. Harrison was extremely generous, ultimately giving the museum almost three hundred works. His collection included art by nineteenth- and twentieth-century Europeans and North Americans. In the European modernist arena, among those represented were André Derain, Fernand Léger, and Amedeo Modigliani. Harrison also had inserted a farsighted clause into his contract with the museum. It stipulated that his collection would be reevaluated after twenty-five years (or in 1956) and every ten years thereafter, thus supporting the museum's need to replace lesser works with superior ones or with works that would better complement the collection.[8]

Writing in 1967, LACMA director Ken Donahue admitted that after the donation of Harrison's collection "there were . . . few donors [of modern art] for the next thirty years."[9] This dismal record can be explained in part by the unique cultural situation of Los Angeles. Profoundly affected by the movie industry, it was a city of transients, and its brightest lights kept to themselves and felt little allegiance to the larger community. According to the late actor Vincent Price, even the many European émigré intellectuals and artists who came to L.A. during World War II—authors Franz Werfel and Thomas Mann and composer Igor Stravinsky among them—led very private lives and "didn't mix [with] other society."[10] This could not have helped a young museum in need of financial and public support.

ANDREW DASBURG *Tulips*, c. 1923–24

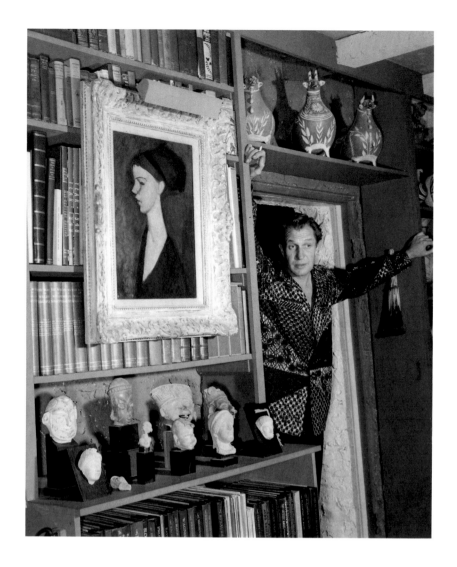

Price, who had studied art history at Yale University and the Courtauld Institute of Art in London, was an avid art collector. Arriving in Los Angeles in 1938, he missed the intellectual and artistic ferment of New York and Europe. In Hollywood he found only a handful of others who shared his passion for the visual arts, director Billy Wilder and actors Edward G. Robinson and Charles Laughton among them. To stay busy between movie roles, from 1948 to 1950 Price had a gallery on Little Santa Monica Boulevard called the Little Gallery, which championed contemporary art, including that of some Los Angeles artists who worked in a modernist vein.[11] The cognoscenti in the United States generally regarded San Francisco as the cultural capital of the West Coast and Los Angeles as an intellectual wasteland. Price felt this was unfair. The problem was that Los Angeles artists were isolated in separate small groups that never seemed to coalesce into a strong community.

The city's poor reputation as a center of the arts may have led some locals to ignore the potential in their own museum, but the museum itself did not help matters. Price spoke for many when he recalled that "it was very difficult because we had a museum that was so dated and antiquated . . . [It] was really one of the dullest places I've ever been in my life. It had a small collection of pictures. It was downtown. It was run by people who didn't have any knowledge of how to get the public there . . . [It] didn't serve anybody." In the late 1930s, the museum still saw no value in vanguard contemporary work. Price considered the institution ultraconservative. He said, "It was run by the old families of Los Angeles, who really didn't give a damn about modern art."

Vincent Price at home, 1950s

WALTER AND LOUISE ARENSBERG

By the 1930s, Los Angeles had a few serious art collectors, most notably Walter and Louise Arensberg. From the 1920s through the 1940s, they amassed spectacular holdings of European modernism—including major works by Marcel Duchamp, Constantin Brancusi, Joan Miró, Picasso, and many others—as well as tribal art. As early as 1936 the Arensbergs began to envision their own museum centered on Duchamp and Brancusi, and they wanted it to be in Los Angeles. Having exhausted the money given to Walter by his father, a Pittsburgh steel executive, they were living on the sizeable income from a New England textile business that had been left to Louise, but they lacked the extra-ordinary wealth needed to maintain an institution in perpetuity.[12]

Although they were in competition with collector Katherine Dreier for the attentions of Duchamp, the Arensbergs joined her in 1938 in an effort to build an addition to the Los Angeles County Museum of History, Science, and Art ("County" was added to the name in 1931). Dreier's friend William Hekking, previously director of the Albright Art Gallery (from 1962 the Albright-Knox Art Gallery) in Buffalo, New York, became director of the museum in January 1938. Walter Arensberg would become a member of the museum's board of governors that June, and in August, Hekking formed a committee to investigate building a structure in Exposition Park that would house the collections of the Arensbergs and some of their friends. The Arensbergs even named Museum Associates (the legal name for the art division's private side) as beneficiaries of their foundation in legal documents.[13]

For some reason, though, the museum seems never to have formally acknowledged the intended gift. At the time, Hekking was deeply enmeshed in attempts to raise the museum's standards in order to put the institution on a par with others like it around the country, and he was encountering difficulties.[14] In February 1939, in protest over the interference of the museum board in administrative matters, Hekking submitted his resignation, effective June 1. On May 6, shortly before leaving the institution, he gave a public talk in which he declared that "subtle political and intellectual sniping have kept Los Angeles from reaching its rightful goal as a great cultural and art center." He called for the ouster of "unsympathetic members of the obviously incompatible board of governors and board of museum associates," who he believed lacked even a semblance

Louise and Walter Arensberg with Marcel Duchamp (right), 1936

of the intellectual sincerity necessary to create "an aboveboard, forthright policy worthy of a great museum—of a great city." He added, "It will be a great day for art in California when it can be taken out of politics . . . Trusteeship is a public trust and should be above ward politics."[15]

Hekking's letter of resignation had been a desperate attempt to alter the board's behavior. He had looked to Arensberg for support, believing that one word from the collector could reverse the whole situation. He was bitterly disappointed when none came. Perhaps Arensberg blamed Hekking for the institution's failure to acknowledge his promised gift. He seems later to have regretted his unwillingness to speak on the director's behalf. Apparently in despair over whether the museum would ever construct a building for his collection, Arensberg resigned from the board on October 25, 1939, less than two years after his appointment.[16]

In September 1944, the Arensbergs again tried to find a permanent location in L.A. for their art, signing their collection of 832 works over to the University of California, Los Angeles.[17] The plan was to build a museum for the collection at UCLA as soon as the war ended in Europe. Had the university built the museum in a timely fashion, they also would have received gallerist Galka Scheyer's great collection of works by the Blue Four: Wassily Kandinsky, Paul Klee, Lyonel Feininger, and Alexei Jawlensky. As of February 1946, however, the president of UCLA had not requested funds for the building, and consequently, the state had not allocated any for it. In August 1947, after much haggling, the

Arensbergs demanded the return of their bequest and got it.[18] It would be their last serious attempt to find a home for their collection with an existing Los Angeles institution.

Sometime in the 1940s, Arensberg told Vincent Price that he would leave his extraordinary collection of modern art in Los Angeles if the actor would found a museum for its display. The idea appealed to Price. At the time, modern art could be seen in only a few places in the country, most of them in New York. "We wanted to bring it here, to Los Angeles," Price said. The Modern Institute of Art opened in a loft space on Rodeo Drive in Beverly Hills in 1947.[19]

In embracing Arensberg's proposal, Price was extremely naive. He may have thought he could model the Modern Institute on the Museum of Modern Art, which in 1929 opened in a loft space in the Heckscher Building on New York's Fifth Avenue. The founders of that institution—Abby Aldrich Rockefeller, Lillie P. Bliss, and Mary Quinn Sullivan—lent it both social cachet and financial stability. In contrast, the social elite of 1940s Los Angeles disapproved of those who worked in the film industry, from which Price's supporters came. Often grouped with Jews (whether they were or not, and Price wasn't), actors and others in the entertainment business were banned from joining certain country clubs and living in particular neighborhoods. Price's endeavor also lacked a stable monetary foundation, since Arensberg appears to have offered the Modern Institute his collection but no supporting funds. Price instead had to finance the venture with gifts from a group of interested friends, including actors Edward G. Robinson and Fanny Brice, talent agent Sam Jaffe, and a few others.

Each donated about two thousand dollars, which in the 1940s was a substantial amount, so those involved genuinely were philanthropic.

As well intentioned as they were, Price and his associates knew nothing about the inner workings of museums and struggled to manage the Modern Institute. They hadn't considered the costs of shipping and insuring works, and they didn't realize how much time is required to organize exhibitions. As a consequence, there was little advance planning or preparation. They mounted some significant exhibitions nevertheless, including a show of works by Paul Klee drawn from local collections. Attendance was often good as well, and Hollywood celebrities came to the institute's openings. According to Price, he and his volunteers also were successful at recruiting students, who joined at special low rates. They failed to attract wealthy donors, however, which proved to be a major problem. In addition, much of the responsibility for the institute's day-to-day operations fell to Price, who worked for free while maintaining his film career. After just two years, the Modern Institute of Art closed. Although Arensberg may have engaged Price because he was frustrated with UCLA, it is difficult to imagine that he really ever took the endeavor seriously.

Price felt used by Arensberg and speculated that the UCLA museum failed because the university could not raise the enormous sums that Arensberg required. Obsessed with the notion that Sir Francis Bacon wrote Shakespeare's plays and poetry, Arensberg had amassed a vast library to prove the theory. He demanded not only that the recipients of the art collection build a wing for it but also that they house Arensberg's Francis Bacon Foundation library and employ researchers to further his investigations of a subject that was in disrepute with most scholars. The Arensbergs ultimately wooed and rejected, or were rejected by, more than thirty institutions before settling, near the end of their lives, on the Philadelphia Museum of Art as the repository for their collection.[20] (The museum did comply with the Arensbergs' requirements.) Clearly, Walter Arensberg was difficult. Sculptor Beatrice Wood, who was close to the Arensbergs, recalled that someone from UCLA told her he had been unreasonable. "And I'm sure of it," she said. "Because I knew them intimately . . . Much as I loved him, I could see that."[21] Price simply called Arensberg a "real pain in the ass."

L.A.'s cultural life was dominated by a conservative business elite with little interest in modern art, so it is not surprising that the city's public institutions lacked the resolve to negotiate a deal with collectors as exasperating as the Arensbergs. In all likelihood, the president of UCLA saw additional dormitories for soldiers home from war and on the GI Bill as a greater necessity—and a greater political asset—than a museum for modern art. At the Los Angeles County Museum, with the exception of Harrison, the board was certainly ignorant about the importance of the Arensbergs' collection. To deal successfully with Walter Arensberg, someone in power at the museum would have needed to understand how profoundly his collection could have affected the cultural history of the region. After Hekking's departure, clearly no one did.

THE MUSEUM'S FIRST JACKSON POLLOCK

James Byrnes was passionate about art but not formally educated. In the navy, he served under Russell Smith, who in civilian life was curator of education at the Los Angeles County Museum of History, Science, and Art. Smith encouraged Byrnes to get a general equivalency diploma. Together with his art school background and experience in the Works Progress Administration during the Depression, it was enough to secure Byrnes a job as an art instructor at the museum. He arrived in 1946, following his discharge from the service. After a few months in the Education Department, the chief curator of the art division, Dr. William Valentiner, took Byrnes under his wing.[22]

The illustrious Dr. Valentiner, who led curatorial affairs at the museum from 1946 to 1953, had founded the journals *Art in America* and *Art Quarterly*. He had also served as director of the Detroit Institute of Arts, where he commissioned the museum's famous murals by Diego Rivera. When he came to Los Angeles at the age of sixty-six, the board offered him the position of museum director, but he preferred to leave that post to a younger person. (James Henry Breasted Jr. in 1946 succeeded Roland McKinney, director since Hekking's departure in 1939.) Valentiner worried that the museum's supporters—William Randolph Hearst notable among them—would be extremely "distressed" if the museum appointed a curator with expertise in "modern art," so he suggested that Byrnes be called assistant curator of American art.[23] (The Department of American Art would not be established until 1965.) Byrnes very much wanted to be associated with international modernism, however, and he got his wish. The *Bulletin of the Art Division of the Los Angeles County Museum* from fall 1947 lists him as "associate curator, modern art."[24]

Nevertheless, Valentiner's concern was justified. The late 1940s and early 1950s were a difficult time for modern art all over the United States. With the Red-baiting of the McCarthy era, it was regularly attacked as subversive. In 1951 the Los Angeles City Council decreed that modern art was communist propaganda and banned its display in the area, but the ordinance does not appear to have had teeth, as the museum continued to show some modernist works.[25] Even in that bastion of liberalism, New York City, MoMA director Alfred Barr felt compelled to write an article for the *New York Times Magazine* in 1952 titled "Is Modern Art Communistic?"[26] (Not surprisingly, it turned out that it wasn't.) In this environment, it is predictable that the Los Angeles County Museum's board would be unsympathetic toward abstract art.

Each year the museum organized a show of work from the Los Angeles region. Featuring a hodgepodge of styles, these exhibitions tended to favor representational modes. In 1950 the artist Robert Irwin was a student at Otis Art Institute, which he remembers as being very provincial and bereft of any sense of the

William Valentiner, c. 1930

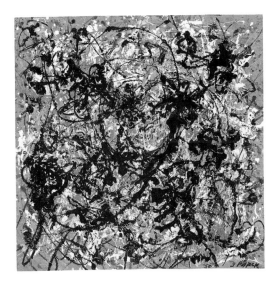

excitement that abstract expressionism was engendering on the East Coast. Irwin's first oil painting, *The Boat Shop*, which depicted a boatyard in somber colors, was accepted into the museum's 1950 annual show.[27] Irwin's tame, well-executed, reassuringly conventional student work complemented the prevailing taste.

Like most exhibitions of its type, the annual was often controversial. One of Byrnes's first responsibilities as curator was to install the show and, with Valentiner, award purchase prizes. The jurors were local artists of different persuasions: three modern, three conservative, and three who Byrnes termed "intermediate." Byrnes had to install four hundred works in two galleries, which required hanging them salon style from floor to ceiling. He and Valentiner awarded a prize to artist Michael Frary for a Miróesque canvas that they considered a little fresher and "less pedestrian" than most of the other works. Newspaper reports underscored the fact that the prize went to an "abstract painter," implying that the good conservative paintings that were in the show were not given proper recognition.[28] One year the jury awarded a prize to artist Saul Steinlauf for a semiabstract painting with a church in the background. According to Byrnes, it and many other works in the exhibition were "interpreted as communist propaganda by local groups such as the California Art Club."[29]

Byrnes soon instituted a number of changes to the annual exhibition process. He abandoned the jury of artists and used curators and collectors instead, Vincent Price among them. Then, in 1951, Byrnes decided to open the exhibition to artists from other parts of the United States. The national section was invitational,

while the regional section was juried. Byrnes claimed that the resulting exhibition marked the first time that abstract expressionist work was shown in any quantity on the West Coast.[30] The museum's Junior Art Council raised funds each year for the exhibition's purchase prizes. Byrnes went to the trustees and asked to use those funds to buy four paintings. With approval from Valentiner, he recommended the purchase of works by Jackson Pollock, Josef Albers, William Baziotes, and Karl Knaths.[31] (He also recommended that they purchase a Mark Rothko, but they lacked the funds to cover the cost.) He justified the Pollock and the Albers as meeting an urgent educational need: the paintings represented the polarities—expressionistic and geometric—of pure abstraction, which was flourishing at the time. With these acquisitions, the curators could help the Los Angeles public understand crucial aspects of this important tendency. It looked as if the board would reject Byrnes's proposal, when one of the trustees came up with a novel solution: he would vote for the acquisitions if, and only if, Byrnes promised not to hang the paintings on the gallery walls. They were to be used exclusively for educational purposes and carried into the galleries only when necessary. Byrnes did not respond. "I was so anxious to get them [and] . . . I knew the moment we got hold of them, Valentiner and I would nail them to the walls and that would be the end of it," he said later.[32] With the proviso that the paintings were for educational purposes only, the purchases were approved.

This incident gives a sense of the biases of the board and its willingness to pit its power against the expertise of the staff.

JACKSON POLLOCK *No. 15, 1950*

JOSEF ALBERS *Homage to the Square,* 1951

It also reveals the lengths to which curators sometimes went to acquire art that they believed in. The funding structure for museums in the United States—a board of private citizens that supports the institution financially and has fiduciary responsibility for it—creates an environment that is ripe for such difficulties, and LACMA was not alone in facing them. At MoMA (a contemporary art museum rather than a general museum with trustees interested in art of different periods), curator Dorothy Miller recalled that Barr

> brought a beautiful Rothko before the [acquisitions] committee—in fact he brought three Rothkos . . . just to try and get them used to it. And then, say, a year later, he brought one he wanted to buy—this was about 1950, 1951 [the same time that LACMA acquired the Pollock and the Albers]—that was when those old trustees were outraged . . . Stephen Clark left the committee because he didn't like [Alberto] Giacometti . . . Conger Goodyear left because of Rothko.

The museum could not afford to hemorrhage support, so at Barr's and Miller's request, MoMA trustee and famed architect Philip Johnson acquired works for his personal collection (among them Jasper Johns's *Flag*, 1954–55) that could not get past the board. Years later, he gave the works to the museum.[33] Even at a New York museum dedicated exclusively to recent art, it was a culturally conservative time.

After Mr. and Mrs. George Gard de Sylva's 1946 gift of funds to purchase works by Picasso, Vincent van Gogh, Edgar Degas, Paul Cézanne, Georges Rouault, and others, however, donations of

works by modernists such as Braque, René Magritte, Modigliani, Max Pechstein, Rothko, Karl Schmidt-Rottluff, and Jacques Villon began to trickle into the collection.[34] This was no doubt due to the encouragement of Valentiner. He founded the museum's Prints and Drawings Department, and as a German émigré himself, championed German expressionism. Through his friendship with playwright and screenwriter Clifford Odets, Valentiner met and encouraged members of the Hollywood community to collect this work. Some of those paintings—donated by Odets and directors Billy Wilder and Josef von Sternberg, among others—found a permanent home at LACMA, forming the basis for the museum's distinguished German expressionist collection.[35]

It was only in the late 1950s and early 1960s that donations of modern art increased substantially. During this period, the museum received gifts of works by Baziotes, Max Beckmann, Pierre Bonnard, Marc Chagall, Adolph Gottlieb, Erich Heckel, Hans Hofmann, Ernst Ludwig Kirchner, Henri Matisse, Emil Nolde, Édouard Vuillard, and scores of younger artists.[36] In 1960 the Art Museum Council bought an important Stuart Davis, and in 1963, the Contemporary Art Council (founded in 1961) acquired a significant abstract expressionist painting by Philip Guston. With contributions from a number of donors, the museum also bought Kurt Schwitters's great large collage *Construction for Noble Ladies* (1919) in 1962. According to Donahue, "By the time the museum moved into the new building [in Hancock Park] in 1965, the collection of nineteenth- and twentieth-century paintings was richer than that of any other epoch."[37]

THE CONTEMPORARY ART COUNCIL

Around 1960 a friend took Jim Elliott to visit Joann and Gifford Phillips (the nephew of Duncan Phillips, who founded the Phillips Collection—the first museum in the U.S. devoted to modern art—in Washington, D.C.). The Phillipses had been collecting contemporary art by figures such as Rothko, Richard Diebenkorn, and Ad Reinhardt since the early 1950s, and Elliott was impressed. They believe that he hadn't realized there were contemporary collections of that quality in Los Angeles. Sometime later Elliott asked them to help him found a committee that would raise funds for contemporary acquisitions and exhibitions.[48] With the help of the Phillipses and others, Elliott became the leading force behind the Contemporary Art Council (later known as the Modern and Contemporary Art Council), which was founded in 1961, the same year that LACMA became a legal entity unto itself. The council would prove crucial to the development of the contemporary art program at the museum.

Gifford Phillips became the CAC's first chairman. The organization began with five or six couples, and then each of them invited one or two other couples to join. Betty Asher, at different times a collector, LACMA staff member, and gallerist, was deeply involved with the council from its inception. There are no official records of the earliest days of the CAC, but she recalls the first members being Michael and Dorothy Blankfort, Betty and Stanley Freeman, Pauli and Mel Hirsch, the Phillipses, Henry and Roz Rodgers, and Harry and Phyllis Sherwood. (Asher and her husband were in the second wave, invited by the Blankforts.) Fred and Marcia Weisman also may have attended the first meeting. Other prominent patrons,

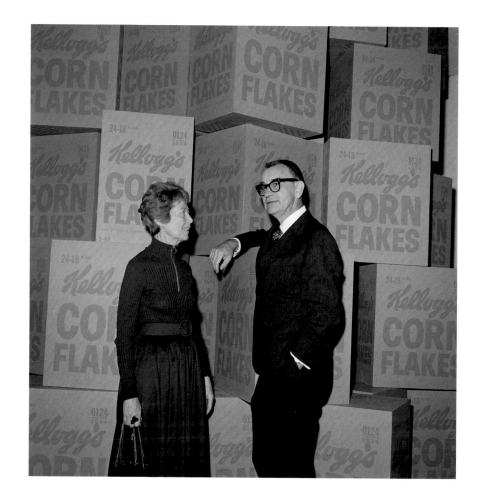

including Monte and Betty Factor and Elyse and Stanley Grinstein, would join soon afterward.

The CAC's purpose was to support the activities of the Modern Art Department. Council members paid five hundred dollars a year in dues, which was expensive at a time when significant works of art could be purchased for a few hundred dollars and exhibitions could be mounted for under ten thousand.[49] In return for their dues, the museum staff provided the members with educational and social activities. Hopkins recalls that the group met fairly regularly at someone's home; they would all "pile in" to see their hosts' collection and listen to a speaker. A nationally known figure—such as critic Harold Rosenberg, curator William Seitz, or artist Roy Lichtenstein—would lecture. Local artists also were invited.

105

LACMA director Ken Donahue with Andy Warhol's *Kellogg's Corn Flakes*, 1972

CLYFFORD STILL *1955-H,* 1955

At a meeting at the Hirsches' house, where Lichtenstein was the guest of honor, Robert Rauschenberg came by with some friends, including the *Village Voice* critic Jill Johnston. He also brought his dog, which peed on a new bedspread, thus upsetting the hostess. Rauschenberg and his friends then took off their clothes and, in the middle of Lichtenstein's lecture, went skinny-dipping in the pool. The house was largely glass, and the other guests stood and stared. Elyse Grinstein remembers Johnston wearing nothing but black men's briefs. Hopkins also recalls a party at the Grinsteins' house at which everyone swam naked. It was the '60s.

Incidents of nude bathing notwithstanding, the CAC took its role very seriously. In 1964 Fred Weisman resigned in protest as chairman of the council when the museum board and director appointed a very young Maurice Tuchman, who came from New York's Solomon R. Guggenheim Museum and was then twenty-eight, to the position of curator of modern art. Weisman believed that the board had promised the council a role in the hiring process. He wanted a more established curator, an art world star. However, the museum did have a successful history of bringing relatively untried but promising newcomers from the East Coast. Brown had been hired with this strategy, which was no doubt a

ARS LONGA, VITA BREVIS

107

FRANK STELLA *Getty Tomb,* 1959

money-saving mechanism. The curators and the administration supported the board's right to make the decision without the approval of the CAC, believing that the council's role was to support the museum and its staff, not to make personnel decisions.[50]

In general, though, the CAC understood its job and did it well. After the move to Hancock Park, on December 19, 1972, LACMA opened new galleries devoted to contemporary art with the exhibition *Ten Years of Contemporary Art Council Acquisitions*. A memo from Maurice Tuchman, written in anticipation of the show, reads:

> [V]irtually all of the collections of the museum in the area of contemporary art have come to the museum through the Contemporary Art Council. These include direct acquisitions of generally acknowledged modern masterpieces such as David Smith's Cubi XXIII, 1964 (acquired 1967), Sam Francis's Toward Disappearance, 1957 (acquired 1970), and Philip Guston's [The Room], 1954–55 (acquired 1963), and seminal works by a younger generation, including Frank Stella's Getty Tomb, 1959 (acquired 1963), Robert Irwin's untitled aluminum disc of [1966–67] (acquired 1968), and Ron Davis's Roto, 1968 (acquired 1969).[51]

Tuchman states that the council had paid "particular attention" to Los Angeles artists, acquiring works by Edward Kienholz, Ed Ruscha, John Baldessari, and others. He also notes that individual members who had themselves generously donated art induced nonmembers to do the same. Examples of major contemporary works acquired in this way include Claes Oldenburg's *Giant Pool Balls* (1967), Stella's *Bampur* (1966), and Andy Warhol's *Black and White Disaster* (1962).

Tuchman went on to describe the Young Talent Award purchase grant, the council's most prominent program. It provided funds to local artists—thereby encouraging them to remain in L.A. and not decamp for New York—while building the museum's contemporary collection, since the winning artist would give a work to the museum in exchange for the grant and an exhibition. Initially, the Young Talent Committee was composed of equal numbers of council members and museum staff. Each committee member would nominate three potential winners of the award and then come to a meeting, prepared to argue for their favorites. The meetings could get contentious; two council members once quit in the belief that the staff had conspired to back the same artists before the group met (something Betty Asher adamantly denied).

ANDY WARHOL *Black and White Disaster,* 1962

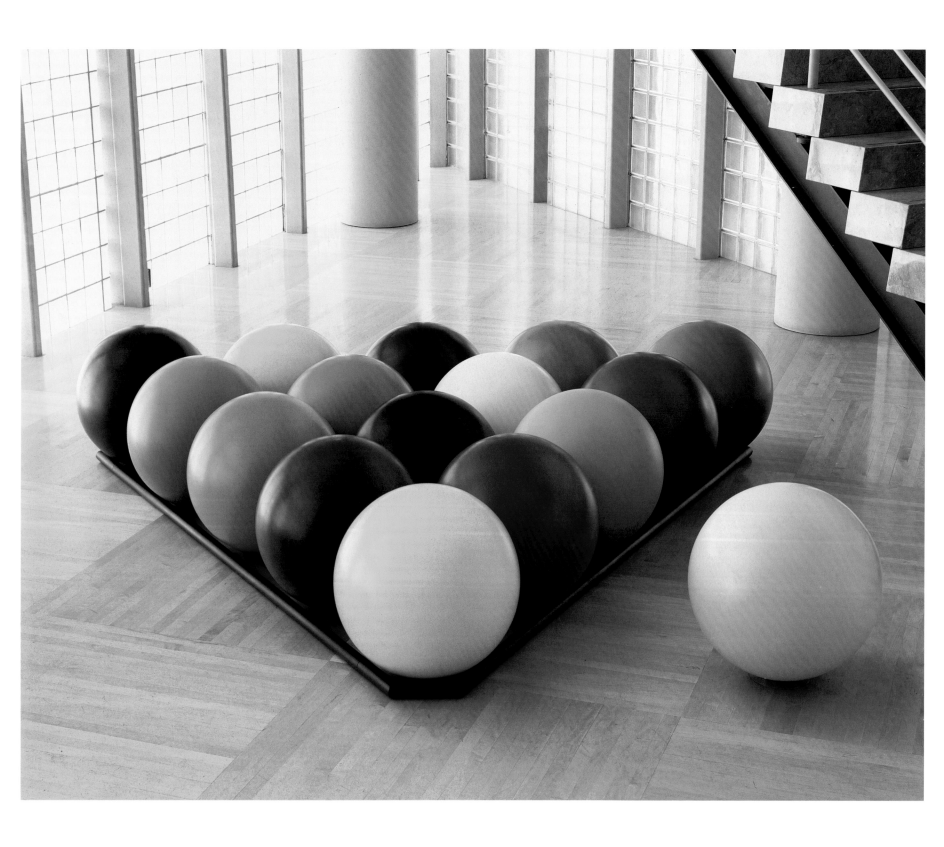

CLAES OLDENBURG *Giant Pool Balls,* 1967

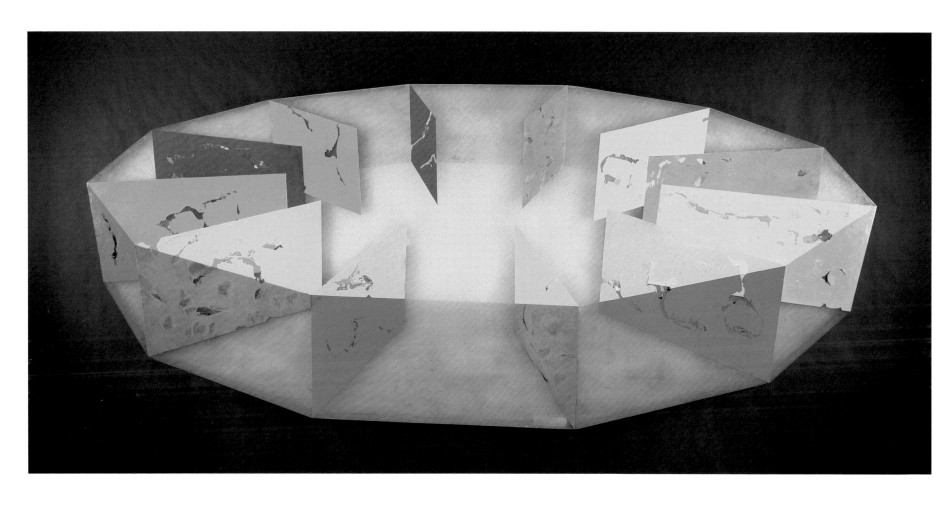

RON DAVIS *Roto*, 1968

Bea Cooper, Judd Marmor, John Baldessari, and Katherine Marmor
at *Ten Years of Contemporary Art Council Acquisitions*, 1972

Betty Asher, Maurice Tuchman, Stephanie Barron, and Cecil Fergerson
in Tuchman's Mercedes, 1977

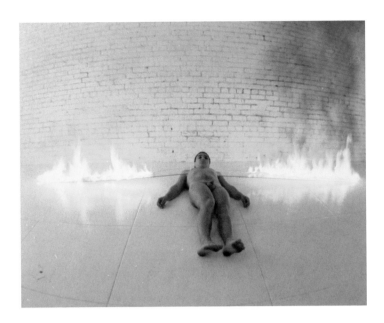

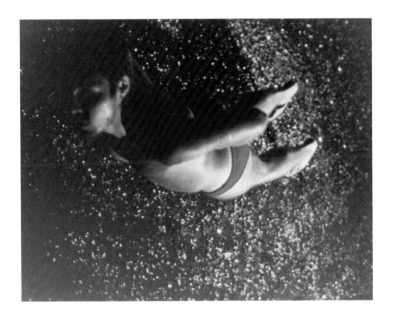

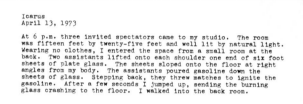

```
Icarus
April 13, 1973

At 6 p.m. three invited spectators came to my studio.  The room
was fifteen feet by twenty-five feet and well lit by natural light.
Wearing no clothes, I entered the space from a small room at the
back.  Two assistants lifted onto each shoulder one end of six foot
sheets of plate glass.  The sheets sloped onto the floor at right
angles from my body.  The assistants poured gasoline down the
sheets of glass.  Stepping back, they threw matches to ignite the
gasoline.  After a few seconds I jumped up, sending the burning
glass crashing to the floor.  I walked into the back room.
```

```
Through the Night Softly
Main Street, Los Angeles: September 12, 1973

Holding my hands behind my back, I crawled through fifty feet of
broken glass.  There were very few spectators, most of them passersby.
This piece was documented with a 16mm film.
```

The process was changed, and after trying out several different methods, a lasting formula emerged: Once a month, a staff member would take the YTA committee, a carefully chosen group of about eight council members, to several studios. At the end of the year, the committee and the contemporary curators would select five or six artists to be revisited by the professional staff, which then would choose the winner. The Young Talent Award initially was $1,200. A LACMA press release states that the award "was established to provide a year's basic subsistence funds to artists of outstanding promise who are unaffiliated with educational institutions, and who are as yet not generally eligible for national grants because of a lack of wide exhibition, awards, or similar recognition."[52] Museum lore has it that the grant amount was based on the cost of a year's studio rental in Venice, California. Artists such as Barry Le Va, Chris Burden, and Alexis Smith were early recipients of the Young Talent Award. Smith says that the award was very important for her, as much for the exposure and public support it provided as for the honorarium.[53]

At a time in L.A. when anti-Semitism was common and the old families of Hancock Park and Pasadena rarely associated with the wealthy individuals of the Westside, who were more likely to be Jewish or from the entertainment industry, Gifford Phillips believes that LACMA—with its old-family board and Westsider Contemporary Art Council—became a meeting ground. However, Phillips also remembers an incident at the museum in which the CAC was referred to as the "Jewish Council." In fact, Phillips (who, as chair of the CAC, was representing the group) came from a more august Protestant family than most members of LACMA's board of trustees, but he was never asked to join it (which some council members bitterly resented), perhaps because of his leftist politics.

In many respects, the Contemporary Art Council's members saw themselves in opposition to the museum's board, which they believed didn't take the CAC seriously. By donating contemporary works and financially supporting exhibitions that focused on living artists, the CAC insulated the Modern Art Department from a board that was at best indifferent to contemporary art and at worst hostile to it. This relationship would continue well into the future.

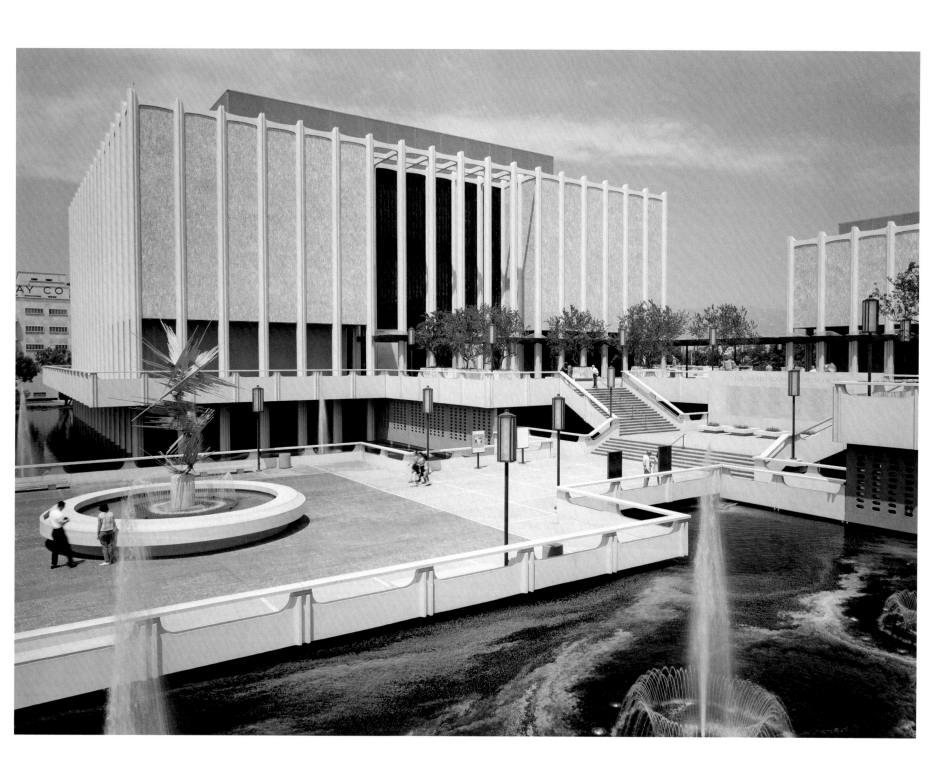

LACMA plaza, 1965

Many partisans of contemporary art had hoped that an eminent architect would design the new art museum. Philip Johnson, Eero Saarinen, Edward Durell Stone, I. M. Pei, Richard Neutra, and Gordon Bunshaft each met with board members; Mies van der Rohe even visited the museum twice.[54] Yet conservative members of the board had envisioned very traditional architecture for the institution. The local but nationally recognized firm of William L. Pereira and Associates offered a compromise.[55] They created a suite of three buildings with a modernist look and classical references. The buildings were surrounded by pools and seemed to float magically on the water. Within ten years of the facility's opening, however, tar began to seep into the fountains, and the water had to be drained and replaced with greenery.[56] Like L.A.'s Music Center (designed by Welton Becket), which opened a month after LACMA, the museum resembled the complex of buildings that makes up Lincoln Center in New York. This may have provided the imprimatur of culture and glamour for some board members. The East Coast performing arts complex had opened over a period of two years, culminating in Saarinen's Vivian Beaumont Theater, which premiered some months after the Hancock Park buildings.

Disagreements over the institution's architecture were put aside, however, and the opening gala for the new Los Angeles County Museum of Art in Hancock Park on March 31, 1965, was by all accounts lavish, thrilling, and star studded. The fund-raising committees that helped realize the museum's completion included a "motion picture and television committee" headed by actor Tony

Curtis and director Billy Wilder. Vincent Price was cochairman of the "general community committee," Bob Hope was a donor to the museum, and Edward G. Robinson and Gene Kelly were among those who attended the festivities.[57]

Clearly, the prestige of the entertainment industry was on the rise. Famous actors, directors, and producers now were acceptable patrons to the power brokers who ran the museum. Connections between Hollywood and the museum remained sporadic, however, involving only those few entertainment figures who, like Robinson, had a pressing interest in art. Over the years, the exponential escalation of celebrity status, with its accompanying wealth and security issues, has created an increasingly hermetic entertainment industry that does not require external validation from its immediate community. This chasm between Hollywood and the rest of the city has only widened as the media has grown more transnational in nature. Today American music, film, and television are produced and distributed all over the globe,

Howard Ahmanson, Edward Carter, and William L. Pereira, LACMA, 1965

Henry T. Hopkins, Maurice Tuchman, and Ken Donahue on the LACMA
plaza during construction, c. 1964–65. Photograph by Dennis Hopper

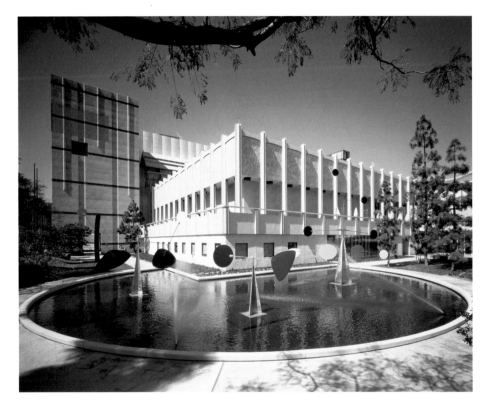

and stars often have residences in different cities and countries, further undermining the industry's emotional connection to Los Angeles and its institutions.

Fortunately, the new museum did not draw Hollywood celebrities alone. It was also extremely popular with the general public. According to Hopkins, the museum rolls grew from 3,000 to more than 20,000 members "practically overnight." In the first seven months of its existence, LACMA hosted more than 1.5 million visitors.[58] The museum also had an army of volunteers that greatly outnumbered the professional staff. (One longtime volunteer estimates that "there were about 64 employees [when the museum opened in Hancock Park] and at least 300 volunteers, including the docents.")[59] These loyal supporters did everything from sorting the mail and manning the information desk to translating texts for the curatorial departments.[60]

Contemporary art was well represented at the museum's opening. An exhibition of works by Los Angeles sculptor Peter

Voulkos was outdoors, and dominating the "causeway" entry was a large sculpture by Norbert Kricke in one of the pools that surrounded the buildings. Alexander Calder's special commission *Hello Girls* (1964), which includes a pool of its own, was also installed outside, as was a sculpture by British modernist stalwart Henry Moore. Within the museum, John Chamberlain's sculpture *Sweet William* (1962) and Ruscha's painting *Actual Size* (1962) were among the contemporary works on view in the new galleries. For the occasion, artist Sam Francis lent the museum his painting *Mexico* (1957), which measured almost eight feet tall and fourteen feet wide.

Museum trustee David E. Bright died suddenly of a cerebral hemorrhage at the age of fifty-seven, just eleven days after the museum opened. As treasurer of LACMA and chairman of the board's building committee, he had been responsible for ensuring that the facility opened on time.[61] According to Tuchman, his death was an enormous blow to the cause of contemporary art at LACMA,

ALEXANDER CALDER *Hello Girls*, 1964 (in its current location)

Alexander Calder installing *Hello Girls* at LACMA, 1965

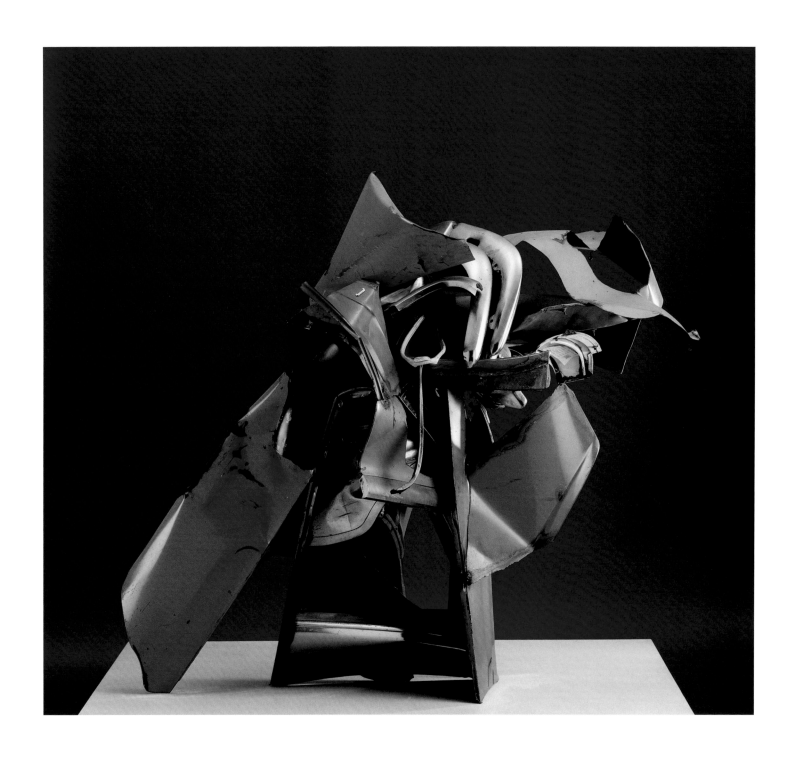

JOHN CHAMBERLAIN *Sweet William,* 1962

Curator Maurice Tuchman arrived at LACMA from New York in August 1964, about six months before the new facility opened in Hancock Park. From the moment of his appointment (which caused Fred Weisman to resign as head of the CAC), Tuchman was a polarizing figure. Extremely social, he knew everyone in town, had connections to the entertainment industry, and always had an "in" at the trendiest restaurants.[72] Joann Phillips recalls that some council members were very supportive of him, while others felt he was using the organization for self-aggrandizement.

To say that Tuchman had an immediate impact, however, is to radically understate the staggering level of his activity in the first few years of his tenure at LACMA. Even his critics had to admit that he raised the profile of the institution with his exhibition program. With strong ties to both New York and Europe, he was intimately connected to the latest trends in contemporary art. Jane Livingston, who came to LACMA after graduate school at Harvard, had trained as a medievalist but found herself drawn to Tuchman and his program. She says that he was "a remarkable force" in those days. She worked with him on the important exhibitions *American Sculpture of the Sixties* (1967) and *Art and Technology* (1971). (She also cocurated *Bruce Nauman: Work from 1965 to 1972*.)[73] Livingston describes a "marvelous working relationship" with Tuchman, in which she learned to stand up for what she believed in and never give up. For Livingston, opposition from the board and county supervisors—which gave her the feeling that she was always on the brink of being fired—

made the job exciting, and she says she only stayed at the museum as long as she did (almost ten years) because of Tuchman.

Tuchman's program carefully balanced exhibitions of work by established and prestigious figures from New York with those of a group of young Los Angeles artists. A few months after his first exhibition, which focused on the work of ceramicist Peter Voulkos and opened with the museum on April 1, 1965, Tuchman organized *The New York School: The First Generation* to critical acclaim. In August 1965, he mounted the first museum exhibition of the Ohio-born, London-based artist R. B. Kitaj, and in November he opened a show of the work of New York sculptor David Smith. The most controversial of all his early exhibitions, however, premiered in March 1966: *Edward Kienholz*.

Kienholz's work was unlikely to garner trustee support. The L.A.-based assemblage artist used found objects and other refuse to create theatrical tableaux that were explicitly sexual or highly aggressive in their social critique. Many of the trustees truly hated contemporary art even when its subject matter was relatively tame, and some did not recognize or respect the expertise of the curatorial staff. Hopkins remembers a board member walking through an exhibition (probably *American Sculpture of the Sixties*, which debuted a year after *Edward Kienholz*) as it was about to open. He saw a sculpture by Stephan Von Huene (*Hermaphroditic Horseback Rider*) that had a phallic element to it and insisted that the work be removed from the show. (The same trustee had objected to Francis's large painting *Mexico* when it was displayed in the museum's opening installation because the large abstrac-

tion was not his idea of art.) Artist Joe Goode withdrew from the exhibition in support of Von Huene. The curators challenged the board member and eventually prevailed; they exhibited the works of Von Huene and Goode, but not without a fight.[74]

Tuchman had wanted to give Kienholz the very first show at the new museum but realized that the work was too controversial. He waited a year, hoping to ease the authorities at LACMA into the contemporary exhibition program and give himself time to warn them of the trouble that might ensue. It was a smart move. Even before the show opened, a dispute erupted over Kienholz's 1964 tableau *Back Seat Dodge '38*. The work consists of the truncated cab of a real car, the door of which is thrown open to expose a couple engaged in sexual play in the backseat. The male figure, which lies on top of the female, is made entirely of chicken wire, making it possible to see the female beneath him. Forced into the position of voyeur, the viewer looks directly up her skirt. She holds a beer bottle in her right hand, while her left rests on her partner's back. Empty bottles litter the cab and the artificial turf that surrounds the car, and the radio plays mood music. Ideally, the work should be seen in a darkened room illuminated only by the automobile's headlights and internal light, as if the viewer has come across it parked along a lovers' lane.[75]

Three days before the exhibition's public opening, the county supervisors, led by Warren M. Dorn, declared *Back Seat Dodge '38* "pornographic" and demanded that LACMA remove it from the exhibition. The trustees had been primed for such a fight and, amazingly, they unified behind Tuchman and refused to comply

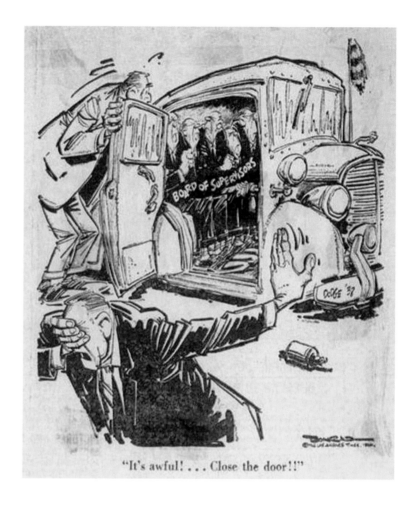

"It's awful! . . . Close the door!!"

with the order. Although it is tempting to view them as chastened by the plethora of bad press generated by Ric Brown's departure only a few months earlier, it is far more likely that they simply objected to governmental interference in the museum's programming. They had an agreement with the county that ensured the museum's autonomy over what was shown in its galleries, they were powerful people in the city, and they weren't going to let the supervisors bully them. Whatever their motivation, though, the trustees championed freedom of expression, a cause that rallied the institution and the community.

When the staff and trustees refused to remove *Back Seat Dodge* from the exhibition, Dorn threatened to shut down the museum and cancel its funding. The supervisors backed Dorn, although most of them hadn't even seen the work. Again, the conflict played out publicly in the local and national press, which was generally unsympathetic to the supervisors and supportive

Paul Conrad's cartoon, *Los Angeles Times*, March 30, 1966

of the museum. Although Dorn represented certain conservative strains in Los Angeles, the political environment in the U.S. had changed radically since the McCarthy era. In the 1960s, avant-garde art was no longer associated with communism. Instead, the public was more concerned with freedom of speech. It was also an election year, and Dorn was running for governor with the slogan "Clean the Slate." He appeared to be using the controversy for political gain.

In the end, the board of supervisors agreed to a compromise: The door on the Dodge would remain closed. If a visitor over the age of eighteen asked to look inside the car, a museum guard would open the door. A *Los Angeles Times* editorial cartoon from March 30, 1966, showed the door of the Dodge opened by a guard to reveal the board of supervisors sitting inside in place of the sexually engaged couple. A museum visitor flees, his hand covering his eyes. The caption reads, "It's awful! . . . Close the door!!" An article published some months later in *Los Angeles* magazine states: "The Kienholz exhibition, which many on the board privately deplored, pulled the whole museum—trustees, staff, and membership—together. And the man who clinched this miracle was Supervisor Warren Dorn."[76] Dorn would never be California's governor.

ARS LONGA, VITA BREVIS

Edward Kienholz at LACMA press conference, March 1966

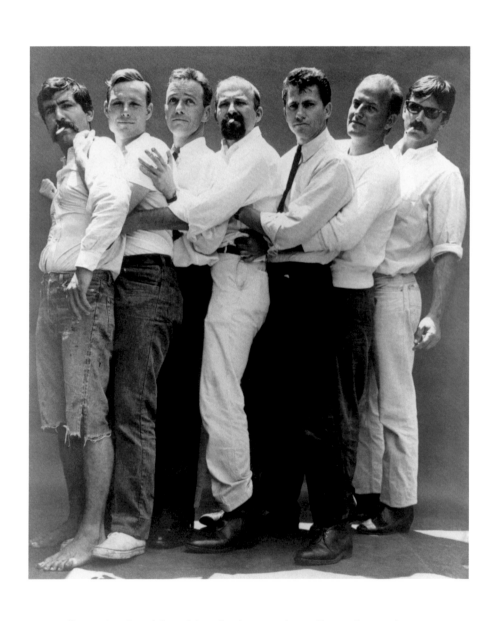

LARRY BELL *Cube,* 1966

Ferus Gallery artists, from left to right: John Altoon, Craig Kauffman, Allen Lynch, Edward Kienholz, Ed Moses, Robert Irwin, and Billy Al Bengston, 1959

ROBERT IRWIN *Untitled,* 1966–67

Ed Ruscha with *Los Angeles County Museum on Fire* (1968) at Irving Blum Gallery (formerly Ferus Gallery), 1968

Kienholz was important not only as an artist but also as a galvaniz-
ing force in the artistic community. He supported the blossoming
art scene in Los Angeles when he joined forces in 1957 with future
curator and museum director Walter Hopps to create the Ferus
Gallery on La Cienega Boulevard. They and their artists were an
incongruous band of beatniks in the midst of what was then called
Gallery Row. From the beginning, Ferus attracted attention, not
all of it welcome. Several months after it opened, the Los Angeles
Police Department raided the gallery and arrested artist Wallace
Berman, claiming that his exhibition of mystical collages was
pornographic. They also levied a fine of $150 on the financially
strapped gallery, which a Ferus friend and supporter, actor Dean
Stockwell, paid. Ferus struggled for funding until 1958, when
Kienholz became bored with the gallery, and art dealer Irving Blum
bought out his interest in the venture for a nominal fee. Sadye
Moss, a silent partner and wealthy widow, backed Ferus, allowing
Hopps and Blum to move to a cleaner, more professional space
across the street.[77]

Between its emergence in 1957 and its closing in 1966, the
gallery made a deep and consistent commitment to a group of
young Southern California artists, including Kienholz, Billy Al
Bengston, John Altoon, and Craig Kauffman, elevating their work by
exhibiting it in the same context as that of New York luminaries
like De Kooning, Rothko, and Pollock. Hopps and Blum showed the
young Jasper Johns with the German master Kurt Schwitters. They
presented Joseph Cornell from New York and Bruce Conner of San
Francisco, as well as local heroes Ruscha and Ken Price. In 1962

the gallery mounted a historic exhibition of Warhol's paintings of
Campbell's soup cans, his very first solo show. In short, Ferus
provided a crash course in contemporary art. Irwin says that, for
him, the gallery functioned as the only art school that ever taught
him anything.[78] He began to show there himself in 1959, at first
with figurative paintings and eventually with abstract expression-
ist works.[79]

The establishment of Ferus marked the start of an extremely
fecund period for contemporary art in L.A., which included the
remarkable years of contemporary programming at the Pasadena
Art Museum that began when Hopps moved there in 1962, as well

Edward Kienholz's *Walter Hopps Hopps Hopps* (1959)
in the window of the Ferus Gallery, 1960

as Tuchman's first seven years at LACMA. *Artforum* was founded in San Francisco during this time with a mandate to spread the word about California art, and in 1965 the journal moved to L.A. because that was where the action was on the West Coast.[80]

The result of all this activity was a stimulating environment that nurtured the first generation of Los Angeles artists who, as a group, gained broad recognition. Not all of the L.A. artists of the 1960s who garnered significant attention showed at Ferus, but most of them saw the exhibitions there. The work of many of these artists would be subsumed under the rubrics of "light and space" or "finish fetish," Southern California's first nationally influential homegrown art trends.

Ferus was the first vanguard gallery of its generation in Los Angeles, but it wasn't the only one. In 1959 Virginia Dwan opened her L.A. space, focusing primarily on art from Paris and New York and presenting artists such as Rauschenberg for the first time on the West Coast. In the early 1960s, Dwan began to represent Kienholz as well.[81] Nicholas Wilder opened his gallery, which featured both L.A. and New York art, in 1965.[82] Like the founders of Ferus, Dwan and Wilder played important roles in the development of the art scene in Los Angeles.

In 1968, two years after Ferus closed, LACMA mounted the commemorative show *Late Fifties at the Ferus*, a first step in building what would become the Ferus legend. Hopps and Blum added to the mystique. They were powerful personalities who went on to have long and illustrious careers in the art world. Each had a hand in shaping the history of 1960s art in Los Angeles, Blum as a prominent dealer in L.A. and New York and Hopps as one of the preeminent curators of the postwar period. After he left Pasadena in 1967, Hopps went on to become director of the Corcoran Gallery of Art in Washington, D.C.; curator of twentieth-century American art at the Smithsonian's National Museum of American Art; and founding director of the Menil Collection in Houston, Texas. Throughout his career, he was known for a chaotic managerial style and innovative, beautifully realized exhibitions.

ZELEVANSKY

134

CRAIG KAUFFMAN *Untitled Wall Relief*, 1967 (no longer extant)

ment money, but industry also footed a good deal of the bill. Corporations could choose from a menu of possible ways to support the project. In the end, twenty corporations donated funds for a total of $95,000, plus in-kind donations. Tuchman also secured more than $40,000 to cover additional costs. This was an expensive exhibition for the 1970s, but Tuchman insists that he raised all the money needed for it. He believes that comments in the press about the cost of the show were deliberately leaked by board members hostile to the project.[91] Certainly *Artforum*'s headline calling the show "a multimillion-dollar art boondoggle" was overblown.[92]

Tuchman was not the first to explore the intersection of art and new technologies in the 1960s. At the Sixty-ninth Regiment Armory in New York in October 1966, engineers Billy Klüver and Fred Waldhauer collaborated with artists Robert Rauschenberg and Robert Whitman to produce *9 Evenings: Theater and Engineering*, which featured forty engineers and ten artists working together to create performances that incorporated new technology. Experiments in Art and Technology (E.A.T.) grew out of that evening. The organization forged collaborations between artists and engineers, sponsoring performances and exhibitions. By 1969 it had two thousand members. Like Tuchman's artists and his museum, E.A.T. participated in Expo '70, initiating artist-engineer collaborations for the Pepsi Pavilion in Osaka. Rauschenberg and Whitman also took part in LACMA's *Art and Technology* exhibition.[93]

The aesthetic that dominated Tuchman's exhibition, however, was different from the one in evidence at *9 Evenings*. The New York group was working from a performance-based, neodada sensibility embodied in the disjunctive, incipient postmodernism of the Judson Dance Theater. Tuchman's artists, in contrast, generally were more inclined to produce objects in the traditional sense or engage in perceptual experimentation. (He noted in the installation at Expo '70 an emphasis on "transient images and evanescent phenomena.")[94] It is true that artists such as Byars presented conceptual art, but Oldenburg's giant ice bag that performed a kind of dance as it executed a series of complex movements over a period of twenty minutes garnered the most attention from the press and general public. It stood just outside the exhibition, on LACMA's plaza. Inside the museum, Boyd Mefferd's throbbing *Strobe Lighted Floor* elicited "head-splitting afterimages" and sent many observers running for cover, while within Newton Harrison's darkened room, five 13-foot-tall Plexiglas columns—each filled with computer-programmed, glowing gas plasmas—created mysterious shapes that seemed to be formed by the light.[95] Rockne Krebs propelled brilliant rays of blue and green light into the night sky above Wilshire Boulevard's Miracle Mile via three argon lasers; two were mounted atop one of LACMA's buildings, while another sat on the roof of a building across the street from the museum.

The catalogue is remarkable. Almost four hundred pages, it is an artwork unto itself. Tuchman says that he based its design and candor on a government-published report on sexual practices in the United States, believing that "if the U.S. government can be this frank, so can we." (Lou Danziger, who designed the catalogue, has no recollection of the report and it has not been identified.)[96] Along with their essays, the curators published the contracts delineating

Gail Scott, Maurice Tuchman, Robert Irwin, and James Turrell at the Garrett Corporation, 1969

the rights and responsibilities of the sponsors and the museum, and of the museum and the artists. Without comment, they reproduced correspondence exposing conflicts that usually remain private. Oldenburg initially was unhappy with the financial and travel arrangements offered him, for example. The catalogue also records in painstaking detail the projects of all the artists who participated in *A&T*—realized or not—and how they developed, often including the evaluation of the corporate representative to the project. As with Byars and Chamberlain, artists frequently were negative about corporations and vice versa.

The *Art and Technology* publication owes something to the catalogue for the *Information* show at MoMA, the first major museum exhibition of conceptual art, which opened in summer 1970, a year before *A&T*. Tuchman's book shares with MoMA's an informal look underscored by the use of newsprintlike paper and occasional reproductions of typewritten contracts, letters, and such. In the preface to *Information*, curator Kynaston McShine notes that MoMA wanted his exhibition to be "an international report" on the state of art at that time. Tuchman calls his book *A Report on the Art and Technology Program of the Los Angeles County Museum of Art, 1967–1971*. Both publications are replete with such language, meant to signify objectivity, a quasi-scientific argot common to conceptualism. In *Information* this linguistic style is found in the individual works of the artists, while in *A Report* Tuchman and his collaborators echo this language in their carefully detailed descriptions of the processes involved in organizing the exhibition.

A&T was organized prior to the women's movement and came to fruition just as that political force began to instigate great changes in the social landscape. There are no women among the sixty-four artists and corporate officers whose photographic portraits appear in a grid on the front cover of the paperback edition of the exhibition catalogue and on the back of the hardcover's book jacket. Two women, however, did have their proposals reproduced within the book itself.

Aleksandra Kasuba's *Spectrum Environment* would have created a series of spaces suffused with green, yellow, orange, red, purple, blue, or white light. Each color would have had its own sound, along with an associated smell and air temperature (piped in through a hole in the ceiling). Kasuba also offered another plan. *The Four Elements* would have evoked earth, fire, water, and air in four circular rooms with sunken lights moving along their perimeters. Channa Davis (now Channa Horwitz) meanwhile proposed *Suspension of Vertical Beams Moving in Space*, in which eight lightweight beams, suspended by magnetism between a base and a floating roof, would have been programmed by a computer to execute choreographed movements.

Although Tuchman claims in the introduction to *Art and Technology*'s catalogue that none of the seventy-eight unsolicited artists' proposals received by the museum was accepted for the project, Horwitz did respond to a notice in the newspaper. She called the museum and spoke to a woman who encouraged her to send in her materials. Her work was reproduced in the catalogue— she believes this is because it was "a pretty presentation"—and

The exhibition *Los Four: Almaraz, de la Rocha, Luján, Romero*, 1974

In the 1960s, with the advent of minimal and conceptual art, as well as earth art, performance, and other vanguard forms that challenged the limitations of the art institution, there was an imperative—almost an ethical policy in the field of contemporary art—not to impose curatorial authority of any kind on the artist. By 1974 non-Latino staff working with Latino artists would have been particularly sensitive to this. LACMA's curators thus refused to restrict Los Four in any way. The exhibition catalogue had no text, presumably an effort not to impinge on the artists' vision. During the installation, a degree of institutional chaos reigned, which was embraced by the curators as part of the ethic of the endeavor but resented by some other staff members.

Registrar Patricia Nauert, for example, sent a memo to the Modern Art Department after the exhibition complaining that "there was no control by anyone in the museum over what objects were coming in to be included in the show." During the installation the artists still were bringing in works, the ownership of which was unclear, and for which the registrars often were unable to obtain loan agreements. As a result, some pieces went uninsured. The return process did not go any more smoothly. In a manner that may have seemed condescending, Nauert proposed ways of controlling the process when dealing with living artists.[107]

From the tone of the memo she wrote in response, curator Jane Livingston seems to have relished taking a stand on this issue. She replied that the exhibition was undertaken in large part as "a service to the community" and had to be treated somewhat specially. While this may sound patronizing today, Livingston

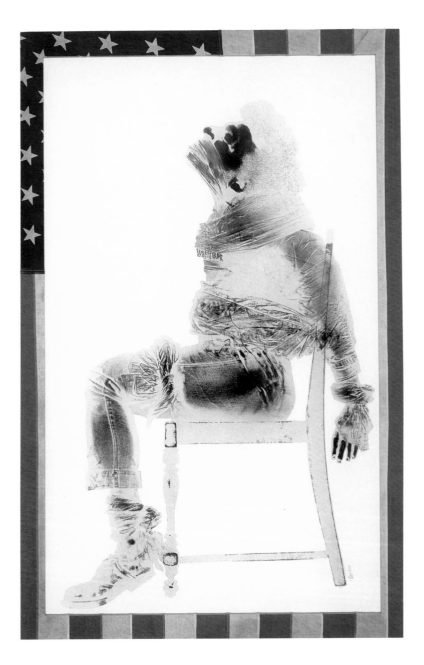

stands by her comment. She remains proud that the museum mounted the show. In her response to Nauert, she noted that the artists were extremely sensitive about any restrictions imposed by the institution, even if they involved what the staff considered reasonable precautions. In addition, Livingston refused to guarantee that *Chicanismo en el Arte*, a juried exhibition of Chicano student work scheduled for the art rental and sales gallery that fall, could be handled any differently.[108]

DAVID HAMMONS *Injustice Case,* 1970

ZELEVANSKY

Los Four was among the most significant exhibitions organized within a roughly five-year period, heralded by Asco and shaped by the black power and Chicano movements of the 1960s as well as the early years of contemporary feminism, when LACMA presented a number of shows focusing on art by minorities and women. In 1971 LACMA's Prints and Drawings Department exhibited the work of three black Los Angeles artists—Charles White, David Hammons, and Timothy Washington—under the title *Three Graphic Artists*. The museum purchased three works from the show, including Hammons's important *Injustice Case* (1970). The following year, the museum presented *Los Angeles 1972: A Panorama of Black Artists*, co-organized with the nonprofit Black Arts Council and curated by Carroll Greene Jr., a specialist in African American art. The show was in the art rental and sales gallery and works were available for purchase. Jane Livingston's *Four Women Artists of Los Angeles: Margaret Lowe, Barbara Munger, Alexis Smith, and Margaret Wilson* also opened that year.

Los Four and *Chicanismo* were mounted in 1974; in 1976 LACMA hosted *Two Centuries of Black American Art: 1750–1950*, a traveling show independently curated by David C. Driskell. *Women Artists, 1550–1950*, the concession to women artists who protested their lack of representation in *Art and Technology*, was a historically important survey organized by LACMA with guest curators Ann Sutherland Harris and Linda Nochlin. It opened in Los Angeles in December 1976 and traveled to Austin, Pittsburgh, and Brooklyn.

After 1976, exhibitions centered on gender or ethnicity fell off at LACMA until 1989, when the museum hosted the large-scale exhibition *Hispanic Art in the United States: Thirty Contemporary Painters and Sculptors*, organized by the Museum of Fine Arts, Houston. In the 1990s and early 2000s, increasing numbers of women and minorities were included in group shows or were the subjects of their own solo exhibitions. Of the ten exhibitions in the museum's Contemporary Projects series between 1997 and 2006, eight included artists of color and six included women. There were also larger monographic exhibitions devoted to the work of artists such as Carlos Almaraz, Yayoi Kusama, Annette Messager, and Lorna Simpson. Works by minority artists and women—Kara Walker, Dario Robleto, and Kerry James Marshall among them— also began to enter the collection with some regularity.

David Hammons at *Three Graphic Artists: Charles White, David Hammons, Timothy Washington*, 1971

Jane Livingston, 1974

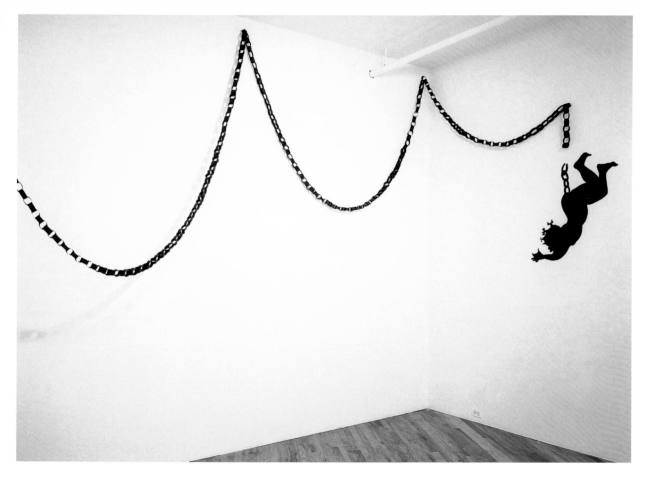

KARA WALKER *And Thus . . . (present tense),* 1996

KERRY JAMES MARSHALL *De Style,* 1993

THE PASADENA ART MUSEUM

In 1974 the Pasadena Art Museum (PAM), the only institution in the Los Angeles area other than LACMA that collected and displayed vanguard contemporary art, collapsed after a prolonged and valiant struggle waged by its supporters.[109] By 1960 PAM was an exciting place for contemporary art. After his stint at Ferus Gallery, Walter Hopps went to Pasadena in 1962, where he was first curator and then director. He presented several highly influential exhibitions there. Ruscha, among L.A.'s best-known artists, remembers the Marcel Duchamp retrospective that Hopps mounted in 1963, which had an enormous impact on him and his peers.[110] Amazingly, this was the first-ever comprehensive look at Duchamp's career, and it happened in a small museum in Pasadena.

It is not surprising that certain LACMA supporters—especially early Contemporary Art Council members such as Marcia and Fred Weisman, Stanley and Elyse Grinstein, and Gifford and Joann Phillips—would become personally invested in the Pasadena museum. Here was an institution exclusively dedicated to their greatest passion, something LACMA could never be.[111]

Despite the opposition of Hopps, the Weismans, and others, powerful members of the Pasadena Art Museum's board of trustees were determined to build a new, more suitable home for the fledgling institution, then housed in a Chinese-style edifice (now occupied by the Pacific Asia Museum) that was built in the 1920s as a private residence and gallery.[112] The new building, modernist in style and designed by local architects Thornton Ladd and John Kelsey, opened in 1969. Originally budgeted at $3 million, it actually cost $5 million. The board was unable to maintain and program the museum while servicing the additional $2 million in debt (a considerable sum for a small institution), and within two years the building project had officially bankrupted PAM.

There was an attempt to merge the Pasadena Art Museum with LACMA. Franklin Murphy, former chancellor of UCLA and chairman of LACMA's board of trustees, proposed that the Pasadena Art Museum become LACMA's modern wing, with Tuchman as its director.[113] On March 12, 1971, Tuchman drew up a nine-point plan titled "Conditions for Annex of Pasadena Art Museum by County." It involved renaming the institution the "Los Angeles County Museum of Modern Art at Pasadena." (The term *modern* still appears to have carried more respectability than *contemporary*.) The space would be devoted exclusively to temporary exhibitions. LACMA's twentieth-century art collection—greatly enhanced by the holdings that renowned art dealer Galka Scheyer had left to Pasadena and the contemporary works PAM had acquired—would be housed on Wilshire Boulevard.[114] Unfortunately, the idea met with powerful resistance. LACMA's dependence on public funds made it politically untenable for the museum to take on PAM's debt.[115]

In 1974 Norton Simon (the brother of PAM supporter and CAC member Marcia Weisman) acquired the Pasadena Art Museum as a home for his own collection, which consisted largely of old masters and nineteenth-century and early modern art, as well as traditional works from Asia. The Norton Simon Museum of Art's mission was far removed from the concerns of the Pasadena Art Museum. PAM's former supporters were bitterly disappointed, but

the desire of L.A.'s contemporary art community for an institution that focused exclusively on its area of interest was far from dead.

However, there was no way that LACMA could satisfy such needs. Its Modern Art Department (soon to be called the Twentieth-Century Art Department) was small; until 1984 it had only two permanent curators and one curatorial assistant who handled all the museum's modern and contemporary programming, with the occasional help of temporary, project-specific staff. Curator Stephanie Barron joined the department in 1976; she replaced Jane Livingston, who had left for a position at the Corcoran Gallery of Art in Washington, D.C. (where she eventually would become chief curator and associate director). While working on the research-heavy exhibition *The Avant-Garde in Russia, 1910–1930: New Perspectives* (1980), Barron and Tuchman produced a series of smaller contemporary shows, most of them monographic and

many of them focusing on L.A. art. In 1977, when the College Art Association held its annual meeting in Los Angeles, Tuchman and Barron organized *California: 5 Footnotes to Modern Art History*, which included five individual exhibitions: *Morgan Russell: Unknown Paintings; Dynaton Revisited; Los Angeles Hard-Edge: The Fifties and the Seventies; John McLaughlin Letters and Documents; and Environmental Communications Looks at Los Angeles.*[116] They did this in eleven months on a budget of $17,500—a heroic achievement. Their choice of programming, however, seemed to reinforce a common perception that LACMA's Twentieth-Century Art Department favored historical modernism and established figures over cutting-edge contemporary art.

In the 1970s, Tuchman himself became a lightning rod for the art community's dissatisfaction with the museum's contemporary program. Some of this was due to the community's unrealistic

Marcel Duchamp and Eve Babitz playing chess at *A Retrospective Exhibition By or of Marcel Duchamp or Rrose Sélavy*, Pasadena Art Museum, October 1963

expectations and some to his own poor judgment, exacerbated by the museum administration's and board's equally inappropriate actions. In summer 1973, county supervisor Ernest E. Debs received an anonymous postcard complaining of Tuchman's six-month absence from the museum, which he forwarded to LACMA director Donahue. Donahue responded, explaining that Tuchman was away from the museum for only three months, a two-month working trip to Europe followed by a month of vacation, during which Tuchman was working on his PhD dissertation on the painter Chaïm Soutine.[117] Given the spotlight on Tuchman's frequent and prolonged absences from the museum, it is stupefying that Donahue shortly thereafter granted the curator an additional six-month unpaid leave to advance his research on a definitive catalogue of Soutine's paintings.[118]

More serious trouble arose in June 1974. Donahue sent Tuchman a memo in reference to persistent rumors that Tuchman had an ongoing relationship with Marlborough Galleries (then an international art world powerhouse with spaces in various cities in Europe and North America), for which he received financial remuneration, works of art, and/or funds for travel and expenses.

Donahue asked for a formal accounting of Tuchman's past and present relationship with the gallery.[119] Tuchman replied that with the exception of a Soutine exhibition he curated for Marlborough, he had never received compensation from it or any other gallery during his tenure at LACMA. He reminded Donahue that he had obtained the director's permission to organize the Soutine show. Tuchman also informed the director, apparently for the first time, that he had been given five thousand dollars plus travel funds by the gallery for this work.[120] It seems that Donahue had not asked Tuchman if he would be paid for organizing the Marlborough exhibition before approving Tuchman's participation in the project.

In January 1975, the *Los Angeles Free Press*, one of the most widely distributed underground newspapers of the period, got wind of the story and published a series of articles that appeared over the next six months. It noted that in accepting an honorarium from Marlborough, Tuchman may have violated the county's conflict-of-interest statutes. The newspaper reported that Marlborough's reputation was "unsavory," that litigation pending against the gallery accused it of "wasting the assets" of abstract expressionist Mark Rothko's estate, and that the gallery also was accused of violating a court order not to sell any more Rothko works. The *Free Press* was justly outraged that neither LACMA's director nor its board chairman had asked Tuchman for the financial details of his arrangement with Marlborough before approving it, writing that "the Tuchman incident is more than ample justification for a reexamination of the entire structure of the Los Angeles County Museum of Art."[121] The newspaper also

Maurice Tuchman, 1974

Chicago had founded the first feminist art program in the nation at what was then Fresno State College (now California State University, Fresno); the following year she moved her base of operations to the California Institute of the Arts (CalArts) in Valencia. There, with artist Miriam Schapiro, she codirected a legendary program based on performance and installation that, like feminist art in general, was significant more for its collaborative ventures (including the famous 1972 art environment *Womanhouse*) than for the art stars it launched.[129] Although the CalArts program ended in 1975, feminist artists remained active in Southern California. The Woman's Building, a nonprofit public art and educational center showcasing women's art, was founded in Los Angeles in 1973 and remained in operation until 1991. There was little chance in L.A. in 1981 that an all-male history of 1960s art wasn't going to generate a major protest.

Vija Celmins with *Untitled (Comb)*, 1970

THE MUSEUM OF CONTEMPORARY ART

By the mid-1970s, there was a growing perception that LACMA was not fully committed to developing the contemporary collection. To many, Tuchman simply didn't care enough. According to Barron:

> Maurice was a pretty dynamic presence, and he knew everybody in town. He'd seen every collection. He'd been everywhere, but it never congealed into gifts, and it was very hard to get around that. I mean, these were contacts that he enjoyed schmoozing with, he enjoyed visiting. They enjoyed having a drink with him. I'm sure he advised them but it rarely seemed to benefit the institution in terms of major [donations].

Barron recalls a meeting in 1981 in which the collector Bea Gersh quit the Modern and Contemporary Art Council. She was furious that Tuchman had spent almost $24,000 on a huge painting that New York artist Larry Poons had completed in 1972, a point when Poons generally was considered past his prime.[130] Marcia Weisman also believed that the museum's twentieth-century holdings would not improve "until Ken Donahue is gone and until Maurice [Tuchman] is gone."[131]

Weisman had myriad complaints about the museum. She considered it outrageous that certain early MCAC members who were obvious candidates for LACMA's board, Gifford Phillips and Robert Rowan among them, had never been invited to join.[132] Once the Pasadena Art Museum failed, a number of those who had been active there—including Ed Janss, the Weismans, and Rowan—joined the board of the San Francisco Museum of Modern Art, where Henry Hopkins had become director. Exploiting the rivalry between the art scenes in San Francisco and L.A., Weisman loved to tell board members at LACMA how great things were in San Francisco and how much money she and her husband were donating to the museum. Despite the many complaints she had about LACMA, however, as late as 1978 Weisman believed strongly in supporting the museum because ultimately it would outlive individuals, and it was "the only crap game in town."[133] Thanks in large part to Weisman herself, this would not be the case for long.

At the same time that the board of trustees was slighting LACMA's long-standing supporters of contemporary art, it invited Eli Broad, a rising businessman in Los Angeles who would become renowned as a philanthropist and civic leader, to join one of its committees but never asked him to join the board. Richard Koshalek, who directed L.A.'s Museum of Contemporary Art for almost twenty years, reports that when he arrived in L.A. in 1979, he often heard a litany of complaints about the LACMA board's neglect of contemporary art, the lack of a real contemporary program at the museum, and Tuchman's apparent "distraction."[134]

As early as 1976, articles in local magazines and newspapers began to report rumors about the establishment of a new museum of contemporary art. Barron recalls that in the late 1970s Ed Helfeld of the Community Redevelopment Agency (CRA), which was developing downtown Los Angeles, came to see her and Tuchman at LACMA. He showed them a map of the Bunker Hill area and made it clear that the city wanted to "do something cultural downtown."[135]

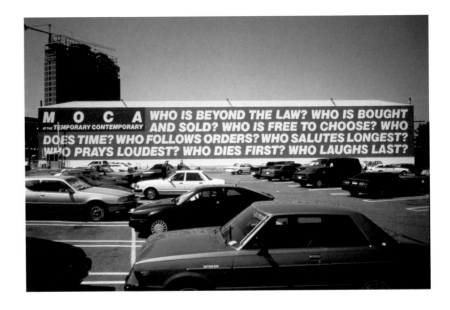

That "something" would become L.A.'s Museum of Contemporary Art (MOCA). Marcia Weisman was formidable in her energy, persistence, and passion for art, and was quite close to then-mayor Tom Bradley. She was a driving force behind the institution. Koshalek also credits William Norris, who had ties to Bradley; Don Cosgrove and Helfeld from the CRA, who worked with the mayor; and the artists' community in L.A., especially Robert Irwin and Sam Francis, who would be the first artists on MOCA's board. Broad would become MOCA's first board chairman. (Broad eventually left MOCA's board, but he did not become a LACMA board member until 1995, when director Andrea Rich asked for his help in reshaping the group to meet current financial and administrative demands.)

Founded in 1979, MOCA's beginnings were rocky. Funds for the $23 million project were raised through a CRA initiative. The agency stipulated that its Percent for Art Program, in which 1 to 1.5 percent of the total budget of any development under its jurisdiction was earmarked for public art, be channeled to the new museum.[136] Private corporations also contributed to the venture. It was slated to open on Bunker Hill in time for the 1984 Olympic Games; when construction delays made that impossible, the MOCA board commissioned architect Frank Gehry to renovate a factory building in L.A.'s Little Tokyo neighborhood. The Temporary Contemporary opened in 1983. An exciting, informal space for art, it proved so popular that it became permanent. (Today it is the Geffen Contemporary at MOCA.)

Powerful members of LACMA's board saw MOCA as a threat. Koshalek says that Ed Carter (of Carter Hawley Hale, one of the country's largest department store chains), LACMA's first president (1961–66) and a major figure in downtown Los Angeles, "went to [Mayor] Bradley and tried to convince him not to support the founding of MOCA. He made a powerful move . . . to stop it." Longtime LACMA trustee Stanley Grinstein also believes that some on the museum's board saw Los Angeles as a "small pie" and felt that any support of MOCA was detrimental to LACMA.[137] This attempt to undermine the still-nascent institution increased animosity among MOCA's donors. Ultimately, the ill will generated over the years resulted in important contemporary collections belonging to Marcia Weisman, Barry Lowen, Rita and Taft Schreiber, and others being given to the Museum of Contemporary Art. According to Koshalek, this never should have happened. MOCA was, in his words, "an upstart museum with no money."[138]

Many in Los Angeles saw MOCA's success as a sign of LACMA's failure, but that assessment is too simplistic. Whatever its failings, LACMA was not a contemporary art museum. Its mandate and responsibilities to the community were different. The city was maturing culturally and needed a serious museum devoted exclusively to the art of the day. The failure of the Pasadena Art Museum left a vacuum that had to be filled.

Barbara Kruger's *Untitled Questions* (1989–90) at the Temporary Contemporary, MOCA, 1989

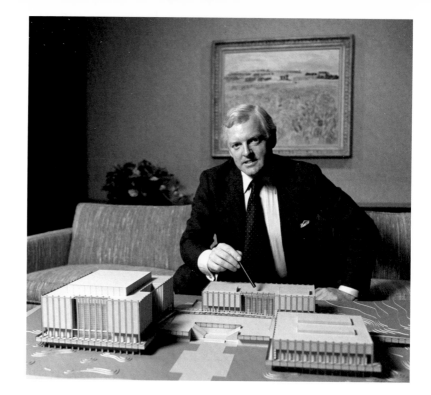

THE ANDERSON BUILDING

In August 1978, Mia Frost, who was then president of LACMA's board (the first and only woman to hold the position until Nancy Daly Riordan assumed the post in 2005), met with Ken Donahue to relieve him of some of his administrative duties. Apparently there was a growing realization that he had always been a poor leader, and it was Frost's task to tell him that his "long-standing lack of direction could not continue."[139]

Pratapaditya Pal, head of Indian and Southeast Asian art, was made acting chief curator in mid-August. When Donahue had a heart attack at the end of that month, Pal was then made acting director and Donahue became director emeritus. This was not an easy transition. Armand Hammer, a powerful member of the board, opposed the change. He was close to Donahue and disliked Pal. According to notes Frost prepared before a special board meeting, Hammer refused "to do business" with Pal. He may have tried actively to sabotage the appointment. In the end, though, Pal acted as the museum's director for more than a year.[140]

Tuchman and Barron knew this would be a difficult time for the Twentieth-Century Art Department. The Indian art specialist had an aggressively stated antipathy toward modern and contemporary art. In 1976, without warning, Pal had written a memo to Donahue and board president Richard Sherwood stating that he found the acquisition of an album of performance documentation by L.A. artist Chris Burden "disgraceful." He added, "[I] cannot believe that masochism is now regarded as artistic expression."[141] Barron and Tuchman felt fortunate that funding from the National Endowment for the Arts and the National Endowment for the Humanities was in place for the exhibition *The Avant-Garde in Russia*. Barron believes that under Pal's leadership, the groundbreaking exhibition might otherwise have been canceled.

Pal had hoped to become director permanently,[142] but in 1980 the board of trustees hired the thirty-six-year-old Earl A. "Rusty" Powell III, former senior curator at the National Gallery of Art, to fill the position. Although Powell's expertise was in American art, he had an openness to, and an interest in, contemporary art. He found the active art world of Los Angeles stimulating, and artists always were included at his parties, which were, by all accounts, welcoming and fun. Tuchman says that Powell created the most supportive environment for contemporary art that he had experienced since the days of Ric Brown and Jim Elliott. Barron describes the atmosphere at LACMA under Powell as "invigorating" and "full of promise."[143]

Powell came to Los Angeles when MOCA was still just an idea and watched it develop. He viewed the young museum positively, not as a competitor but as an institution with a very different role from that of a general museum like LACMA. He believes the contemporary art community in L.A. for years had expectations of LACMA that, due to its broad mandate, could never be fulfilled. Powell, who had a good relationship with Tuchman, felt that the curator was unjustly criticized because of these "misplaced expectations."[144]

Under Powell's leadership, the museum grew physically. When he arrived in March 1980, planning for a 20,000-square-foot expansion to the Ahmanson Building was under way, and there was talk of a separate building devoted to modern and contemporary art.

Earl A. "Rusty" Powell III, 1981

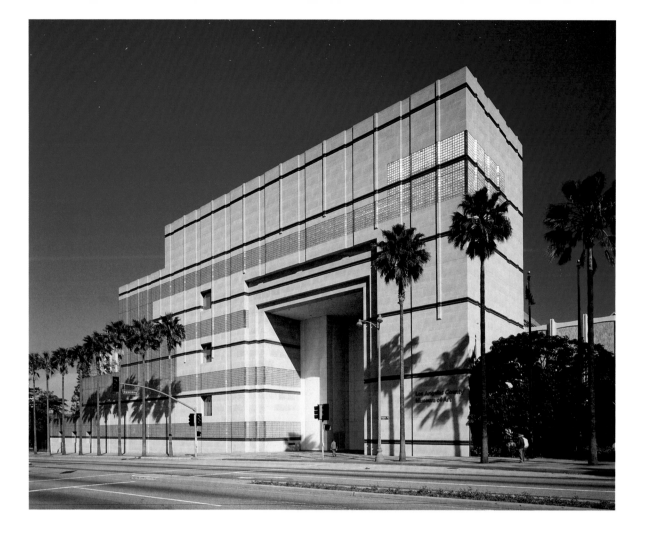

This was long overdue. When the museum's Hancock Park facilities were in the planning stages, Bart Lytton, president of the Lytton Savings and Loan Association and a civic leader, gave $500,000 to LACMA, hoping the funds would support a building for contemporary art. Lytton planned to sway the board to his way of thinking but, once constructed, the Lytton Gallery of the Los Angeles County Museum of Art was used for traveling exhibitions of all kinds. Ultimately, Lytton withdrew his financial support. (The Lytton building was later renamed for Hammer, the entrepreneur and LACMA trustee.)[145] In 1978 the museum also attempted to acquire Prudential Square, a nearby complex of office buildings that would have been used for modern and contemporary art, but funding fell through.[146]

With Powell at the helm, in 1981 the museum hired the New York architectural firm of Hardy Holzman Pfeiffer Associates (HHPA) to produce a master plan for the reorganization of the museum. The first phase of the plan included the construction of a modern and contemporary art building. It also added new administrative and curatorial offices, a central court, a conservation center, the Doris Stein Research Center for Costume and Textiles, the Robert Gore Rifkind Center for German Expressionist Studies, and an expansion of the central plant. The estimated cost was $30 million. The second

phase, estimated at only $3 million, included the construction of the Dorothy Collins Brown Auditorium and the remodeling and expansion of the museum's library.

In 1988 the museum opened its most adventurous building, the Pavilion for Japanese Art, which was designed by architect Bruce Goff. At a projected $40 million, however, the third and most expensive part of the HHPA plan would remain unrealized. It would have included the renovation and expansion of the Ahmanson Building (in part by filling in the atrium), a new 50,000-square-foot addition for decorative arts (primarily to house the Arthur A. Gilbert Collection, which ultimately did not come to LACMA), an expansion of the central court, and landscaping. Exterior renovations included refacing the Ahmanson Building and providing it with a grand new entrance off the central court. Two additional bridges also were planned.[147]

In a city that had been without a major institution focused on contemporary art, the promise of two new buildings for its display (one at LACMA and one a new contemporary art museum downtown) caused much excitement in the press. As early as September 1979, Suzanne Muchnic wrote in *Artweek*, "Now, after years of mourning and teeth-gnashing over collections lost, shows

Robert O. Anderson Building, 1986

that go elsewhere, and the drain of local artists, Los Angeles has the possibility of not one, but two, modern art museums." According to Muchnic, LACMA announced its plans first, and soon afterward the Los Angeles Community Redevelopment Agency included funds in its Bunker Hill development budget for a 100,000-square-foot "museum of modern art." Muchnic cautioned that either or both projects could fail, since they would compete for funds from the same donor pool. LACMA's plan, part of an existing institution with an established support base, seemed more likely to succeed.[148]

Although LACMA announced its project before MOCA did, LACMA's most powerful board members would have known about the plan to create a museum of contemporary art, and many believe that the Anderson Building was conceived to respond to the advent of MOCA. Barron concurs with that view. She says that at LACMA "word came down" that former president Ed Carter had decided there should be a building for modern and contemporary art at the museum, even though this wasn't Carter's usual area of interest. Tuchman, however, thinks there was no connection. In his opinion, Carter simply understood that the city needed a designated space for art of the present and wanted LACMA to provide it.

LACMA's Robert O. Anderson Building for modern and contemporary art opened to the public on November 23, 1986, a few weeks before the December 10 opening of MOCA's main facility on Grand Avenue in downtown Los Angeles. A lead gift of $3 million from the Atlantic Richfield Company (ARCO) allowed LACMA's building to expand from relatively modest beginnings to 115,000 square feet. At the last moment, the corporation named the building after Anderson, its outgoing chairman. A powerful business leader and an important force for culture in Los Angeles, he had pledged an additional $1 million of his own money to the project. (Anderson did not follow through on this pledge, so in 1999 LACMA removed his name from the building.)

Powell says that LACMA chose HHPA to design the Anderson Building because he and the board were impressed with the master plan it had created and they enjoyed working with the firm. In his introduction to the publication produced on the occasion of the building's opening, Powell wrote that he traveled throughout the United States with staff and trustees to see new architecture and interview firms that seemed appropriate to the reorganization of LACMA. Hardy Holzman Pfeiffer Associates was awarded the commission in part because of its experience reorganizing the Saint Louis Art Museum and working on projects with the Cooper-

DAVID HOCKNEY *Mulholland Drive: The Road to the Studio,* 1980

Hewitt National Design Museum in New York, the Toledo Museum of Art in Ohio, and the Virginia Museum of Fine Arts.[149]

Powell was pleased with the building but to this day regrets that the third phase of the master plan was abandoned when he left in 1992 to become director of the National Gallery. He believes it would have unified the museum's structures. In choosing HHPA, Powell and the board hoped to integrate new architecture with the existing campus (a quest that has continued to the present day). As it stands, however, the Anderson Building seems more like a reaction against Pereira's 1960s architecture. Many critics noted that the new building seemed to swallow the rest of the museum's structures, and Norman Pfeiffer was quoted in the *Los Angeles Herald Examiner* as saying that "the most difficult part of the project was dealing with an existing architectural vocabulary that we were clearly not going to repeat. The Pereira buildings were the last vestiges of a style that borrowed from the classical world to present a layer of elegance over complexes of enormous scale. The public never had a sense of where the front door was."[150] The Pereira buildings were not well received when they were built and would have been at their least fashionable twenty years later. The temptation to make them disappear must have been great.

Reviewing the Anderson Building in the *New York Times*, critic Paul Goldberger's preconceptions about Los Angeles are evident in his comment about the building's "stage-set grandiosity" that "calls to mind 1930s musicals; it looks like it might revolve on a turntable and a thousand dancing girls emerge from behind it," a remark that, in all fairness, pertains more to New York's Chrysler

Building.[151] Writing in the *Los Angeles Times*, critic William Wilson was generally exuberant about the changes at LACMA, but he did worry that "this iron-pumping hunk of building may appear a trifle too mid-80s, too *Miami Vice*, ten years down the line."[152]

The Anderson Building's interior spaces garnered more praise than its exterior. Powell worked closely with Barron on the plan, a sequence of more or less fixed galleries offering clear linear vistas. In the *Los Angeles Herald Examiner*, Christopher Knight called the building "incoherent and grandiose" but said that the interior galleries "fare much better." Knight noted that the gallery design worked especially well on the building's third floor, which housed the museum's modern collection, but he found it jarring for works made "in the 1960s and beyond."[153] It is true that the building does not seem to have been constructed with the scale and installation demands of much recent art in mind. For example, Barron remembers that it was impossible to install Burden's *Medusa's Head* (1990) in the building because the sculpture, which is fourteen feet in diameter, would not fit.[154]

Whatever its shortcomings, however, LACMA now had a designated space for art of the twentieth century. Implicit in the creation of the Anderson Building was a recognition by the administration and the board of the needs of a serious contemporary program—and an acknowledgment that L.A.'s collecting community generally was more focused on contemporary art than on any other area. In that sense, the Anderson Building represented a leap forward.

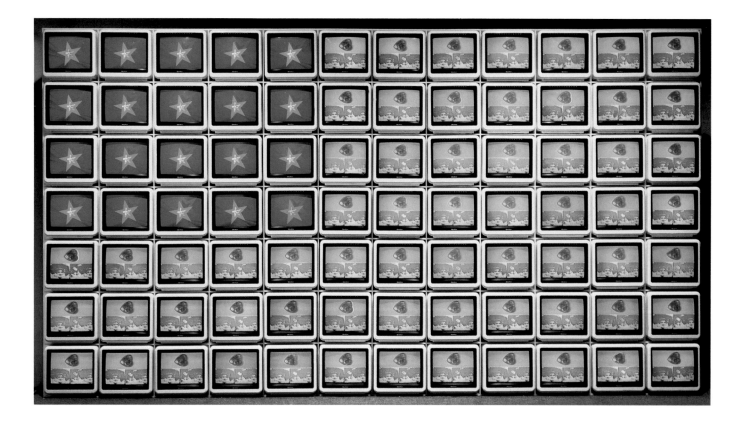

NAM JUNE PAIK *Video Flag Z,* 1986

One clear advantage of the Anderson Building was that it provided an opportunity to solicit gifts of art or money. In the three years before the building opened, a host of major postwar pieces entered the collection, greatly enriching it. Works such as David Hockney's *Mulholland Drive: The Road to the Studio* (1980) and Bruce Nauman's neon *Human Nature/Life Death/ Knows Doesn't Know* (1983) became icons of the collection. Like Nauman, Jonathan Borofsky worked in Los Angeles in the early years of his career. It was fitting that Borofsky's kinetic *Hammering Man* (1983), an image very much associated with him, would come to the museum in part through the Modern and Contemporary Art Council. During the 1980s, European art was resurgent after being eclipsed by work from the United States for three decades after World War II. No contemporary European artist was more popular in the U.S. than the German Anselm Kiefer, whose sculpture *Das Buch (The Book)* (1985) complemented the museum's strong holdings in prewar German expressionism. Nam June Paik's *Video Flag Z* (1986), LACMA's first contemporary work by a Korean artist, and Robert Gober's *Single Basin Sink* (1985) also were welcome as major pieces by a highly regarded pioneer in the field of video and a rising young New Yorker, respectively.

Throughout LACMA's history, its curators of contemporary art have struggled to build the collection. Livingston says it was a "big deal" when she finally got together enough money to buy a major painting by Diebenkorn (*Ocean Park Series No. 49*, the 1973 acquisition from Marlborough Galleries), and she recalls her excitement when she went to the studio to pick it out. Asked why the acquisitions record wasn't more impressive during her tenure at LACMA, she says simply, "We really tried."[155] Tuchman points to members of the board, who he claims did nothing to support his work with local collectors and would not often dip into their personal resources to help purchase contemporary works. Barron concurs, adding that the most depressing documents she read when she first came to LACMA were minutes from board meetings that recorded the artworks that had been rejected.

With the exception of the Photography Department, which was established with a $1 million acquisitions endowment by the Ralph M. Parsons Foundation in 1984, there has never been significant permanent funding in LACMA's budget for the purchase of contemporary art. The support councils were formed to meet that need. Still, according to Tuchman, even in its heyday in the 1960s the Contemporary Art Council provided enough money for only one major acquisition and a few smaller works each year. When Barron arrived at LACMA in 1976, the group still focused on significant acquisitions at a time when such works could be had for fifty thousand dollars. The Modern and Contemporary Art Council also brought emerging Los Angeles artists into the collection and contributed to works that were acquired in part through the National Endowment for the Arts, which in those years awarded museums matching grants for the purchase of art. One of the most important acquisitions of the 1970s was Donald Judd's *Untitled (for Leo Castelli)* (1977), the artist's first open-cube cement sculpture. Barron recalls some resistance on the council's part to paying for the work; ultimately, its members did so (with the additional help

BRUCE NAUMAN *Human Nature/Life Death/Knows Doesn't Know,* 1983

DONALD JUDD *Untitled (for Leo Castelli),* 1977

of MCAC member Robert Halff) because they realized that the board would reject the piece if it weren't already fully funded.

The council grew larger over the years but included fewer passionate collectors. Council dues remained the same for two decades and thus did not keep pace with the market, so the capabilities of the group diminished. Nevertheless, the MCAC has remained vitally important to the departments it serves because, with the exception of occasional gifts and small endowments, it provides the only guaranteed acquisition funds for nonphotographic contemporary art at LACMA.

Some of LACMA's early supporters of contemporary art continued to donate major works and purchase funds to the museum during the second half of the 1970s and early 1980s. Of particular note was the gift of the Dorothy and Michael Blankfort Collection, works from which began to enter the museum's holdings in 1982. This was the first significant collection of contemporary art to come to LACMA since David Bright's bequest in 1965. Michael Blankfort had been on LACMA's board, and he and his wife never defected to MOCA. They gave LACMA important paintings, multiples, and works on paper, such as R. B. Kitaj's early *Dismantling the Red Tent* (1963–64) and Yves Klein's *Anthropometrie* (1962). Willem de Kooning's fine *Montauk Highway* (1958), the first canvas by the artist to enter the collection, came to the museum as a twenty-fifth anniversary gift from the Blankforts in 1990. Among a number of other important gifts marking LACMA's anniversary was David Park's *Two Women* (1957), donated by actor Steve Martin, who served on LACMA's board at the time. In 1995 Ann and Aaron Nisenson gave the museum more than forty works in memory of their son, Michael. With significant pieces by Marina Abramovic, Enrique Chagoya, and Cindy Sherman, among others, this gift greatly added to the museum's holdings of art from the 1980s.

Along with the Bright bequest, the most significant gift of contemporary art in LACMA's history was the Robert H. Halff Collection. Halff was an early and stalwart member of the Modern and Contemporary Art Council and later of LACMA's board of trustees. He promised most of his important collection of midcentury works to LACMA in 1994, and they came to the museum ten years later, after his death at the age of ninety-six. Halff lacked extraordinary wealth but had an excellent eye, and he bought early in an artist's career when prices were low. Among the sixty-eight works that he either gave or bequeathed to the museum were important paintings by Lichtenstein, Johns, Warhol, and Stella, as well as major works on paper by Cy Twombly and Chuck Close. His donations also included significant pieces by younger artists such as Gober, Toba Khedoori, and Jeff Koons, and he left a much-needed endowment for the purchase of contemporary art. In accordance with Halff's wishes, all of the works he donated and his endowment came to LACMA through the Modern and Contemporary Art Council.

YVES KLEIN *Anthropometrie,* 1962

WILLEM DE KOONING *Montauk Highway,* 1958

CHUCK CLOSE *Large Phil,* 1979

THE NEW CONTEMPORARY PROGRAM

In anticipation of the Anderson Building's opening, LACMA increased the permanent curatorial staff of the Twentieth-Century Art Department by 100 percent. The museum hired Howard N. Fox as curator of contemporary art, Judi Freeman as assistant curator of twentieth-century art, and Carol S. Eliel as curatorial assistant of twentieth-century art. Fox came to the museum in 1985, when the Anderson Building and MOCA's main facility on Grand Avenue were under construction. In his view, many Angelenos loved to foment problems between the two institutions. He felt that the competition that did exist was, in many ways, healthy—a sign of ambition and the city's coming of age.

Fox was LACMA's first curator devoted exclusively to contemporary art (Tuchman's purview had always included art from 1900 to the present, and for a time it even extended back to the nineteenth century), and as such he excited quite a bit of curiosity and anticipation. He reports that when he arrived, he had so many dinner invitations that he could have dined out every night for a

solid year if he had wished. The Modern and Contemporary Art Council showed its support by hosting a lavish party for Fox and providing him with generous funds for travel and research. He returned the favor by increasing the number of educational events, such as question-and-answer sessions with artists in galleries and walk-throughs of exhibitions. Resisting the idea of a competition among artists, Fox changed the council's Young Talent Award to the Art Here and Now program, doing away with the promise of an exhibition and shifting the program's central focus to the acquisition of art. At the time, he reports that although the MCAC did not have abundant funds at its disposal, it had a "robust, ballsy view of itself" as a patron of the arts.

Although he sometimes met with complaints about Tuchman, Fox never had a problem with the curator, whom he found "smart, genuinely interested in the welfare of the collection, encouraging, open-minded." Tuchman might disagree with an idea, but if Fox could make a convincing case, Tuchman never stood in the way.[156]

ROBERT GOBER *Single Basin Sink*, 1985

JASPER JOHNS *Figure 7,* 1955

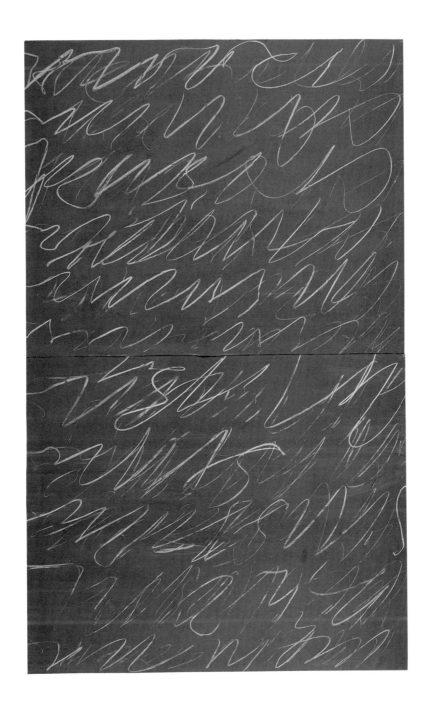

CY TWOMBLY *Roman Notes #3*, 1970

ROY LICHTENSTEIN *Cold Shoulder,* 1963

CINDY SHERMAN *Untitled,* 1987

Anselm Kiefer's *Das Buch* (1985) at the entrance to the exhibition *Avant-Garde in the Eighties*, 1987

Fox had come to LACMA from the Hirshhorn Museum and Sculpture Garden in Washington, D.C. His first Los Angeles exhibition, *Avant-Garde in the Eighties*, was the second temporary exhibition in the new Anderson Building and the first wholly contemporary show seen there. (The first exhibition in the new building was *The Spiritual in Art: Abstract Painting, 1890–1985*, curated by Tuchman with Freeman.) It was conceived as a sequel to his last Hirshhorn show, *Content*, organized with Miranda McClintic and Phyllis Rosenzweig. *Content* contained work made between 1974 (the year of the Hirshhorn's founding) and 1984 (the year of the exhibition). Its premise was that narrative content—meaning above and beyond the formal qualities of a work—was a distinguishing feature of the art of the previous decade.

In *Avant-Garde in the Eighties*, Fox confronted more directly some issues of postmodernism that he had begun to grapple with in *Content*. Questions about the viability of utopian modernism, the nature of representation, and whether it was still possible to create anything wholly original were raging in art and academic circles at the time. His premise was that key concerns of the modernist avant-garde—among them "originality . . . art's relation to the larger culture, [and] the limits of art"—survived into postmodernism and remained as pressing as ever. The contemporary response to them, however, was "different from, even antithetical to, the modernist response."[157] Extremely ambitious in scope, the exhibition contained approximately 130 works by almost as many artists. Fox placed the art under rubrics: "originality and source"; "community, shared values, and culture"; and "the limits of art."

In taking on the topic, Fox had stepped onto a minefield. For years intellectuals in the U.S. and abroad had been debating the issues surrounding postmodern theory, including the notion of the avant-garde. Thomas Lawson, writing in *L.A. Weekly*, accused Fox of being out of touch with contemporary discussion on the subject and reducing it to a "manic display of flimsy connections" in which viewers were pressed to acknowledge that one work did or did not look like another.[158]

For others in Los Angeles, however, what Fox presented was revelatory. *Los Angeles Times* critic William Wilson was nothing short of ecstatic in his response to the show, proclaiming that "Howard Fox's first major exhibition at the County Museum of Art has the guts to define the decade of postmodernism and moves Los Angeles to the forefront in the thoughtful evaluation of the present." He added, "The County Museum is on a roll . . . The energy level of the place is amazing. Instead of taking a well-deserved breather after major construction, it is functioning with the drive of the Met." He compared Tuchman's *Spiritual in Art* to earlier "landmark exhibitions like *The Avant-Garde in Russia* and *German Expressionist Sculpture*," declaring that "LACMA at its best is as good as MoMA at its best."[159]

This was certainly the case, but the problem remained that, with the exception of Fox's shows, LACMA's early Anderson Building programming did not address the concerns that occupied the contemporary art world at the time. Art discourse was then focused on the new generation of European artists, the transcontinental debate about the reemergence of painting,

and the many influential younger artists and critics, here and abroad, who were grappling with poststructuralist and post-modern theory.

Rusty Powell says that it was not LACMA's role to show emerging art, which was MOCA's concern. While that may be true, timing is especially important in the presentation of recent work, whether by new or established artists; Tuchman seems to have had difficulty getting beyond his earliest predilections in order to grapple with the issues of the day. If LACMA's contemporary program in the late 1980s is compared with the shows that Tuchman mounted in the 1960s, many of which presented the work of established artists, it is lackluster. In the two years following *The Spiritual in Art,* he mounted *Robert Graham: The Duke Ellington Memorial in Progress* and, with the assistance of other members of the department, a show of Young Talent Award winners. The museum also hosted a Bengston exhibition organized by the Contemporary Art Museum, Houston. These offerings could have fit nicely within a broader context, but by themselves, at that moment, they were not going to bolster LACMA's reputation nationally or internationally.

In 1988 Tuchman and Barron organized the first retrospective exhibition of the work of David Hockney. While the British-born, L.A.-based artist's work was a welcome addition to the group of living artists with whom Tuchman worked, in the United States his influence wouldn't be felt until the 1990s, when he had a major impact on a number of prominent younger painters, Elizabeth Peyton among them.

LACMA in 1989 hosted MoMA's Frank Stella show (the second one that it had produced), a sensible decision given the depth in which Stella is represented in LACMA's holdings and the strong support for him in L.A.'s collecting community. The museum was also a venue for Helen Frankenthaler and Francis Bacon retrospectives (both 1990), as well as for *Andrew Wyeth: The Helga Pictures* (1988). A controversial choice within the art world—where Wyeth's work was considered by many to be fundamentally commercial, even pandering—the exhibition proved popular with the general public. The museum sold 217,000 tickets, suggesting an overall attendance of more than a quarter of a million people. Two scheduled lectures on the Helga paintings encouraged debate about the value of the work. The first talk, by L.A. art critic Christopher Knight, was titled "Andrew Wyeth: Who Cares?" The second, by famed art historian Robert Rosenblum, had the more measured title "Andrew Wyeth: Satan, Savior, or American Artist?"[160]

As always at LACMA, the contemporary art program was buttressed by significant modern exhibitions, notably *The Spiritual in Art* and Barron's *German Expressionism, 1915–1925: The Second Generation* (1988). A lively photography program developed but it, too, was dominated by modernism (Ansel Adams, Edward Weston, and Frederick Evans, for example). The museum also hosted shows of drawings and prints that focused on the work of Diebenkorn, Johns, and Ellsworth Kelly.

The 1980s were a transitional decade for the L.A. art world. As active as it had been in the 1970s, L.A. did not produce as many figures of national prominence as it had in the preceding decade.

(Burden was perhaps the most notable exception, and it is questionable how many people outside of the U.S. realized that he was based in Southern California.) For the cognoscenti on the East Coast and in Europe, the light and space and finish fetish artists of the 1960s still defined the Southern California landscape. Throughout the 1970s, Baldessari sent his students from CalArts—David Salle, Jack Goldstein, and Matt Mullican among them—to New York because he believed there was no support for their intellectual and aesthetic concerns in Los Angeles.[161] Once on the East Coast, they helped define the pervasive sensibility of the 1980s.

Broadly influential figures such as Mike Kelley, Charles Ray, and Lari Pittman came to prominence in L.A. in the 1980s. Kelley, Stephen Prina, and Barbara Kruger, who began spending extended periods in Los Angeles in 1979, were among those who made major contributions to the theoretical dialogue of the time. Kruger feels that most museums were out of touch with the concerns of younger artists, but some still managed to acknowledge the cultural moment, at least in small ways. MoMA, for instance,

presented *Projects* exhibitions on the work of Louise Lawler and Mike Glier amid its more traditional offerings, as well as *Berlinart*, a major endeavor by curator Kynaston McShine that highlighted postwar work in the German city. Along with many others, Kruger recalls that in Los Angeles the art schools (such as Otis, CalArts, UCLA, and Claremont) provided the most exciting, up-to-the-minute discourse on the visual arts.[162] Conceptualists such as Michael Asher, Douglas Huebler, and Baldessari, all of whom remained in Los Angeles and survived by teaching, served as important models for a younger generation. As it had from its inception, CalArts brought to town significant artists from Europe and New York, further balancing what had become L.A.'s traditional emphasis on craft and perception with conceptual art.

Perhaps because, in Koshalek's words, it was "created as an artists' museum," MOCA's offerings were more attuned to the moment than LACMA's. Between 1987 and 1989, MOCA hosted or organized exhibitions of work by artists who had emerged or come to increased international attention during the 1980s, such as Salle,

HANS HAACKE *Oelgemaelde, Hommage à Marcel Broodthaers*, 1982

Francesco Clemente, Kiefer, Ann Hamilton, and Fischli and Weiss. To this compelling group of younger artists it added established figures like the Belgian conceptualist Marcel Broodthaers, who was not well known in the United States but was of particular interest to artists and scholars at that time. MOCA also supported the local community, presenting works by Los Angeles figures Prina and architect Frank Gehry, as well as the groundbreaking thematic exhibition *Blueprints for Modern Living: History and Legacy of the Case Study Houses*. Despite its fledgling status, the downtown museum became the prime venue for challenging contemporary shows traveling from museums on the East Coast and in the Midwest.

Much of LACMA's problem in crafting its contemporary program stemmed from the fact that, despite the increase in curatorial staff that came with the new building, it still had only one curator whose primary focus was contemporary art, a field that demands a great deal of resources. Barron had concentrated most of her energies on Russian and German modernism, and

Freeman and Eliel at that point had little experience in the contemporary realm. To make matters worse, Fox's next big enterprise, *Robert Longo*, had to be postponed for funding reasons. It is difficult to say whether this delay made a difference in its reception, but it is certain that timing worked against LACMA once again.

Longo was a central figure in the New York art world in the early 1980s. As the decade wore on and the economy grew, the work of the best-known New York and European artists of the period often tended to grow in size and production cost along with it. The art seemed to mirror the era's materialism (epitomized by Gordon Gekko, the slick stockbroker played by Michael Douglas in the 1987 movie *Wall Street*, who declared "Greed . . . is good"). No artist was more associated with the trend toward grandiosity than Longo, whose work alluded to fascist design and had come to include sculptural elements almost on the scale of architecture. Today Longo's early work, such as his iconic Men in the Cities series of life-size drawings that depict corporate workers alone or warring among themselves, has regained much of its original

MARK TANSEY *Picasso and Braque*, 1992

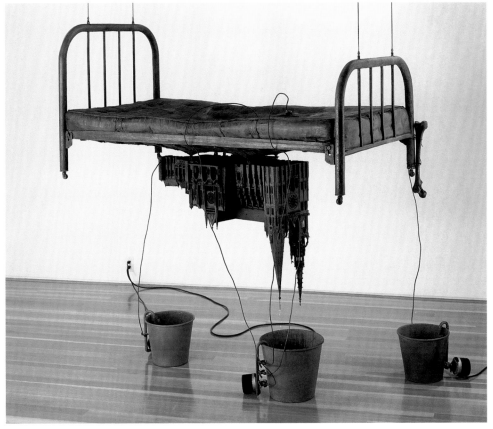

ARS LONGA, VITA BREVIS

resonance. In 1989, however, his work had come to seem simply overblown. Where Fox saw "vulnerability and romantic pathos," others saw excess for its own sake.[163]

Los Angeles in the 1980s had considerably fewer galleries and museums than it does today. It had not been exposed to enormous art with the unrelenting constancy that New York had, and its critics generally were kind to *Robert Longo*. National publications were less tolerant. Writing in *Newsweek*, Peter Plagens complained that Longo's "glossy gigantism" buried any democratic values his

work might have. He accused Longo of producing art that was "just violent enough to imply anger at corporate society and just slick enough to fit snugly into the Saatchi Collection" (the much-publicized holdings of Charles Saatchi, the cofounder of the worldwide advertising agencies Saatchi and Saatchi and M & C Saatchi).[164] In the *New York Times*, Roberta Smith was particularly cruel, repeating an unattributed insult she heard at the opening, which referred to Longo as "Robert Long Ago" and opining that the artist's career "suffered sudden celebrity and rapid decline."[165]

Judi Freeman and MoMA's John Elderfield, 1991

PETER SHELTON *Churchsnakebedbone,* 1993

Carol S. Eliel, 1996

182

Around 1990 things began to improve for the Twentieth-Century Art Department, especially in terms of exhibitions. In the realm of modern art, Barron's monumental *Degenerate Art: The Fate of the Avant-Garde in Nazi Germany* opened to great acclaim in 1991. A year after *Robert Longo*, Fox organized *A Primal Spirit: Ten Contemporary Japanese Sculptors*, also to critical praise. In addition, the department's junior curators began to work in the contemporary arena. Judi Freeman presented *Mark Tansey* (1993) and Carol Eliel organized *Peter Shelton: bottlesbonesandthings-getwet* (1994). When the exhibition *Mike Kelley* came from New York's Whitney Museum of American Art to LACMA rather than MOCA in 1994 (due to Fox's involvement with it), it was a coup of sorts and a morale boost.

Robert Sobieszek had come to LACMA in 1990 from the George Eastman House in Rochester, New York, to head the young Photography Department. An intellectual with an original sensibility, he embraced and acquired all kinds of photography, supporting not only those artists who were part of the traditional photography world but also conceptual artists who created text- and photo-based work and those who produced video and new media projects. Under his leadership, LACMA hosted or organized an increased number of exhibitions of contemporary photography, including shows focusing on the work of Emmet Gowin (1992), Sarah Charlesworth (1992–93), John Pfahl (1993), Catherine Wagner (curated by Sheryl Conkelton, 1993), Helen Levitt (1994), and Annie Leibovitz (1994–95). Most notable among these shows was Sobieszek's own exhibition *Robert Smithson: Photo Works* (1993).

Robert Sobieszek, 1992

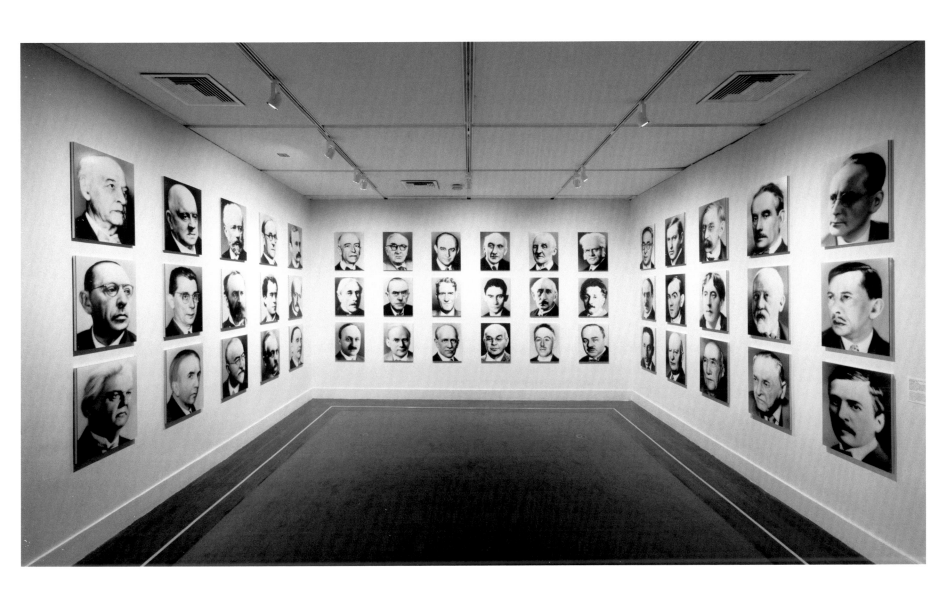

GERHARD RICHTER *48 Portraits,* 1998

1995 TO THE PRESENT

In 1992, after Powell was named director of the National Gallery in Washington, D.C., the LACMA board attempted to use the strategy it employed in recruiting him to hire his successor. That August they named Michael Shapiro, chief curator of the Saint Louis Art Museum, to the position. At forty-two Shapiro was only a few years older than Powell had been when he assumed the directorship. It was a surprising appointment, contradicting the common assumption (based in part on a published job description) that the board hoped to find a major museum figure, someone with extensive experience.[166] Shapiro had the misfortune to take over just as a recession hit. During his tenure, it resulted in multi-million-dollar cutbacks of county funds. Museum workers were laid off and galleries closed. LACMA had grown significantly in size and complexity through the 1980s; even in good times it would have been challenging for a curator lacking administrative experience to successfully guide the museum. Under such strained conditions, it was impossible. Shapiro announced his resignation on August 20, 1993. The museum's fiscal problems and the departure of a director after only ten months made it difficult to find a suitable candidate for the position. For more than two years, the museum had no director.

At the end of February 1995, in the midst of this shaky, directorless period, I arrived at LACMA from the Museum of Modern Art in New York to replace Judi Freeman as associate curator of modern and contemporary art. Freeman had left in June 1993 to become the chief curator of the Portland Museum of Art in Maine. Chief deputy director Ronald Bratton was overseeing the museum

with Barron, who managed curatorial affairs, and Melody Kanschat, who headed the administrative side. In the absence of a director, board presidents Robert McGuire and William Mingst also played significant roles.

Los Angeles itself was recovering from the same economic recession that had crippled LACMA. The economic slump had been fueled by the riots of 1992 (sparked by the Rodney King verdict), the fires of 1993, and the Northridge earthquake of 1994. It was a low moment for the city, but change was already in the air. In 1995 Los Angeles was shedding the last vestiges of a cultural marginality dictated by one hundred years of physical distance from other artistic centers. Globalization was making the city's art world an international force. In the second half of the 1990s, it was no longer

SHARON LOCKHART *Ruby,* 1995

BILL VIOLA *Slowly Turning Narrative,* 1992

CHRIS BURDEN *L.A.P.D. Uniforms,* 1993

LARI PITTMAN *This Wholesomeness, Beloved and Despised, Continues Regardless,* 1989–90

I brought to the museum an interest in Latin American contemporary art and began to collect in that area soon after my arrival. Latin American art was also a priority for Rich, who spearheaded the acquisition of the Bernard and Edith Lewin Collection, which included more than two thousand works, most by Mexican modernists. The collection came to the museum in 1997, and Ilona Katzew became LACMA's first curator of Latin American art in 2000. Katzew, who has expertise in the colonial and modern eras, rapidly developed an interest in contemporary art. Together we have overseen the acquisition of works by Mexican, Cuban, and South American artists.

During the first five years of Rich's tenure, the contemporary curators continued to organize significant exhibitions, including *Annette Messager* (Eliel with Sheryl Conkelton, who had moved to MoMA, 1995); *Lari Pittman* (Fox, 1996); *Love Forever: Yayoi Kusama, 1958–1968* (Zelevansky with Laura Hoptman, then of MoMA, 1998); *Eleanor Antin* (Fox, 1999); and *Robert Therrien* (Zelevansky, 2000). We also served as a venue for major shows on the work of Bill Viola (1997–98) and the German neoexpressionist Georg Baselitz (1995–96). Sobieszek, together with photography curator Tim Wride, organized *P.L.A.N.: Photography Los Angeles Now* (1995). They hosted *Photography and Beyond in Japan: Space, Time, and Memory* (1996), as well as exhibitions devoted to the work of Roy De Carava (1996–97), Minor White (1997), and Lorna Simpson (1998–99), among others. The Prints and Drawings Department contributed a retrospective on L.A. artist June Wayne (Bruce Davis and Victor Carlson, 1998–99). Together with our

Contemporary Projects series and other smaller ventures, it made for a rich program.

In 1999, however, the director decided that the plaza level of the Anderson Building—arguably the best temporary-exhibition space in the old configuration of LACMA buildings—should no longer be used exclusively for modern and contemporary exhibitions.[168] In addition, shows coming to LACMA from other institutions would no longer be selected for programmatic reasons alone. They now had to either raise funds or broaden the museum's constituency by appealing to a very wide or to a specifically targeted audience. Rich also cut back on the rotations of works within the permanent collection galleries, which are crucial for contemporary curators attempting to reflect the contingent nature of the collection and the constantly shifting values on which it is based.[169] Together, the loss of a designated temporary-exhibition space, the inability to host touring exhibitions carefully selected to augment LACMA's own offerings, and the restriction on reinstallations of the collection galleries greatly undermined the contemporary art program as a whole.

Despite the difficulties, the Modern and Contemporary Art Department continued to present ambitious homegrown shows, among them *Made in California: Art, Image, and Identity, 1900–2000* (2000–2001), a collaboration with the American Art Department spearheaded by Stephanie Barron, Ilene Susan Fort, and Sheri Bernstein. The enormous exhibition contained more than eight hundred works and occupied 47,000 square feet, making it the largest temporary show ever mounted by the museum. It stretched

Postcards from Eleanor Antin's *100 BOOTS*, 1971–73

into the hallways and stairwells of the museum; across Ogden Drive to the staff parking lot, which was decorated with murals by San Francisco artists Margaret Kilgallen and Barry McGee; and into LACMA West, where LACMALab (the museum's new experimental children's gallery) presented *Made in California: NOW*, interactive installations by eleven contemporary California artists.

The exhibition surveyed a century of art in the state and involved many of the museum's curatorial departments. With an interdisciplinary approach and documentation and ephemera of different kinds, it was extremely controversial. In the *New York Times*, Roberta Smith complained that the show treated art as "an artifact, just another manifestation of visual culture," while a critic in the *Wall Street Journal* called it "an anticapitalist, anti-Anglo, pessimistic take on the Golden State."[170] On the same day, however, the *Wall Street Journal* also listed the exhibition under "The Season's Best," noting that "critics and locals either loved or hated

this deliberately provincial and insular show" and reporting that the *San Francisco Examiner* had called it "the landmark exhibition on art made in this state."[171]

In 2001 Barron and I co-organized *Jasper Johns to Jeff Koons: Four Decades of Art from the Broad Collections*. As a trustee, Eli Broad had become a leading force within the institution. He and his wife, Edythe L. Broad, had amassed a personal collection of contemporary art with important works by some of the most prominent figures in the field. The larger and equally formidable Broad Art Foundation, conceived in 1984 as a kind of lending library for art, collects and makes pieces available to museums worldwide. The exhibition included works from both collections and mirrored their acquisition methodology, which involves a focus on the achievements of individual artists. It highlighted twenty-five of the approximately two hundred artists then represented in their holdings, mostly in monographic rooms. Among them were Johns,

Lynn Zelevansky with Robert Therrien's *No Title (Blue Plastic Plates)*, 1999

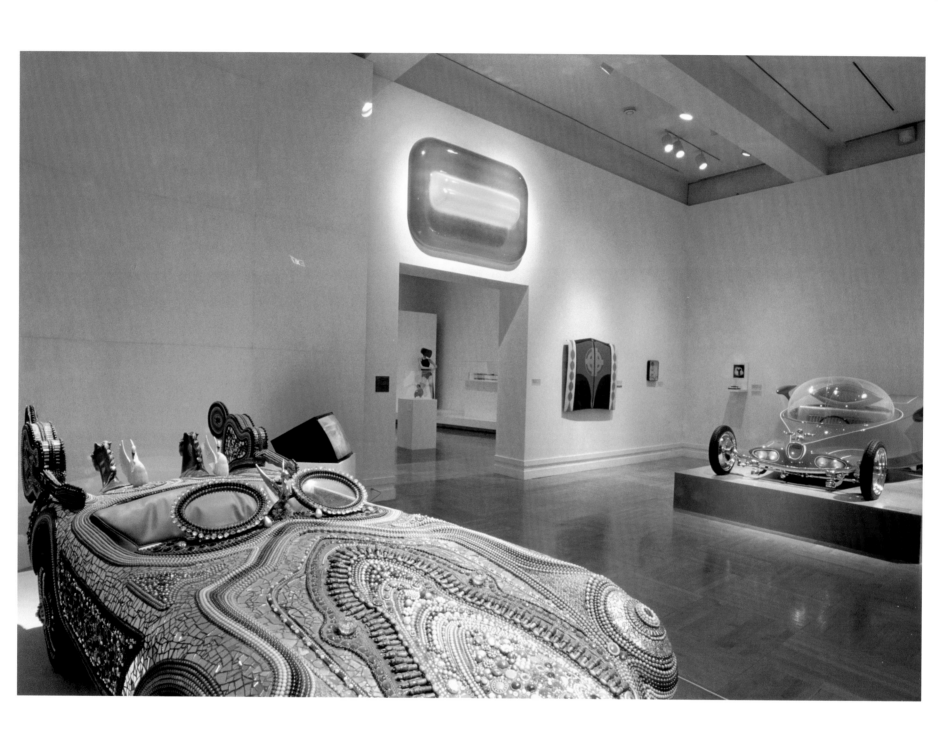

Made in California: Art, Image, and Identity, 1900–2000, 2000–2001

One of Margaret Kilgallen's murals in LACMA's parking garage, commissioned for *Made in California*, 2000

Visitor in Stanislaw Dróżdż's *Między (Between)*, 1977, in the exhibition *Beyond Geometry: Experiments in Form, 1940s–70s*, 2004

Koons, Warhol, Sherman, and Ray. After its Los Angeles showing, *Jasper Johns to Jeff Koons* traveled to the Corcoran Gallery of Art in Washington, D.C.; the Museum of Fine Arts, Boston; and the Guggenheim Museum Bilbao in Spain, with its still-new and celebrated building by L.A. architect Frank Gehry.

In 2004 I organized *Beyond Geometry: Experiments in Form, 1940s–70s*. The culmination of about seven years of work, it examined the use of radically reduced form and systematic processes in central and western Europe and North and South America in the decades after World War II. Intended to dispute the notion that U.S. minimalism was the sole precursor of important conceptual and formal innovations of the 1960s and 1970s, the exhibition identified concerns that occupied artists all over the West during the postwar period. Among these were the phenomenology of the French philosopher Maurice Merleau-Ponty, the art and attitude of dadaist Marcel Duchamp, the use of systems for art making, and—perhaps

most significantly—the desire to define a new, more interactive relationship with the viewer.

The show got a mixed reception. In *Artforum*, critic Dave Hickey called it "a sprawling, labyrinthine mess," but Michael Kimmelman's review on the front page of the *New York Times*' weekend arts section proclaimed that "to dismiss the effort as just chaotic would be to shortchange its eccentric pleasures, which are varied, and, most important, to overlook the big point: that globalism isn't a new cultural phenomenon."[172] It was named best thematic exhibition nationally by the International Association of Art Critics and best exhibition in the Pacific time zone by the Association of Art Museum Curators. Between 2001 and 2005, the department also produced two fine monographic exhibitions, *Lee Mullican: An Abundant Harvest of Sun* (Eliel, 2005) and *Tim Hawkinson* (Fox and Lawrence Rinder of the Whitney, 2005), and several Contemporary Projects shows.

Howard N. Fox at *Tim Hawkinson*, 2005

Rich had always said that she did not want to expand LACMA physically; she preferred to improve existing buildings and raise endowment funds, which have always been sorely lacking at the museum. However, it soon became apparent that additional space was needed. Because there was support for contemporary art on the board (a very different board than the one that prevailed through the 1970s) and within the community, Rich and the board leadership decided to construct a new building for art created after World War II. Not long after having its temporary-exhibition galleries taken away, contemporary art again was looking forward to having a designated space at LACMA. In 2001 the museum undertook an architectural competition in which Steven Holl, Rem Koolhaas, Daniel Libeskind, Morphosis, and Jean Nouvel were asked to submit proposals that would create the new building, address what could be done with LACMA West (the old May Company building), and leave the rest of the campus untouched.

Koolhaas was the only architect who boldly disregarded the final directive. An advisory committee composed of community leaders and architectural experts supported his plan nonetheless, and the board voted for it. In early 2002, Rich announced that Koolhaas had won the competition. He proposed to demolish the three original Hancock Park structures as well as the Anderson Building and replace them with a single enormous building that would house all of the museum's collections. Koolhaas's plan was in many ways ingenious—a kind of three-dimensional timeline that would have allowed a visitor to move easily between exhibits of different cultures—but it never developed beyond an idea.

An important part of its funding package was a municipal bond that covered earthquake, fire, and safety improvements for LACMA and a group of other cultural institutions. When voters failed to approve the November 2002 ballot initiative, the Koolhaas project was doomed, too.

In 2003 Eli Broad generously committed to funding a new building for art after World War II, to be named the Broad Contemporary Art Museum at LACMA. He also pledged $10 million for art acquisitions. BCAM would rise on the lawn between the Ahmanson and LACMA West buildings. The older structures on the east side of the campus would remain, making this plan far less expensive than Koolhaas's. This time there was no competition; Broad chose Renzo Piano to be the architect of the new building. When faced with the hodgepodge of styles that is LACMA, Piano advocated developing a master plan for the museum, arguing that a new building without a master plan would only make the campus more confusing (the same rationale that underlay the HHPA master plan of the early 1980s). In *At LACMA*, the museum members' magazine, Rich called Piano's idea "a framework that is achievable today, with room for continuing development."[173] In other words, it could be done in stages, greatly reducing the financial risk to the institution—a relief to all concerned.

For those of us who work in the contemporary arena, BCAM is a particularly welcome development. It is terribly important that LACMA have a building dedicated to recent art, because it serves a unique purpose within a general museum. When contemporary art is present, creativity in general and art making in particular cannot

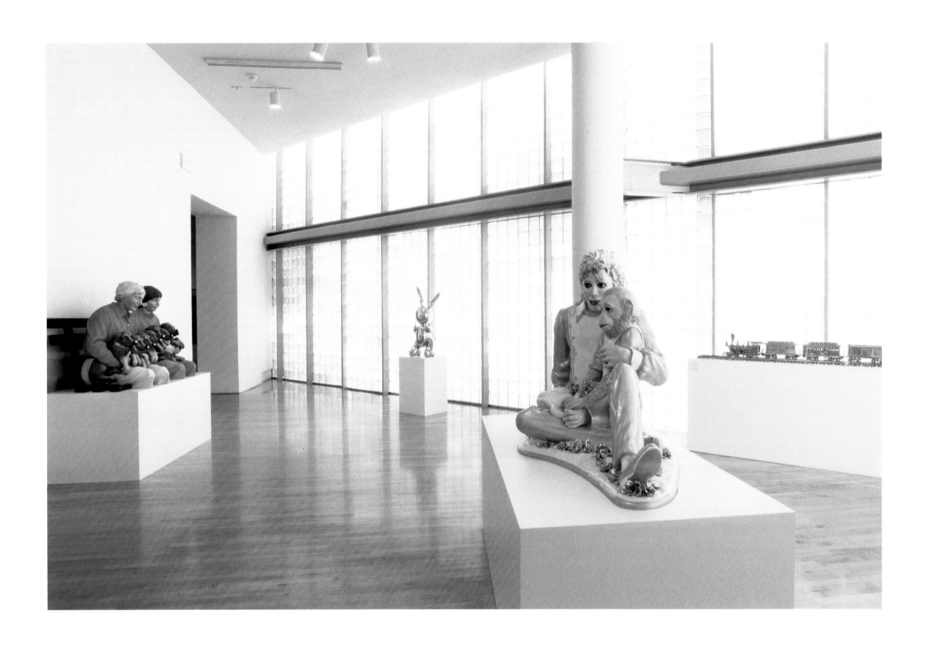

Jasper Johns to Jeff Koons: Four Decades of Art from the Broad Collections, 2001–2

be relegated to the past. For the young viewer, still in formation, art produced in a more familiar idiom is often accessible, offering an alternative path to different cultures and eras. It also suggests that they, too, can be artists should they so choose. For artists of today—virtually all of whom have been influenced by art of the past—there is a weight and meaning to showing within an institution that houses historical collections that cannot be duplicated in a contemporary art museum alone.

BCAM not only gives us back a designated space for the art of our time, a space more beautiful and flexible than any we have had before, but also brings us the Broad collections. At any given moment, up to two hundred works from Eli and Edye Broad's personal and foundation collections will be on loan to BCAM, along with LACMA's own postwar holdings. LACMA's collection is

strong in Southern California art of the 1960s and 1970s, and it contains iconic works by figures such as Stella, Lichtenstein, Kusama, Mel Bochner, Vito Acconci, Lucas Samaras, Bruce Nauman, and others, but it lacks depth. Quirky and interesting, with a good deal of heart, the collection has many gaps. Since the Broads, on the other hand, have made firm commitments to well-known artists whose work they consistently acquire over the years, they have great depth in the art of Warhol, Lichtenstein, Ruscha, Koons, Sherman, Ray, Jean-Michel Basquiat, Damien Hirst, and other major names in contemporary art. By combining the Broad holdings with LACMA's collection, BCAM will, on an ongoing basis, provide the people of Los Angeles with the richest representation of postwar art ever on public display in the city.

200

ALIGHIERO BOETTI *Mappa*, 1979

MEL BOCHNER *Language Is Not Transparent,* 1970

TAKASHI MURAKAMI *PO + KO Surrealism (Green),* 1999

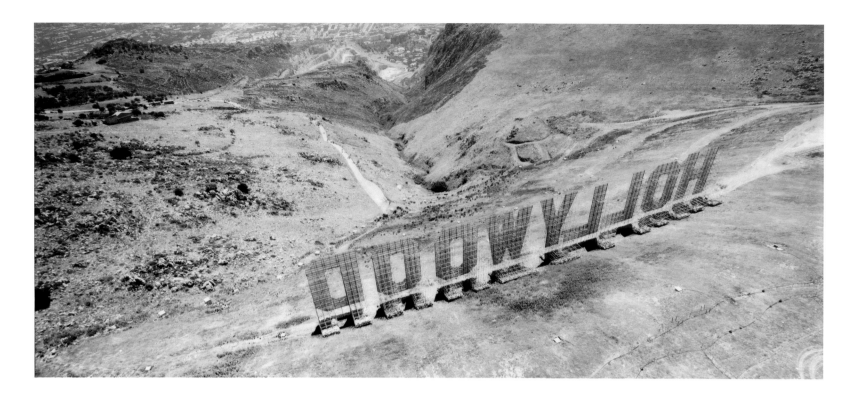

Rich retired in November 2005, ten years after her arrival at LACMA. In April 2006, Michael Govan became LACMA's sixth director. Only a few years older than Rusty Powell was when he began his tenure here, Govan is far more experienced, having been deputy director of the Solomon R. Guggenheim Museum and director and president of the Dia Art Foundation in New York, a position he attained at only thirty-one. To be the successful director of a major museum requires a daunting set of skills: you must have a deep appreciation for visual art of all kinds; you must be a politician and a diplomat, a fund-raiser and an intellectual; you must know what you want, know when to listen, and be decisive.

We have an art specialist at the helm of the museum, and it is an exciting moment for all of the curators. For the field of contemporary art in particular, Govan's broad knowledge and deep understanding of that discipline are crucial. In a general museum, working with living artists can be difficult, as it requires a flexibility not often built into the institution's processes and systems. Govan's profound commitment to artists and their role within the museum as thinkers and creators has already done a great deal to enliven our programs. Since he arrived, many proposed plans have been challenged and new ones put into play. Most important, Govan has made the acquisition of art from all the museum's areas of specialization a priority, and there is some much-needed glamour, along with real energy, about the place.

YOSHITOMO NARA *Black Dog,* 1999 MAURIZIO CATTELAN *Hollywood,* 2001

JENNIFER STEINKAMP *Jimmy Carter,* 2006

EPILOGUE

It's January 4, 2007, a little more than a year before the Broad Contemporary Art Museum is scheduled to open at LACMA and about five months after I began writing this essay. Some of the building's construction phases have moved quickly, while others seemed glacially slow. It took months for the enormous hole from which the bones came to be fully excavated, but when the steel went up to frame the new building, it happened in a matter of weeks. For a while, there was something new to see almost every day, then months would pass without much dramatic change. Pouring the concrete floors took considerable time, as did the construction of the trusses that hold the complex structure for the skylights in the roof. Bolts all over the building had to be tightened by hand, and a fireproof coating was sprayed wherever there was steel (which was almost everywhere). While all this was happening, the garage—a two-story underground structure that occupies most of the gigantic hole that was on LACMA's lawn—was built.

Today, surveying the vast construction site from the portico at the back of the Ahmanson Building, I noted two significant developments: There was a roof over three-quarters of the parking garage; eventually the whole thing will be covered with sod and perhaps a new exhibition building, seamlessly integrated with the rest of the park. And BCAM's skin of rectangular, tan marble slabs had begun to appear on the ground floor, where it was starting to frame a large window onto the gallery within.

There is no sign yet of the entry pavilion, where the box office will stand, nor the walkway that will extend from the Ahmanson Building past BCAM to LACMA West. The ancient bones still have not been carted off to a laboratory to be cleaned and catalogued. They are stored in the northeast corner of the construction area, in several enormous crates the size of small houses and in a group of smaller crates, the shape of each defined by the width and breadth of the cache it encases.

By the time you read this, it will have been almost one hundred years since the founding of the Los Angeles Museum of History, Science, and Art in Exposition Park. LACMA has had a tumultuous but exciting past, defined in part by its unconventional beginnings and its relationship to contemporary art. BCAM not only reconfirms the museum's commitment to that field but also provides more space and renewed vitality for the entire institution.

Tar, that insistent, disruptive stuff, is no longer visible on the construction site, but the roiling muck that exists beneath everything in Hancock Park is sure to make its way to the surface with time. Unpredictable, the tar has buffered the museum from seismic shocks during earthquakes, and it contains real treasures. Ancient, it supports the most contemporary of general museums. There could not be a more appropriate place for BCAM or the Los Angeles County Museum of Art.

NOTES

1 See www.tarpits.org/info/visit.html.

2 Diane Haithman, "On the Lookout for *Smilodon fatalis*," Arts Notes, *Los Angeles Times*, July 24, 2005, home edition.

3 Arthur C. Danto, *After the End of Art: Contemporary Art and the Pale of History* (Princeton, NJ: Princeton University Press, 1997), 10.

4 This account of the early history of LACMA and Los Angeles depends in large part on Ilene Susan Fort's essay "The View from Los Angeles," in *LACMA: Masterworks (Obras Maestras), 1750–1950* (Mexico City: Museo Nacional de Arte, 2006).

5 Alfred H. Barr, quoted in preface to *The Museum of Modern Art at Mid-Century: Continuity and Change*, Studies in Modern Art 5, ed. Barbara Ross (New York: Museum of Modern Art, 1995), 8.

6 Kirk Varnedoe, "The Evolving Torpedo: Changing Ideas of the Collection of Painting and Sculpture of the Museum of Modern Art," in *The Museum of Modern Art at Mid-Century: Continuity and Change*, Studies in Modern Art 5, ed. Barbara Ross (New York: Museum of Modern Art, 1995), 14–15. In fact, the Modern's agreement with the Metropolitan Museum of Art, discussed since 1931, was put into effect in 1947 and lasted only five years. In all, MoMA sold twenty-six works to the Met. In 1953, John Hay Whitney, MoMA's board chairman, announced that "the museum has come to believe that its former policy, by which all the works of art in its possession would eventually be transferred to other institutions, did not work out to the benefit of its public." Quoted in Russell Lynes, *Good Old Modern: An Intimate Portrait of the Museum of Modern Art* (New York: Atheneum, 1973), 291.

7 "For many of the new Anglo arrivals, the image of California as unaffected by the massive immigration from southern and eastern Europe then changing the complexion of the country's major East Coast and midwestern urban centers was a strong attraction." Sheri Bernstein, "Selling California, 1900–1920," in *Made in California: Art, Image, and Identity, 1900–2000*, by Stephanie Barron, Bernstein, and Ilene Susan Fort (Los Angeles and Berkeley: Los Angeles County Museum of Art and University of California Press, 2000), 65.

8 Contract for bequest of the William Preston Harrison Collection to the Los Angeles County Museum of History, Science, and Art, signed 1931, 10–11. Harrison set out a complex process for deaccessioning works from his collection; it would involve a jury composed of curators from the Art Institute of Chicago, the Fine Arts Gallery of San Diego, the Henry E. Huntington Foundation of San Marino, the Palace of the Legion of Honor of San Francisco, "or their respective successors." The Los Angeles County Museum's director was to sit on the jury without a vote but with the discretion to accept or reject, "in whole or in part, the verdict of the jury— a discretionary power which should always remain with the official head of any institution in possession of art treasures."

9 Ken Donahue, introduction to *The David E. Bright Collection, Los Angeles County Museum of Art*, by James Monte, Helene Winer, and Ellen Landis (Los Angeles: Los Angeles County Museum of Art, 1967), 10.

10 All quotations from and information about the career and curatorial enterprises of Vincent Price come from an interview by Paul Karlstrom, August 6 and 14, 1992, Archives of American Art, Smithsonian Institution, Washington, D.C., which is accessible at www.aaa.si.edu/collections/oralhistories/transcripts/price92.htm.

11 In his oral history, Price gives the Little Gallery's opening date as both 1940 and 1942, but in fact it appears to have operated from 1948 to 1950.

12 Suzanne Muchnic, *Odd Man In: Norton Simon and the Pursuit of Culture* (Berkeley: University of California Press, 1998), 32.

13 Naomi Sawelson-Gorse, "'For Want of a Nail': The Disposition of the Louise and Walter Arensberg Collection" (master's thesis, University of California, Riverside, 1987), 33–38.

14 Ibid.

15 "Political Bias Blamed for Museum's Ills," *Los Angeles Times*, May 6, 1939.

16 Sawelson-Gorse, master's thesis, 33–38.

17 Naomi Sawelson-Gorse, "Hollywood Conversations: Duchamp and the Arensbergs," in *West Coast Duchamp*, ed. Bonnie Clearwater (Miami Beach: Grassfield Press, 1991), 34.

18 Sawelson-Gorse, master's thesis, 33–38.

19 In his oral history, Price asserts that the Little Gallery opened before the Modern Institute. He gives the Modern Institute's opening date as 1941 and 1944, but evidence suggests that it actually preceded the Little Gallery and operated from 1947 to 1948 (see note 11). A number of publications have given incorrect dates for both institutions, perhaps in part because of these discrepancies.

20 Sawelson-Gorse, "Hollywood Conversations: Duchamp and the Arensbergs," in *West Coast Duchamp*, 32–33, 38.

21 Beatrice Wood, interview by Paul Karlstrom, March 2, 1992, Archives of American Art, Smithsonian Institution, Washington, D.C., www.aaa.si.edu/collections/oralhistories/transcripts/wood92.htm.

22 James Byrnes, interview by George M. Goodwin, 1977, "Los Angeles Art Community: Group Portrait, James Byrnes," vol. 1, oral history program, University of California, Los Angeles, 38–43.

23 Ibid.

24 *Bulletin of the Art Division of the Los Angeles County Museum* 1, no. 2 (Fall 1947): 28. Byrnes's rise was meteoric. In the first issue of the bulletin, published six months prior, he was listed simply as "assistant curator." In his UCLA oral history, Byrnes says that at one point he was called "curator of American, modern, and contemporary art," but I have found nothing to substantiate that.

25 For example, the same year the ordinance was passed (1951), Jackson Pollock, Mark Rothko, and Josef Albers were among the artists represented in LACMA's annual exhibition.

26 Alfred Barr, "Is Modern Art Communistic?" in *Defining Modern Art: Selected Writings of Alfred H. Barr Jr.*, ed. Amy Newman (New York: Abrams, 1986), 214–19. First published in the *New York Times Magazine*, December 14, 1952.

27 Lawrence Weschler, *Seeing Is Forgetting the Name of the Thing One Sees: A Life of Contemporary Artist Robert Irwin* (Berkeley: University of California Press, 1982), 31.

28 Byrnes, UCLA oral history, 38–43.

29 Ibid., 47–48. Byrnes says that the California Art Club was led by Edward Withers, who was "one of the prime attackers."

30 Byrnes, UCLA oral history, 38–43.

31 No works by Baziotes or Knaths entered the collection in 1951. The Museum Associates Purchase Awards for that year went to Jackson Pollock's *No. 15* (1950), Josef Albers's *Homage to the Square* (1951), and Ynez Johnston's *Archaic Vessel* (1951).

32 Byrnes, UCLA oral history, 98.

33 Lynn Zelevansky, "Dorothy Miller's *Americans*, 1942–1963," in *The Museum of Modern Art at Mid-Century: At Home and Abroad*, Studies in Modern Art 4, ed. John Elderfield and John Szarkowski (New York: Museum of Modern Art, 1994), 90.

34 Donahue, introduction to *The David E. Bright Collection*, 10.

35 Kevin Salatino, "LACMA Exhibits Prints and Drawings from Permanent Collection, Including Masterworks from Renaissance through Present Day," press release for exhibition on view from December 13, 2001, to April 7, 2002.

36 Donahue, introduction to *The David E. Bright Collection*, 10.

37 Ibid.

38 There was a secretarial pool outside Brown's office. Curators who wanted a manuscript or letter typed brought it there. According to Kuwayama, one of the great advances brought by the move to Hancock Park was that the curators each were assigned a secretary and, soon after they arrived, they each were assigned a curatorial assistant. Over his years at LACMA, as the collection grew to warrant it, Kuwayama hired experts in South and Southeast Asian art and in Japanese art, continuing to oversee Chinese art himself.

39 Victoria Behner, "Identity, Status, and Power: The Architecture of Contemporary Art Exhibition in Los Angeles" (PhD diss., University of Michigan, 2003), 43–44, 54.

40 Byrnes, UCLA oral history, 61–62.

41 Ric Brown, memo to Marvin Ross, Los Angeles County Museum of Art, January 22, 1955.

42 Art Seidenbaum, "A Man to Move a Museum," *Los Angeles Times Magazine*, March 28, 1965.

43 Museum director James H. Breasted in 1948, quoted in Behner, PhD diss., 52.

44 Behner, PhD diss., 54.

45 Unless otherwise noted, all comments attributed to Mia Frost come from a conversation with the author on August 11, 2006.

46 Unless otherwise noted, information and quotations from Henry T. Hopkins come from an interview by Joanne L. Ratner, July 1995, "A Life in Art: Henry T. Hopkins," vol. 1, oral history program, University of California, Los Angeles.

47 Betty Freeman, telephone conversation with the author, August 9, 2006.

48 Information and quotations from Betty Asher come from an interview by Thomas H. Garver, June 30 and July 7, 1980, Archives of American Art, Smithsonian Institution, Washington, D.C., www.aaa.si.edu/collections/oralhistories/transcripts/asher80.htm.

49 W. Osmun (senior curator of decorative arts), memo to Ken Donahue, Los Angeles County Museum of Art, May 11, 1966. The memo concerns three exhibitions proposed by Maurice Tuchman: *American Sculpture of the Sixties*, budgeted at $10,000; *Chaïm Soutine*, budgeted at $25,000; and *Robert Morris*, budgeted at $8,000.

50 See Hopkins, UCLA oral history, 110.

51 In his memo, Tuchman incorrectly identified Guston's *The Room* as "Room I" and mistakenly gave the year for Robert Irwin's untitled disc as 1966, when it was actually made from 1966 to 1967. These errors have been corrected in the bracketed text.

52 Artist Llyn Foulkes, collection file, Los Angeles County Museum of Art.

53 Alexis Smith, telephone conversation with the author, April 12, 2007.

54 Behner, PhD diss., 64.

55 See Behner, PhD diss., on William L. Pereira and Associates' many important projects, 125–27.

56 See Behner, PhD diss.

57 Program for the opening gala, Los Angeles County Museum of Art, March 31, 1965.

58 Ric Brown, "Outline of Statistics Concerning Art Museum Program," memo released on November, 8, 1965, the day that he announced his resignation as director of LACMA. The document also states that in its first seven months the museum produced 10 special exhibitions, published 7 catalogues, produced a handbook, an architectural guide to Southern California, 3 bulletins, and 7 monthly calendars. It presented 11 concerts, 17 scholarly lectures, and 15 film programs. Six hundred children had participated in its workshops and 1,500 employees from city and county schools received art education training at a special institute. The museum did this with a staff of 150, of which 133 were service staff and 17 were professional staff. At this time, the Met had a staff of more than 800 and the Cleveland Museum of Art, the National Gallery of Art, and MoMA each had staffs of about 300.

59 Helena Ku, "History Lessons: Interview with Rose Norton," *MSC Connection* (quarterly newsletter of LACMA's Museum Service Council) 40, no. 2 (Winter 2007): 5.

60 Mickie Berg, "Our Beginnings, Part 2," *MSC Connection* 40, no. 2 (Winter 2007): 4.

61 "Industrialist David E. Bright, Patron of the Arts, Dies at 57," *Los Angeles Times*, April 13, 1965.

62 For details of the arrangement with UCLA, see Cynthia Burlingham, "Creating the Murphy Sculpture Garden Collection," in *The Franklin D. Murphy Sculpture Garden at UCLA* (Los Angeles: Hammer Museum, 2007).

63 Ken Donahue, interview by George W. Goodwin, 1980, "Collections and Programs at the Los Angeles County Museum of Art," oral history program, University of California, Los Angeles, 146.

64 LACMA's exhibition records are inexact. Included in this count are shows focusing on the architecture of Rudolph Michael Schindler and the photography of Dorothea Lange.

65 Ric Brown, memo to the staff, Los Angeles County Museum of Art, November 8, 1965.

66 Ric Brown, news release issued upon his resignation from the Los Angeles County Museum of Art, November 8, 1965.

67 Typescript of *Artforum* editorial by Philip Leider from LACMA director's office files. "The Art Wagon," *The Nation*, December 13, 1965, 459–60.

68 Gifford Phillips, "The Community and the Museum," *Frontier* 17, no. 2 (1965): 13.

69 Peter Bart, "Museum on Coast Faces Big Protest," *New York Times*, November 12, 1965. The committee included the collectors and CAC members Monte Factor and Gifford Phillips, dealer Irving Blum, and *Artforum* publisher Charles Cowles, among others.

70 Peter Bart, "Museum on Coast Causing Concern," *New York Times*, November 30, 1965.

71 See Hopkins, UCLA oral history, 168.

72 Samara Whitesides, interview with the author, August 24, 2006.

73 Livingston co-organized this exhibition with Marcia Tucker, the founding director of the New Museum of Contemporary Art in New York, who at that time was a curator at the Whitney Museum of American Art.

74 Henry T. Hopkins, telephone conversation with the author, April 12, 2007.

75 *Back Seat Dodge* has rarely if ever been shown illuminated exclusively by its own headlights and one internal light, an oversight that has been rectified in Carol S. Eliel's exhibition *SoCal: Southern California Art of the 1960s and 70s from LACMA's Collection*, on view from August 19, 2007, to March 30, 2008.

76 Arthur Millier, "The Museum Gets Its Second Wind," *Los Angeles*, February 1967, 25. The description of the controversy is taken from Michele Urton's online exhibition *Ed Kienholz: Back Seat Dodge '38* at www.lacma.org.

77 Information on the history of the Ferus Gallery comes from Kirk Varnedoe, *Ferus* (New York: Gagosian Gallery, 2002), published on the occasion of the exhibition, on view from September 12 through October 19, 2002.

78 Weschler, *Seeing Is Forgetting the Name of the Thing One Sees*, 42.

79 Ibid., 46–47.

80 Amy Newman, *Challenging Art: Artforum, 1962–1974* (New York: Soho Press, 2000), 124.

81 Suzaan Boettger, "Behind the Earth Movers," *Art in America*, April 2004, 54.

82 Nicholas Wilder Gallery records, 1965–79, Archives of American Art, Smithsonian Institution, Washington, D.C., www.aaa.si.edu/collections.

83 Maurice Tuchman, introduction to *A Report on the Art and Technology Program of the Los Angeles County Museum of Art, 1967–1971* (Los Angeles: Los Angeles County Museum of Art, 1971), 14.

84 Jane Livingston, "James Lee Byars," in *Art and Technology*, by Tuchman, 58.

85 Ibid., 60.

86 Jane Livingston, "John Chamberlain," in *Art and Technology*, by Tuchman, 72.

87 Ibid.

88 Robert Irwin, conversation with the author, February 6, 2007.

89 Ibid.

90 Weschler, *Seeing Is Forgetting the Name of the Thing One Sees*, 124–31.

91 Unless otherwise indicated, Maurice Tuchman's comments come from an interview with the author on September 11, 2006.

92 Max Kozloff, "The Multimillion-Dollar Art Boondoggle," *Artforum*, October 1971, 76.

93 Robert Rauschenberg worked with Teledyne, an aeronautics company focused on developing new technologies. When he was lying on the beach, it occurred to him to use mud to reproduce the bubbling activity of the "paint pots" in Yellowstone National Park. The resulting work, *Mud-Muse*, was a 9 x 12 foot tank of mud activated by air ducts. A sound recording that mixed human noises with sounds from nature responded to the random action of the mud. Gail R. Scott, "Robert Rauschenberg," in *Art and Technology*, by Tuchman, 280–84.

 Robert Whitman worked with Philco-Ford to create an environment dealing with optics, in which mirrors were used to enhance the disorienting effects of different kinds of projections. Gail R. Scott, "Robert Whitman," in *Art and Technology*, by Tuchman, 340–50.

94 Tuchman, *Art and Technology*, 29.

95 Hilton Kramer, "'Art and Technology' to Open on Coast," *New York Times*, May 12, 1971.

96 Lou Danziger, email to the author, October 2, 2006.

97 Unless otherwise noted, Channa Davis Horwitz's comments come from a telephone conversation with the author on September 1, 2006.

98 James Agee, introductory essay, in *A Way of Seeing, by Helen Levitt* (Durham, NC: Duke University Press, 1989), x.

99 "Women Artists' Say," *Herald News* (Passaic, New Jersey), June 25, 1971.

100 Ann Sutherland Harris and Linda Nochlin, *Women Artists: 1550–1950* (Los Angeles: Los Angeles County Museum of Art; New York: Alfred A. Knopf, 1977), 8.

101 Kramer's articles for the *New York Times* included "'Art and Technology' to Open on Coast" on May 12, 1971, and "I Got My Inspiration at IBM" on May 23, 1971.

102 William Wilson, "'A&T' Catalog Paints Picture of Struggle," *Los Angeles Times*, August 8, 1971.

103 Tuchman, acknowledgments, in *Art and Technology*, 7. In addition to being a critic, Antin was the director of the art gallery at the University of California, San Diego, at the time. Tuchman states that Antin was commissioned by Viking Press in January 1968 to write a book about LACMA's art and technology program.
 David Antin, "Art and the Corporations," *Art News*, September 1971, 23.

104 Jack Burnham, "Corporate Art," *Artforum*, October 1971, 66.

105 Kozloff, "The Multimillion-Dollar Art Boondoggle," 76.

106 One source for the second version of events is Mario Joseph Ontiveros, "Reconfiguring Activism: Inquiries into Obligation, Responsibility, and Social Relations in Post-1960s Art Practices in the United States" (PhD diss., University of California, Los Angeles, 2005), 97–98. Thanks to LACMA assistant curator for American art Rita Gonzalez for pointing this out.

107 Patricia Nauert, memo to the Modern Art Department, Los Angeles County Museum of Art, June 1, 1974.

108 Jane Livingston, memo to Nauert, June 6, 1974.

109 Hal Glicksman said of the demise of the Pasadena Art Museum: "It was before MOCA, so there was nothing . . . in contemporary art except the County Museum. Well, they have a tough time showing enough of anything, especially contemporary art, and Maurice had already been sort of boxed in a corner as his plans to do certain shows were thwarted, and he was taking a more or less safe course, not showing anything too daring." Glicksman, interviewed by Joanne L. Ratner, 1988, "Pasadena Art Museum Oral History Transcript," oral history program, University of California, Los Angeles.

110 Lynn Zelevansky, "Interview with Ed Ruscha," in *Magritte and Contemporary Art: The Treachery of Images* (Los Angeles: Los Angeles County Museum of Art; Brussels: Ludion, 2006), 143.

111 It should be noted that the UCLA art galleries also had a significant place in the Los Angeles art scene of the 1950s and 1960s. Under the leadership of Frederick Wight, who had been the associate director of Boston's Institute of Contemporary Art from 1953 to 1973, the university presented exhibitions of work by artists such as Charles Sheeler (1954), Morris Graves (1956), Hans Hofmann (1957), Arthur Dove (1959), Jacques Lipchitz (1963), Stuart Davis (1965), and George Rickey (1971). See Burlingham, "Creating the Murphy Sculpture Garden Collection."

112 Businessman Harold S. Jurgenson, who owned a chain of gourmet wine and grocery stores, supported the building plan, as did Robert Rowan, who "took charge of the project in 1965, with a vision of transforming the Pasadena Art Museum into a major showcase for contemporary art." Muchnic, *Odd Man In*, 104–5.

POLLY APFELBAUM *Black Flag,* 2002

113 Muchnic, *Odd Man In,* 207–10.

114 Maurice Tuchman, "Conditions for Annex of Pasadena Art Museum by County," memo, Los Angeles County Museum of Art, March 12, 1971.

115 Muchnic, *Odd Man In,* 207–10.

116 In the exhibition catalogue, Maurice Tuchman describes Environmental Communications as "a small group of Los Angeles photographers, videotapers, researchers, and editors." It was founded in 1969 by David Greenberg. "With a passion verging on obsession this talented group has documented the visuals of Los Angeles lifestyles in a manner almost archaeological in intent," Tuchman said. Maurice Tuchman, "Environmental Communications Looks at Los Angeles" and foreword, in *California: 5 Footnotes to Modern Art History,* ed. Stephanie Barron (Los Angeles: Los Angeles County Museum of Art, 1977), 96, 9.

117 Ken Donahue, memo to Ernest E. Debs, August 20, 1973. Donahue explained that he had approved Tuchman's two-month trip to Europe so that the curator could investigate what was happening there in the field of modern art, look for works that others might purchase for the museum (at the time, LACMA did not use museum funds to acquire contemporary European works), and research the collection for a revision to the museum handbook. While away, Tuchman received his salary but no additional county funds for travel expenses. Tuchman's leaves apparently continued, as Stephanie Barron remarked on their persistence during her twenty years of working with Tuchman. Barron, interview with the author, September 22, 2006.

118 Ken Donahue, memo to Maurice Tuchman, Los Angeles County Museum of Art, October 8, 1973.

119 Ken Donahue, memo to Tuchman, June 10, 1974.

120 Maurice Tuchman, memo to Donahue, June 13, 1974.

121 Clark Potak's articles on Tuchman and LACMA appeared in the *Los Angeles Free Press* between January and July 1975.

122 *Art Letter* 4, no. 2 (February 1975): 5.

123 "Tuchman 'Honorarium' Seen as Unethical But Not Illegal," *Los Angeles Free Press,* July 11–17, 1975.

124 Richard E. Sherwood (LACMA trustee), memo to Tuchman, July 1975.

125 Unless otherwise noted, all comments and quotations attributed to Howard N. Fox are from an interview with the author on August 30, 2006.

126 These numbers are approximate because they are based on the records of works attributed to LACMA's Modern or Twentieth-Century Art Department in the museum's online collections database. A few works included are multiples that would more commonly be listed under LACMA's Prints and Drawings Department. By the same token, some works that could reasonably be considered the purview of Contemporary Art may have ended up in the lists of other museum departments. In addition, the question of which artists are nationally and/or internationally influential, whether from Los Angeles or elsewhere, is a subjective one.

127 The first part of *Los Angeles Prints, 1883–1980, Los Angeles Prints, 1883–1959,* was curated by Ebria Feinblatt and opened the previous September.

128 See Deborah Caulfield, "County Art Exhibits Protested," *Los Angeles Times,* July 17, 1981; Lennie La Guire, "Making Faces to Protest a 'Discriminatory' Art Exhibit," *Los Angeles Herald Examiner,* July 16, 1981.

129 Howard N. Fox, "Tremors in Paradise, 1960–1980," in *Made in California: Art, Image, and Identity, 1900–2000,* by Barron et al., 229–33.

130 Stephanie Barron, interview with the author, September 22, 2006.

131 Marcia S. Weisman, "Collecting, Sharing, and Promoting Contemporary Art in California: Marcia S. Weisman," 1983, oral history program, University of California, Los Angeles, 223.

132 Ibid., 221.

133 Ibid., 214.

134 Koshalek was deputy director and chief curator at MOCA from 1980 to 1982 and director from 1982 to 1998. Unless otherwise noted, his comments come from an interview with the author on September 22, 2006.

135 Stephanie Barron, interview with the author, August 22, 2006.

136 See www.moca.org. In 1989 the Los Angeles Percent for Art Program was placed under the jurisdiction of the Cultural Affairs Department. See www.cac.ca.gov/90/.

137 Stanley Grinstein, interview with the author, September 5, 2006.

138 It is a measure of Rita Schreiber's disenchantment with LACMA that she bequeathed their most important modern works—a 1926 Picasso, a 1927 Brancusi *Bird in Flight,* and a 1940 Matisse—to the National Gallery of Art; she left SFMoMA a 1910 cubist Braque and a 1969 Calder stabile. The Los Angeles museum, where Taft had been a trustee, received a 1918 Jacques Lipchitz sculpture, a 1947 work on paper by Morris Graves, and a 1969 Josef Albers *Homage to the Square,* all promised many years before.

139 Mia Frost, handwritten preparatory notes for a special board meeting on Saturday, January 20, 1979, at Ed Carter's home. All information on the firing of Donahue comes from a file given to the author by Frost.

140 Ibid.

141 Pratapaditya Pal, memo to Ken Donahue, Los Angeles County Museum of Art, September 27, 1976 (Chris Burden permanent collection object file).

142 Frost, handwritten preparatory notes for special board meeting, January 20, 1979.

143 Barron, interview with the author, September 22, 2006.

144 Rusty Powell, telephone interview with the author, December 4, 2006.

145 Behner, PhD diss., 65, 83, 122. In January 1988, industrialist and LACMA trustee Armand Hammer broke a seventeen-year agreement with LACMA, reneging on a promise to give his $250 million collection to the museum. Hammer claimed that the museum lacked the space for his artworks. Director Rusty Powell responded, "We have had a constant dialogue with him and his staff over the years [concerning space allotment]. It's a fallacy that there is not enough space." An anonymous source from the museum claimed that Hammer had demanded his own curator, who would report to his foundation rather than the museum's director, and that his works be displayed together, separate from the rest of the museum's old masters collection. He wanted donor names removed from the galleries that housed his collection, and there were reports that Hammer required that life-size pictures of him and his wife be placed in the entry to his galleries. When LACMA balked, he unveiled plans for a $30 million museum for his collection in the building that headquartered his Occidental Petroleum Corporation. See Suzanne Muchnic, "Hammer Will Build His Own Museum for Art Collection," Los Angeles Times, January 22, 1988. Hammer formally resigned from LACMA's board of trustees on June 1, 1989.

146 Behner, PhD diss., 84–85.

147 All information on the HHPA master plan comes from "Los Angeles County Museum of Art Project Summary/Scope of Work," a report prepared by Hardy Holzman Pfeiffer Associates, November 1, 1988. It is curious that the report is dated after the building opened, but it may have been formally written in preparation for the fund-raising necessary for later phases of the building project.

148 Suzanne Muchnic, "New L.A. Museums—The Impossible Dream?" Artweek, September 15, 1979, 2.

149 Earl A. Powell III, introduction to The Robert O. Anderson Building (Los Angeles: Los Angeles County Museum of Art, 1986), 7.

150 Leon Whiteson, article in Los Angeles Herald Examiner, December 1, 1985.

151 Paul Goldberger, "New Wing Conquers Los Angeles County Museum," New York Times, November 16, 1986.

152 William Wilson, "A Place for Modern Art to Hang Out," Los Angeles Times, calendar section, November 16, 1986.

153 Christopher Knight, "Split Decision on LACMA's New Addition," Los Angeles Herald Examiner, November 19, 1986.

154 Stephanie Barron, telephone conversation with the author, June 6, 2007.

155 Jane Livingston, telephone conversation with the author, September 9, 2006.

156 In the first months of his tenure, Fox telephoned the collector Robert Rowan and asked to see his art, a request that was denied simply because Fox worked with Tuchman.

157 Howard N. Fox, introduction to Avant-Garde in the Eighties (Los Angeles: Los Angeles County Museum of Art, 1987), 24.

158 Thomas Lawson, "Reheating the Avant-Garde," L.A. Weekly, May 18, 1987, 30.

159 William Wilson, "Eye to Eye with the Avant-Garde," Los Angeles Times, May 3, 1987.

160 Press release for Andrew Wyeth: The Helga Pictures, exhibition on view from April 28 to July 10, 1988.

161 See Lynn Zelevansky, "A Place in the Sun: The Los Angeles Art World and the New Global Context," in Reading California: Art, Image, and Identity, 1900–2000, ed. Stephanie Barron, Sheri Bernstein, Ilene Susan Fort (Los Angeles and Berkeley: Los Angeles County Museum of Art and University of California Press, 2000), 296.

162 All comments by Barbara Kruger come from a telephone conversation with the author, January 19, 2007.

163 Howard N. Fox, Robert Longo (Los Angeles: Los Angeles County Museum of Art; New York: Rizzoli, 1989), 41.

164 Peter Plagens, "What Makes Longo Run?" Newsweek, October 23, 1989, 80.

165 Roberta Smith, "Once a Wunderkind, Now Robert Long Ago?" New York Times, October 29, 1989.

166 Suzanne Muchnic, "County Art Museum Fills Director Post," Los Angeles Times, August 27, 1992.

167 For example, Christopher Knight wrote of Rich's becoming director (as well as president) of LACMA: "The new director follows predecessors who each claimed advanced degrees in art history, as well as extensive curatorial experience in the museum field. Rich has neither. A backdoor revolution has thus been completed, as a nonprofessional board has now replicated itself at the staff level." He added, "Rich cannot be expected to evaluate LACMA's artistic program . . . Art is not her field. Nor can she assess with any credibility the artistic success or failure of the museum's curatorial team, even though she's its boss. Yet any smart manager finally knows that if the person at the top can't knowledgeably defend the integrity of the institution's professional standards, it suffers a serious weakness." Christopher Knight, "Commentary: Who Should Run an Art Museum?" Los Angeles Times, calendar section, September 10, 1999.

168 The first nonmodern, noncontemporary exhibition in the space was Donato Creti: Melancholy and Perfection, which was coordinated by the museum's European Painting and Sculpture Department. The exhibition had been organized by the Musei Civici d'Arte Antica di Bologna in Italy and had traveled to the Metropolitan Museum of Art before coming to LACMA, where it was on view from February 12 through April 12, 1999.

169 See, for example, Howard N. Fox, "The Right to Be Wrong," in Collecting the New, ed. Bruce Altshuler (Princeton, NJ: Princeton University Press, 2005), 22.

170 Roberta Smith, "Memo to Art Museums: Don't Give Up on Art," New York Times, December 3, 2000. David Littlejohn, "Made in California," Wall Street Journal, December 8, 2000.

171 "The Season's Best," Wall Street Journal, December 8, 2000.

172 Dave Hickey, "Beyond Geometry: Experiments in Form, 1940s–70s," Artforum, November 2004. Michael Kimmelman, "Modernism Wasn't So American After All," New York Times, weekend arts section, July 2, 2004.

173 "Sacro e Profano: Transforming LACMA," At LACMA, Summer 2004, 6.

A museum is more than an immediate housing for cultural artifacts. And it is more than a local architectural expression of form balanced by function. Beyond the rooms and buildings, a museum is engaged in an unspoken interaction with faraway places, connected to the rest of the landscape of the world through the translocation of its physical constituents.

The Broad Contemporary Art Museum came from the earth, just as, one day, it will return.

By tracking down the terrestrial sources for the building's primary construction materials, we find that this museum has touched the ground in a constellation of places. Material trucked off-site helped to make mountains in landfills, and excavation sites in a number of states and two countries were altered and enlarged for the raw materials that make up the building's floors, walls, and roof.

In its construction the museum has engaged in a dialogue with the ground, forming a network of incidental earthworks across the land.

For every pile there is a pit, for every pit there is a pile. For every heap of architecture, there is a terrestrial void.

PUENTE HILLS LANDFILL, WHITTIER, CALIFORNIA, 2007
Puente Hills is one of three landfills where soil from the construction site was taken,
including the remains of South Ogden Drive, which cut through the site (the other
landfills are Chiquita landfill, near Valencia, and the Central Coast Remedial Resources
landfill in Santa Maria, California). The material was considered "nonhazardous"
but was tainted by hydrocarbons, such as the asphalt from the dug-up street and
the tar seeps that are prevalent in the ground of the site. Puente Hills receives a third
of the waste generated in Los Angeles County, and is one of the largest landfills in
the nation.

AZUSA QUARRY, AZUSA, CALIFORNIA, 2007
The concrete used for the foundation, parking garage, and floors of the museum
came from a number of local batch plants operated by the Cemex company.
The aggregate (crushed rock, gravel, and sand—the primary constituent of concrete)
used by these plants at the time the deliveries were made came from Cemex's
Azusa quarry, east of Los Angeles. The Azusa quarry is one of several in the region
around Irwindale, the primary source for aggregate in the Los Angeles basin. The
Azusa quarry was started in 1941; it is 315 feet deep and nearly a square mile in size.

BLACK MOUNTAIN QUARRY, SAN BERNARDINO COUNTY, CALIFORNIA, 2007
Cement, the other main ingredient of concrete, binds aggregate together when mixed with water. The cement for the concrete used in the museum came from the Black Mountain quarry, in the desert north of Victorville, California. Hidden from the highway by a hill, this quarry, and the on-site plant, is one of the largest cement production sites in the nation. Limestone is blasted out of the earth here and ground up into a powder, which is cooked and mixed with other ingredients to make dry cement.

FISH CREEK QUARRY, IMPERIAL COUNTY, CALIFORNIA, 2007
Operated by U.S. Gypsum, this mine was the source of the gypsum for the wallboard
used to make the interior walls of the museum. The wallboard was assembled at
a plant at Plaster City, connected to the quarry by a dedicated narrow-gauge rail-
way twenty-six miles long, the last one in commercial use in the country. Gypsum is
removed from the ground by blasting, using a combination of ammonium nitrate and
diesel fuel. This quarry and plant produce more than half of the wallboard sold
in Southern California. It is located in the southeastern part of the state, next to Anza
Borrego State Park.

GENERAL IRON INDUSTRIES, CHICAGO, ILLINOIS, 2007
The steel beams that make up the structural skeleton of the museum were
fabricated by companies in the Inland Empire, east of Los Angeles, using steel that
was manufactured in the Nucor-Yamato steel mill in Blytheville, Arkansas. The
source of the steel manufactured by Nucor-Yamato was scrap, provided by numerous
suppliers collecting scrap metal from nearly a third of the nation, from Texas
to Illinois. One of the largest suppliers for the plant is General Iron Industries, on
the north side of Chicago. Consumer and commercial waste, including cars,
appliances, and former building materials, are ground up here and shipped to
Arkansas on barges traveling on the Ohio and Mississippi rivers.

U.S. SILICA QUARRY, ROCKWOOD, MICHIGAN, 2007
The large windows and the glass roof of the museum were built at a fabrication
shop in Wisconsin, using specialty glass made at a PPG plant in Carlisle, Pennsylvania.
Most (73 percent) of this type of glass is composed of silicon dioxide, using a sand
that is excavated from a pit next to the Huron River, south of Detroit, Michigan, oper-
ated by the U.S. Silica Company.

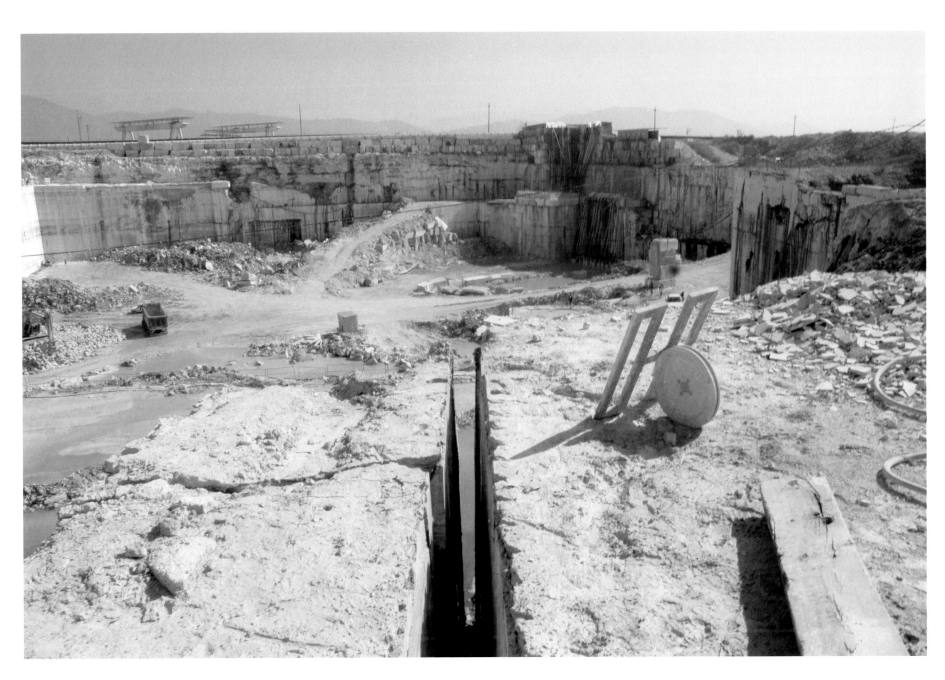

BRUNO POGGI & SONS QUARRY, BAGNI DI TIVOLI, ITALY, 2007
The skin of the museum is facing stone, cut from a quarry twenty miles east of
Rome, Italy. The quarry is one of several in this district, near Tivoli, the source
of Roman travertine for more than two thousand years. Another nearby quarry,
the Mariotti Company quarry, supplied the stone for the skin of the Getty Center.
And from another, long ago disappeared, came the walls of the Colosseum.

THE BCAM PHOTOGRAPHY PROJECTS

MICHELE URTON

When the contents of this volume were first mapped out, in the spring of 2006, the notion of incorporating some unique element that would underscore and celebrate the theme of contemporary art at LACMA quickly led to the idea of commissioning local artists to respond to—"document" in their own terms—the building project with original photographic portfolios created especially for the book. Within a few days a master list of forty or so candidates had emerged, and quite naturally this list was whittled down to the four you see here.

Although an architectural photographer had been considered, there was no desire to produce simply another book about a building. As Renzo Piano and Eli Broad recount in the interview herein, the Broad Contemporary Art Museum was designed not as an architectural showpiece but entirely in the service of its contents—"85 percent for art," as they put it. And since the core of the book—Lynn Zelevansky's pathbreaking essay on the history of contemporary art at LACMA—brought the story up to the present, we wanted something that would capture the moment itself in more intimate terms than straight architectural photography could manage. As Piano says, "Architecture is about human beings, it's about climate, it's about air, vibration, and song. It's about metaphor, it's about illusion, it's about technique. It's about science." We feel that the four portfolios here—by focusing not on the building qua building but on its phenomenological, metaphysical, archaeological underpinnings as comprehended by art—richly convey what Piano had in mind.

Uta Barth, best known for photographing domestic interiors, agreed to work in a public building that, still under construc-tion, offered little in the way of walls or windows. Barth is deeply committed to the exploration of perception, and to instilling in viewers an awareness of the experience of seeing. She often explores these ideas in images of things that exist at the periph-ery of consciousness. The paired photographs presented here are of a bit of transient sunlight falling on the floor of the unfin-ished BCAM building. The light shifts slightly from one image to the other, implying a sequence, but it's impossible to know which picture came first. A vertical support pole of some kind on the right side of the pictures is the only physical reference point; the place itself is undefined. There is something familiar in the nature of the light, however, that communicates a bit of what it felt like to be there, on a spring day in 2007, taking the photograph.

Situated somewhere between filmmaker and documentary photographer, Sharon Lockhart often photographs workers inhabiting their environments, forming a relationship with them that allows her subtly to guide the activity within the frame. When she first visited the BCAM construction site in the late summer of 2006, her interest was piqued by the arch-aeologists at work in the vast hole that would become LACMA's underground parking lot. The rich soil, blackened by tar, provided a stark contrast to the shapes of workers crouched in roped-off pits slowly excavating the bones of myriad fossils. Lockhart proposed a short series of images that would document the excavation.

In the end, she had to rethink her idea to accommodate changes in the construction schedule. The fossils needed to be cleared from the pit quickly. Concentrated bone deposits were

identified and dug out, dirt and all, then boxed, strapped, and craned out of the pit, with their original coordinates painted on the box exteriors for identification.

When Lockhart returned to the site in early spring 2007, the original pit was gone, now replaced by the covered underground parking lot that was near completion. Instead of a rich subterranean background, the artist encountered enormous boxes of earth, some weighing more than sixty tons, that required ladders to access. Lockhart worked with a lift operator to gain views of the archaeological activity within. A full week of improvisation led to her final portfolio, three images that are at once subtle studies and grand cinematic gestures.

The Center for Land Use Interpretation (CLUI), founded in 1994 by Matthew Coolidge, takes a broadly interdisciplinary approach to the investigation of land use, weaving together strands from science, sociology, art, architecture, and history. The Center, headquartered in Los Angeles, has produced exhibits on a diverse range of land-use themes and also operates a network of regional interpretive sites across the country, including Robert Smithson's renowned earthwork *Spiral Jetty* (1970) on the Great Salt Lake in Utah. A research organization "interested in understanding the nature and extent of human interaction with the earth's surface," CLUI also operates in the realm of conceptual art. Thus, the accompanying text is a critical component of their portfolio for this book. By photographing one of the landfills where material removed from the building site went, and the far-flung quarries, mines, and recycling plants from which raw building materials came, the center highlights the literal way in which human constructions come from (and return to) the earth.

CLUI refers to the transformed sites they document as "incidental earthworks," which underscores the concerns they share with artists of the late 1960s and early 1970s who used landforms and their displacement as a medium for sculpture. Although the Center uses academic language, and its images often resemble scientific documentation, their compositions capture the power of the landscape in the manner of artists such as Smithson, Michael Heizer, Walter de Maria, and Dennis Oppenheim, who challenged the definition of art by expanding the scale of their work beyond what can fit in museums.

Los Angeles native Anthony Hernandez has been a longtime observer of the city, documenting everything from busy Beverly Hills intersections to homeless encampments under freeway overpasses. His photographs often capture urban environments transformed by human inhabitants who are distinctly absent from the images. For this project Hernandez visited the construction site on weekends over a six-month period, each time exploring the entire area, from the unlit underground parking lot to the building's top floor. At first the open beams framed views of the Hollywood Hills to the north and endless blue sky to the south. As the walls went up, glistening metal ductwork and thick ropes of wire appeared and were quickly installed; enormous crates of glass and stone were delivered and staged near the building, their installation carried out at a slower pace. In the end, the portfolio that Hernandez created signaled a marked departure for him— abstract construction details surrounded by the blue California sky. All of the surfaces seen in these works were in the end hidden from view. They represent isolated moments in the trajectory of the building—a project that will continue to be shaped and transformed by use. Hernandez has always investigated the fluid, transformative nature of place in his photographs, and though this series has a different aesthetic than previous work, it shares that concern.

These four portfolios offer unique perspectives of the process of erecting a new museum building and represent LACMA's continuing commitment to the contemporary art of the region. We thank Uta Barth, Sharon Lockhart, the Center for Land Use Interpretation, and Anthony Hernandez for their contributions.

223

ACKNOWLEDGMENTS

History may look back on this first phase of LACMA's Transformation campaign and the opening of the Broad Contemporary Art Museum as the most significant events in this institution's life since it was physically established forty-three years ago on Wilshire Boulevard, thanks to the cultural foresight and commitment of Los Angeles County and a handful of L.A. patrons including the Ahmanson Foundation, the Bing family, and visionary leaders such as Franklin Murphy.

A project of this scale and importance to the community requires the tireless commitment and efforts of scores of people—everyone from the County Supervisors to the art handlers who installed the works in the galleries. However, the enormous gratitude of the Los Angeles County Museum of Art, along with the local, national, and international art world, the Los Angeles public, and the museum's many visitors from around the United States and abroad are due first and foremost to Eli and Edythe Broad. The Broads have not only assembled one of the foremost collections of contemporary art in the world, they have consistently shared it through the lending practices of The Broad Art Foundation. Longtime donors to many civic causes, they have now made one of the most sizable investments to date in the Los Angeles County Museum of Art. Not only have they built the beautiful Broad Contemporary Art Museum—LACMA's first building devoted exclusively to the art of our times—and provided a large contribution for acquisitions, they have also lent more than two hundred works to this opening installation, and committed to having a substantial representation of works on view here into the future. We all owe them a huge debt of gratitude.

I am personally very grateful for the overwhelming support and encouragement we've received from the Board of Trustees. In particular I would like to thank the early campaign contributors and Phase One donors who provided substantial support, including the Ahmanson Foundation, Wallis Annenberg, Kathy and Frank Baxter, the Anna H. Bing LACMA Trust, MaryLou and George Boone, Suzanne and David Booth, the County of Los Angeles, Kelly and Robert Day, Camilla Chandler Frost, Joan and John Hotchkis, Judy and Steaven Jones, Dona and Dwight Kendall, Nina and Bobby Kotick, Yvonne Lenart, Leza and Eric Lidow, Mary and Robert Looker, Rob Maguire, the Andrew W. Mellon Foundation, Jane and Marc Nathanson, Peter Norton, Lynda and Stewart Resnick, Nancy Daly-Riordan, Terri and Michael Smooke, Eva and Marc Stern, the Joan E. Tanney Trust, Sandy and Jack Terner, Chris Walker, Laura and Casey Wasserman, and Sheila and Wally Weisman. I am also grateful to BP, an early donor to LACMA's campaign who later made a significant contribution by naming the Grand Entrance through an extraordinary gift of corporate philanthropy. Special thanks go to Jane Nathanson for the time and energy she spent chairing the gala host committee, and to Lynda and Stewart Resnick for the wonderful invitation they produced and their early support for the first phase of the campaign.

The LACMA Transformation project was launched under the leadership of Andrea Rich, LACMA's President and CEO from 1995 to 1999 and its President and Director from 1999 to 2005. Her conversations and collaboration with Eli Broad initiated this very ambitious undertaking. I would also like to thank Wally Weisman, Chairman of the Board, and Christopher Walker, Chair of the Finance Committee, for their hard work and intelligent guidance during the early days of this project.

When it came to choosing an architect for BCAM, Eli always wanted Renzo Piano to design the building, and it was he who convinced this world-renowned architect to take on the project. There is a reason that Piano is the most sought-after architect for museums today. He has not only given us an elegant and functional space for art, but also set a path toward unifying LACMA's highly diverse campus—no small feat.

A number of artists have complemented Piano's vision for LACMA, helping to shape the new environment. John Baldessari produced the artful banners that hang on the Wilshire Boulevard

ANTHONY HERNANDEZ

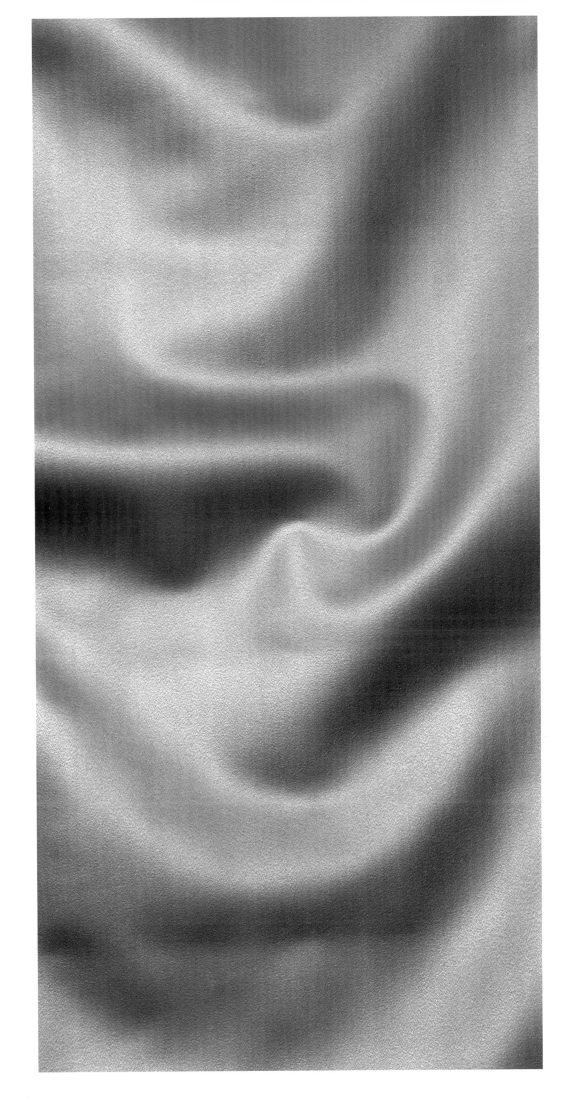

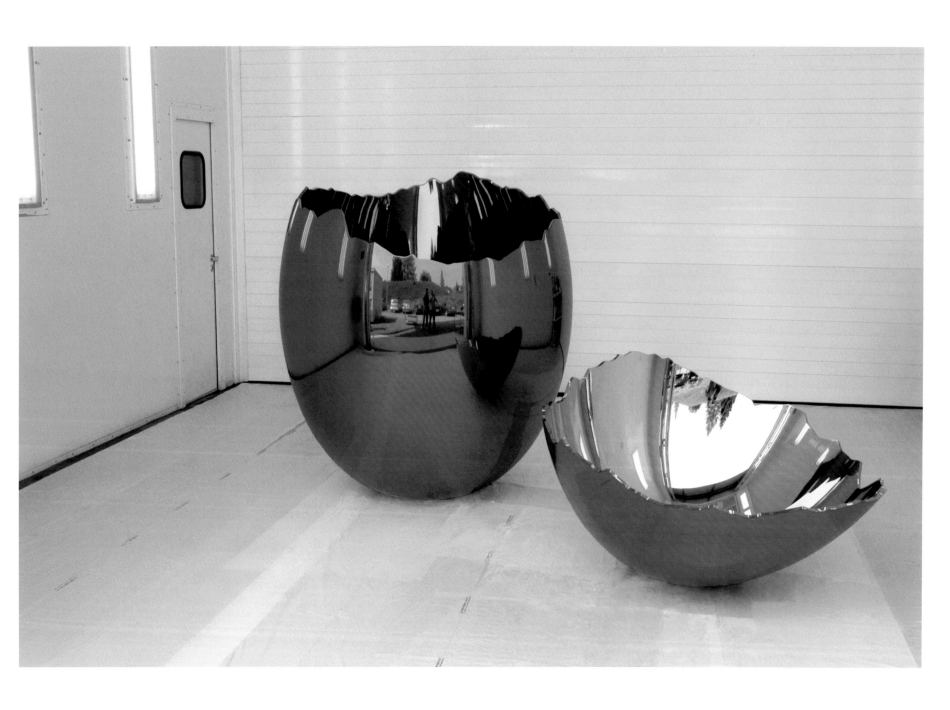

JEFF KOONS *Cracked Egg (Red)*, 1994–2006

LIST OF
ILLUSTRATED
ARTWORKS

JOSEF ALBERS
Germany, 1888–1976, active United States
Homage to the Square, 1951
Oil on Masonite
33 ¹/₂ x 33 ¹/₂ in. (85.1 x 85.1 cm)
Los Angeles County Museum of Art, Museum Associates
Purchase Award
M.51.5.5

ELEANOR ANTIN
United States, b. 1935
100 BOOTS MOVE ON, *100 BOOTS IN THE MARKET*, and *100 BOOTS TURN THE CORNER*, from *100 BOOTS*, 1971–73
Fifty-one black-and-white picture postcards
4 ¹/₂ x 7 in. (11.4 x 17.8 cm) each
Los Angeles County Museum of Art, purchased with funds provided by the Richard and Hinda Rosenthal Foundation, the Modern and Contemporary Art Council, the Nathan B. Cooper Memorial Fund, Sherry and Michael Kramer, and David and Suzanne D. Booth
M.2000.55.1–.51

POLLY APFELBAUM
United States, b. 1955
Black Flag, 2002
Synthetic crushed velvet and dye
Dimensions variable
Los Angeles County Museum of Art, purchased with funds provided by David and Susan Gersh, Barry and Julie Smooke, Mark and Ellie Lainer, Tina Petra and Ken Wong, Patricia and Stanley Silver, and others through the Modern and Contemporary Art Council
M.2005.126

JOHN BALDESSARI
United States, b. 1931
Black and White Decision, 1984
Two gelatin silver prints
Overall: 64 x 70 ³/₄ in. (162.6 x 179.7 cm)
The Broad Art Foundation, Santa Monica

Buildings=Guns=People: Desire, Knowledge, and Hope (with Smog), 1985/2007
Color photographs and black-and-white photographs with oil tint and vinyl paint mounted on 5 panels
Overall: 185 x 446 ¹/₄ x 2 ³/₄ in. (469.9 x 1133.5 x 7 cm)
The Broad Art Foundation, Santa Monica

JEAN-MICHEL BASQUIAT
United States, 1960–1988
Untitled, 1981
Acrylic and mixed media on canvas
81 x 69 ¹/₄ in. (205.7 x 175.9 cm)
The Eli and Edythe L. Broad Collection, Los Angeles

LARRY BELL
United States, b. 1939
Cube, 1966
Vacuum-coated glass
12 ¹/₈ x 12 ¹/₈ x 12 ¹/₈ in. (30.8 x 30.8 x 30.8 cm)
Los Angeles County Museum of Art, gift of the Frederick R. Weisman Company
M.82.112.2

GEORGE BELLOWS
United States, 1882–1925
Cliff Dwellers, 1913
Oil on canvas
40 ¹/₄ x 42 ¹/₈ in. (102.2 x 107 cm)
Los Angeles County Museum of Art, Los Angeles County Fund
16.4

JOSEPH BEUYS
Germany, 1921–1986
Sled, 1969
Wooden sled, felt, belts, flashlight, fat, and rope; sled stamped with oil paint (Browncross)
13 ³/₄ x 35 ³/₈ x 13 ³/₄ in. (34 x 89.9 x 34 cm)
The Broad Art Foundation, Santa Monica

La rivoluzione siamo noi, 1972
Phototype on polyester sheet, with handwritten text, stamped
75 ¹/₄ x 39 ³/₈ in. (190.8 x 100 cm)
The Broad Art Foundation, Santa Monica

ROSS BLECKNER
United States, b. 1949
Unknown Quantities of Light (Part IV), 1988
Oil on canvas
108 x 144 in. (274.3 x 365.8 cm)
The Broad Art Foundation, Santa Monica

MEL BOCHNER
United States, b. 1940
Language Is Not Transparent, 1970
Chalk on paint and wall
72 x 48 ¹/₄ in. (182.9 x 122.6 cm)
Los Angeles County Museum of Art, Modern and Contemporary Art Council Fund
M.2004.61

ALIGHIERO BOETTI
Italy, 1940–1994
Mappa, 1979
Cotton muslin and cotton embroidery floss
48 ³/₈ x 69 x 2 in. (122.9 x 175.3 x 5.1 cm)
Los Angeles County Museum of Art, purchased with funds provided by The Broad Contemporary Art Museum Foundation in honor of the museum's 40th anniversary
M.2005.129

CHRIS BURDEN
United States, b. 1946
Chris Burden Deluxe Photo Book 71-73, 1973
Artist's book
11 ³/₄ x 11 ¹/₂ x 2 ¹/₂ in. (29.8 x 29.2 x 6.4 cm)
Los Angeles County Museum of Art, Modern and Contemporary Art Council/New Talent Award
M.76.95

L.A.P.D. Uniforms, 1993
Fabric, leather, wood, metal, and plastic
88 x 72 x 6 in. (223.5 x 182.9 x 15.2 cm) each
Los Angeles County Museum of Art, Modern and Contemporary Art Council Fund
M.2000.151.1a–v–.4a–v

Urban Light, 2000–2007
Restored cast-iron streetlamps
Dimensions variable
Los Angeles County Museum of Art, made possible by the Gordon Family Foundation's gift to Transformation: The LACMA Campaign
M.2007.147

Bateau de Guerre, 2001
Metal gasoline cans, plastic toys, metal lamps, plastic crates, straw hat, metal framework, and 2 electric Erector motors
71 x 174 x 41 in. (180.3 x 442 x 104.1 cm)
The Broad Art Foundation, Santa Monica

INGRID CALAME
United States, b. 1965
Ffwsptffwsptffwspt, 2000
Enamel paint on aluminum
72 x 72 x 1 in. (182.9 x 182.9 x 2.5 cm)
Los Angeles County Museum of Art, purchased with funds provided by the Marvin B. Meyer Family Endowment in memory of Nan Uhlmann Meyer
M.2001.9

ALEXANDER CALDER
United States, 1898–1976
Hello Girls, 1964
Painted metal
Overall: 275 x 288 x 285 in. (698.5 x 731.5 x 723.9 cm)
Los Angeles County Museum of Art, Art Museum Council Fund
M.65.10

MAURIZIO CATTELAN
Italy, b. 1960, active United States
Hollywood, 2001
Chromogenic print
Framed: 69 ⁵/₈ x 157 ³/₄ in. (176.9 x 400.7 cm)
Los Angeles County Museum of Art, gift of William J. Bell
M.2007.117

JOHN CHAMBERLAIN
United States, b. 1927
Sweet William, 1962
Welded and painted metal on hardwood base
61 x 74 x 43 in. (154.9 x 188 x 109.2 cm)
Los Angeles County Museum of Art, gift of Mr. and Mrs. Abe Adler in memory of Mrs. Esther Steif Rosen through the Contemporary Art Council
M.63.58

241

CHUCK CLOSE
United States, b. 1940
Large Phil, 1979
Fingerprint and random stamp pad ink on canvas-backed paper
Framed: 60 1/2 x 43 1/2 x 2 in. (153.7 x 110.5 x 5.1 cm)
Los Angeles County Museum of Art, gift of Robert H. Halff
through the Modern and Contemporary Art Council
M.2005.38.16

ANDREW DASBURG
France, 1887–1979, active United States
Tulips, c. 1923–24
Oil on canvas
Framed: 35 x 23 in. (88.9 x 58.4 cm)
Los Angeles County Museum of Art, Los Angeles County Fund
25.7.2

RON DAVIS
United States, b. 1937
Roto, 1968
Polyester resin and fiberglass
62 x 136 in. (157.5 x 345.4 cm)
Los Angeles County Museum of Art, Contemporary Art
Council Fund
M.69.8

STUART DAVIS
United States, 1894–1964
Premiere, 1957
Oil on canvas
58 x 50 in. (147.3 x 127 cm)
Los Angeles County Museum of Art, Museum Purchase,
Art Museum Council Fund
M.60.4

WILLEM DE KOONING
Netherlands, 1904–1997, active United States
Montauk Highway, 1958
Oil and combined media on heavy paper mounted to canvas
59 x 48 in. (149.9 x 121.9 cm)
Los Angeles County Museum of Art, gift from the Michael
and Dorothy Blankfort Collection in honor of the museum's
25th anniversary
M.90.13

RICHARD DIEBENKORN
United States, 1922–1993
Ocean Park Series No. 49, 1972
Oil on canvas
93 x 81 in. (236.2 x 205.7 cm)
Los Angeles County Museum of Art, purchased with funds
provided by Paul Rosenberg & Co., Mrs. Lita Hazen, and
the David E. Bright Bequest
M.73.96

ERIC FISCHL
United States, b. 1948
Haircut, 1985
Oil on linen
104 x 84 in. (264.2 x 213.4 cm)
The Broad Art Foundation, Santa Monica

SAM FRANCIS
United States, 1923–1994
Toward Disappearance, 1957
Oil on canvas
114 x 169 1/4 in. (289.6 x 429.9 cm)
Los Angeles County Museum of Art, Modern and
Contemporary Art Council Fund
M.70.14

ROBERT GOBER
United States, b. 1954
Single Basin Sink, 1985
Plaster, wood, steel, wire lath, and semigloss enamel paint
24 x 90 x 27 in. (61 x 228.6 x 68.6 cm)
Los Angeles County Museum of Art, gift of Robert H. Halff
M.86.371

LEON GOLUB
United States, 1922–2004
White Squad V, 1984
Acrylic on linen
120 x 161 in. (304.8 x 408.9 cm)
The Broad Art Foundation, Santa Monica

PHILIP GUSTON
Canada, 1913–1980, active United States
The Room, 1954–55
Oil on canvas
Framed: 73 x 61 1/4 in. (185.4 x 155.6 cm)
Los Angeles County Museum of Art, Museum Purchase,
Contemporary Art Council Fund
M.63.36

HANS HAACKE
Germany, b. 1936, active United States
Oelgemaelde, Hommage à Marcel Broodthaers, 1982
Oil on canvas, stanchions with velvet rope, carpet,
and photomural
Overall: 209 x 348 in. (530.9 x 883.9 cm)
Los Angeles County Museum of Art, gift of The Broad Art
Foundation
M.2001.63a–f

DAVID HAMMONS
United States, b. 1943
Injustice Case, 1970
Body print (margarine and powdered pigments) and
American flag
Sheet: 63 x 40 1/2 in. (160 x 102.9 cm)
Los Angeles County Museum of Art, Museum Acquisition Fund
M.71.7

DAMIEN HIRST
England, b. 1965
Away from the Flock, 1994
Steel, glass, formaldehyde solution, and lamb
37 3/4 x 58 5/8 x 20 in. (95.9 x 148.9 x 50.8 cm)
The Broad Art Foundation, Santa Monica

The Kingdom of the Father, 2007
Butterflies and household gloss on 3 canvas panels
Right and left panel: 113 5/8 x 48 in. (288.6 x 121.9 cm) each;
middle panel: 115 7/8 x 96 1/8 in. (294.3 x 244.2 cm)
The Broad Art Foundation, Santa Monica

DAVID HOCKNEY
England, b. 1937, active United States
Mulholland Drive: The Road to the Studio, 1980
Acrylic on canvas
86 x 243 in. (218.4 x 617.2 cm)
Los Angeles County Museum of Art, purchased with funds
provided by the F. Patrick Burns Bequest
M.83.35

ROBERT IRWIN
United States, b. 1928
Untitled, 1966–67
Acrylic on aluminum wall-relief disc
Diameter: 54 in. (137.2 cm)
Los Angeles County Museum of Art, Museum Purchase,
Contemporary Art Council Fund
M.68.34

JASPER JOHNS
United States, b. 1930
Figure 7, 1955
Encaustic and collage on canvas panel
17 1/2 x 14 in. (44.5 x 35.6 cm)
Los Angeles County Museum of Art, gift of Robert H. Halff
through the Modern and Contemporary Art Council
M.2005.38.1

Watchman, 1964
Oil on 2 canvas panels with objects
85 x 60 1/4 in. (215.9 x 153 cm)
The Eli and Edythe L. Broad Collection, Los Angeles

Flag, 1967
Encaustic and collage on 3 canvas panels
Overall: 33 1/2 x 56 1/4 in. (85.1 x 142.9 cm)
The Eli and Edythe L. Broad Collection, Los Angeles

DONALD JUDD
United States, 1928–1994
Untitled (for Leo Castelli), 1977
Concrete
84 x 84 x 89 in. (213.4 x 213.4 x 226.1 cm) each
Los Angeles County Museum of Art, purchased with funds
provided by the Modern and Contemporary Art Council
and Robert H. Halff
M.78.26a–e

CRAIG KAUFFMAN
United States, b. 1932
Yellow Orange, 1965
Acrylic on Plexiglas
90 x 46 1/2 in. (228.6 x 118.1 cm)
Los Angeles County Museum of Art, Museum Purchase,
Contemporary Art Council Funds
M.66.1

Untitled Wall Relief, 1967
(no longer extant)
Acrylic lacquer on vacuum-formed Plexiglas
52 1/2 x 78 3/4 x 12 in. (133.4 x 198.8 x 30.5 cm)
Los Angeles County Museum of Art, gift of The Kleiner
Foundation
M.73.38.10

MIKE KELLEY
United States, b. 1954
Gym Interior, 2005
Mixed media with video projection
152 x 177 x 124 in. (386.1 x 449.6 x 315 cm)
The Broad Art Foundation, Santa Monica

ELLSWORTH KELLY
United States, b. 1923
Blue Yellow Red IV, 1972
Oil on 3 canvas panels
Overall: 43 x 42 in. (109.2 x 106.7 cm)
The Eli and Edythe L. Broad Collection, Los Angeles

EDWARD KIENHOLZ
United States, 1927–1994
Back Seat Dodge '38, 1964
Paint, fiberglass and flock, 1938 Dodge, recorded music
and player, chicken wire, beer bottles, artificial grass,
and cast plaster
66 x 120 x 156 in. (167.6 x 304.8 x 396.2 cm)
Los Angeles County Museum of Art, purchased with funds
provided by the Art Museum Council Fund
M.81.248a–e

YVES KLEIN
France, 1928–1962
Anthropometrie, 1962
Oil on paper
25 x 15 ¼ in. (63.5 x 38.7 cm)
Los Angeles County Museum of Art, Michael and Dorothy
Blankfort Bequest
AC1999.35.41

FRANZ KLINE
United States, 1910–1962
The Ballantine, 1958–60
Oil on canvas
72 x 72 in. (182.9 x 182.9 cm)
Los Angeles County Museum of Art, David E. Bright Bequest
M.67.25.20

JEFF KOONS
United States, b. 1955
Balloon Dog (Blue), 1994–2000
High chromium stainless steel with transparent color coating
121 x 143 x 45 in. (307.3 x 363.2 x 114.3 cm)
The Broad Art Foundation, Santa Monica

Cracked Egg (Red), 1994–2006
High chromium stainless steel with transparent color coating
Top: 18 x 48 x 48 in. (45.7 x 121.9 x 121.9 cm); bottom: 78 x 62 x 62
in. (198.1 x 157.5 x 157.5 cm)
The Broad Art Foundation, Santa Monica

Tulips, 1995–2004
High chromium stainless steel with transparent color coating
80 x 180 x 205 in. (203.2 x 457.2 x 520.7 cm)
The Broad Art Foundation, Santa Monica

BARBARA KRUGER
United States, b. 1945
Untitled (Your body is a battleground), 1989
Photographic screenprint on vinyl
112 x 112 in. (284.5 x 284.5 cm)
The Broad Art Foundation, Santa Monica

JOSÉ LEONILSON
Brazil, 1957–1993
Puros e Duros (Pure and Hard), 1991
Embroidery and stones on cloth
9 ½ x 7 ½ in. (24.1 x 19.1 cm)
Los Angeles County Museum of Art, gift of the Estate of José
Leonilson and purchased with funds provided by Gary and
Tracy Mezzatesta
AC1999.94.1

ROY LICHTENSTEIN
United States, 1923–1997
Black Flowers, 1961
Oil on canvas
70 x 47 ¾ in. (177.8 x 121.3 cm)
The Eli and Edythe L. Broad Collection, Los Angeles

Cold Shoulder, 1963
Oil on canvas
68 ½ x 48 in. (174 x 121.9 cm)
Los Angeles County Museum of Art, gift of Robert H. Halff
through the Modern and Contemporary Art Council
M.2005.38.5

I . . . I'm Sorry!, 1965–66
Oil and Magna acrylic on canvas
60 x 48 in. (152.4 x 121.9 cm)
The Eli and Edythe L. Broad Collection, Los Angeles

SHARON LOCKHART
United States, b. 1964
Ruby, 1995
Ektacolor print mounted on Gatorfoam board
Framed: 66 x 49 x 1 ¾ in. (167.6 x 124.5 x 4.4 cm)
Los Angeles County Museum of Art, gift of Peter Norton
M.2001.196.8

KERRY JAMES MARSHALL
United States, b. 1955
De Style, 1993
Acrylic and collage on canvas
104 x 122 in. (264.2 x 309.9 cm)
Los Angeles County Museum of Art, purchased with funds
provided by Ruth and Jacob Bloom
AC1993.76.1

TAKASHI MURAKAMI
Japan, b. 1962
PO + KO Surrealism (Green), 1999
Triptych; acrylic on canvas on board
Overall: 110 ½ x 165 x 2 in. (280.7 x 419.1 x 5.1 cm)
Los Angeles County Museum of Art, gift of Peter Norton
and Eileen Harris Norton, Santa Monica, in honor of the
museum's 40th anniversary
M.2005.137.2a–c

YOSHITOMO NARA
Japan, b. 1959
Black Dog, 1999
Fiberglass and high-gloss body paint
44 ½ x 60 x 40 in. (113 x 152.4 x 101.6 cm)
Los Angeles County Museum of Art, gift of Peter Norton
and Eileen Harris Norton, Santa Monica, in honor of the
museum's 40th anniversary
M.84.36

BRUCE NAUMAN
United States, b. 1941
Human Nature/Life Death/Knows Doesn't Know, 1983
Neon
107 ½ x 107 x 5 ⅞ in. (273.1 x 271.8 x 14.9 cm)
Los Angeles County Museum of Art, Modern and
Contemporary Art Council Fund
M.84.36

HÉLIO OITICICA
Brazil, 1937–1980
Seco No. 176, 1956
Gouache on cardboard
Image and sheet: 15 ¼ x 17 in. (38.7 x 43.2 cm)
Los Angeles County Museum of Art, purchased with funds
provided by the Modern and Contemporary Art Council,
JoAnn Busuttil, the American Art Deaccession Fund, and
anonymous donors
M.2005.62.3

Metaesquema No. 346, 1957–58
Gouache on cardboard
Image and sheet: 20 ½ x 25 in. (52.1 x 63.5 cm)
Los Angeles County Museum of Art, purchased with funds
provided by the Modern and Contemporary Art Council,
JoAnn Busuttil, the American Art Deaccession Fund, and
anonymous donors
M.2005.62.2

CLAES OLDENBURG
Sweden, b. 1929, active United States
Giant Pool Balls, 1967
Fiberglass and metal
Overall: 24 x 120 x 108 in. (61 x 304.8 x 274.3 cm)
Los Angeles County Museum of Art given anonymously
through the Contemporary Art Council
M.69.88a–q

GABRIEL OROZCO
Mexico, b. 1962, active United States
Lost Line, 1993–96
Plasticine and cotton string
Diameter: 19 in. (48.3 cm)
Los Angeles County Museum of Art, gift of the Peter Norton
Family Foundation
AC1996.109.1

NAM JUNE PAIK
Korea, 1932–2006, active United States
Video Flag Z, 1986
Television sets, videodiscs, videodisc players, and Plexiglas
modular cabinet
74 x 138 x 18 ½ in. (188 x 350.5 x 47 cm)
Los Angeles County Museum of Art, gift of the Art Museum
Council
M.86.156

LARI PITTMAN
United States, b. 1952
*This Wholesomeness, Beloved and Despised, Continues
Regardless*, 1989–90
Acrylic and enamel on 2 mahogany panels
128 x 96 in. (325.1 x 243.8 cm)
Los Angeles County Museum of Art, purchased with funds
provided by the Ansley I. Graham Trust
AC1995.185.1.1–.2

243

JACKSON POLLOCK
United States, 1912–1956
No. 15, 1950
Oil on Masonite
22 x 22 in. (55.9 x 55.9 cm)
Los Angeles County Museum of Art, Museum Associates
Purchase Award
M.51.5.7

KEN PRICE
United States, b. 1935
Duncan's Primaries, 1980
Earthenware
5 ⅝ x 8 ½ x 8 ½ in. (14.3 x 21.6 x 21.6 cm)
Los Angeles County Museum of Art, Modern and
Contemporary Art Council Fund
M.80.68

ROBERT RAUSCHENBERG
United States, b. 1925
Untitled (Red Painting), 1954
Combine painting: oil, fabric, and paper on canvas
70 ¾ x 48 in. (179.7 x 121.9 cm)
The Eli and Edythe L. Broad Collection, Los Angeles

Untitled, 1963
Oil and silkscreen ink on canvas
58 x 50 in. (147.3 x 127 cm)
The Eli and Edythe L. Broad Collection, Los Angeles

CHARLES RAY
United States, b. 1953
Firetruck, 1993
Painted aluminum, fiberglass, and Plexiglas
144 x 558 x 96 in. (365.8 x 1417.3 x 243.8 cm)
The Broad Art Foundation, Santa Monica

GERHARD RICHTER
Germany, b. 1932
48 Portraits, 1998
Forty-eight gelatin silver prints, mounted on aluminum
and transverse mounted onto Plexiglas, each with
accompanying nameplate
27 ⅛ x 21 ¼ x 1 in. (68.9 x 54 x 2.5 cm) each
Los Angeles County Museum of Art, purchased with funds
provided by Alice and Nahum Lainer, Marilyn and Calvin
Gross, Elyse and Stanley Grinstein, and Lynda and Stewart
Resnick through the 2001 Collectors Committee; Susan Bay-
Nimoy and Leonard Nimoy; and the Ralph M. Parsons
Discretionary Fund
M.2001.81.1–.48

MARK ROTHKO
Latvia, 1903–1970, active United States
White Center, 1957
Oil on canvas
84 x 72 in. (213.4 x 182.9 cm)
Los Angeles County Museum of Art, David E. Bright Bequest
M.67.25.21

ED RUSCHA
United States, b. 1937
Actual Size, 1962
Oil on canvas
67 ⅛ x 72 ⅛ in. (170.5 x 183.2 cm)
Los Angeles County Museum of Art, given anonymously
through the Contemporary Art Council
M.63.14

BLUE COLLAR TECH-CHEM, 1992
Acrylic on canvas
48 ⅝ x 109 ⅜ in. (123.5 x 277.8 cm)
The Broad Art Foundation, Santa Monica

THE OLD TECH-CHEM BUILDING, 2003
Acrylic on canvas
48 ½ x 109 ½ in. (123.2 x 278.1 cm)
The Broad Art Foundation, Santa Monica

RICHARD SERRA
United States, b. 1939
Band, 2006
Steel
153 x 846 x 440 in. (388.6 x 2148.8 x 1117.6 cm)
Los Angeles County Museum of Art, purchased with
funds provided by The Broad Contemporary Art Museum
Foundation
M.2007.122

PETER SHELTON
United States, b. 1951
Churchsnakebedbone, 1993
Bronze, water, copper, and pumps
80 x 77 x 38 in. (203.2 x 195.6 x 96.5 cm)
Los Angeles County Museum of Art, purchased with funds
provided by the Modern and Contemporary Art Council,
Carla Kirkeby, Robert and Mary Looker, and Bill Lucas
AC1997.31.1.1–.10

CINDY SHERMAN
United States, b. 1954
Untitled Film Still #54, 1980
Black-and-white photograph
8 x 10 in. (20.3 x 25.4 cm)
The Broad Art Foundation, Santa Monica

Untitled, 1987
Cibachrome photograph
72 ½ x 49 ½ in. (184.2 x 125.7 cm)
Los Angeles County Museum of Art, gift of Ann and Aaron
Nisenson in memory of Michael Nisenson
AC1995.183.28

Untitled #228, 1990
Color photograph
82 x 48 in. (208.3 x 121.9 cm)
The Broad Art Foundation, Santa Monica

DAVID SMITH
United States, 1906–1965
Cubi XXIII, 1964
Stainless steel
76 ¼ x 172 ⅞ x 35 ⅛ in. (193.7 x 439.1 x 89.9 cm)
Los Angeles County Museum of Art, Modern and
Contemporary Art Council Fund
M.67.26

Cubi XXVIII, 1965
Stainless steel
108 x 110 x 45 in. (274.3 x 279.4 x 114.3 cm)
The Eli and Edythe L. Broad Collection, Los Angeles

JENNIFER STEINKAMP
United States, b. 1958
Jimmy Carter, 2006
Computer-animated video projection, video projectors,
and computers
Dimensions variable
Los Angeles County Museum of Art, gift of the 2007 Collectors
Committee
M.2007.50

FRANK STELLA
United States, b. 1936
Getty Tomb, 1959
Enamel on canvas
84 x 96 in. (213.4 x 243.8 cm)
Los Angeles County Museum of Art, Contemporary Art
Council Fund
M.63.21

CLYFFORD STILL
United States, 1904–1980
1955-H, 1955
Oil on canvas
113 ¼ x 154 in. (287.7 x 391.2 cm)
Los Angeles County Museum of Art, given anonymously,
Los Angeles
M.91.89

DO-HO SUH
South Korea, b. 1962
Gate, 2005
Silk and stainless-steel tube
128 ½ x 83 ¼ x 39 ¼ in. (326.4 x 211.5 x 99.7 cm)
Los Angeles County Museum of Art, purchased with funds
provided by Carla and Fred Sands through the 2006
Collectors Committee
M.2006.104

MARK TANSEY
United States, b. 1949
Picasso and Braque, 1992
Oil on canvas
80 x 108 in. (203.2 x 274.3 cm)
Los Angeles County Museum of Art, Modern and
Contemporary Art Council Fund
AC1992.154.1

CY TWOMBLY
United States, b. 1928
Untitled (Rome), 1961
Oil paint, wax crayon, and graphite on canvas
51 ¼ x 59 ¼ in. (130.2 x 150.5 cm)
The Eli and Edythe L. Broad Collection, Los Angeles

Roman Notes #3, 1970
Gouache and oil crayon on paper
Framed: 60 ½ x 39 ¼ x 1 ½ in. (153.7 x 99.7 x 3.8 cm)
Los Angeles County Museum of Art, gift of Robert H. Halff
through the Modern and Contemporary Art Council
M.2005.38.38

Untitled, 2003
Oil on canvas
85 x 105 in. (215.9 x 266.7 cm)
The Eli and Edythe L. Broad Collection, Los Angeles

BILL VIOLA
United States, b. 1951
Slowly Turning Narrative, 1992
Video-sound installation with rotating screen
Overall: 168 x 240 x 492 in. (426.7 x 609.6 x 1249.7 cm)
Los Angeles County Museum of Art, Modern and
Contemporary Art Council Fund
AC1995.146.1

KARA WALKER
United States, b. 1969
And Thus . . . (present tense), 1996
Paper
Ball: 25 x 17 ¹/₂ in. (63.5 x 44.5 cm); figure: 26 x 35 in. (66 x 88.9 cm);
chain: dimensions variable
Los Angeles County Museum of Art, purchased with funds
provided by The Eli Broad Family Foundation
AC1997.97.1.1–.3

ANDY WARHOL
United States, 1928–1987
Black and White Disaster, 1962
Acrylic and silkscreen enamel on canvas
96 x 72 in. (243.8 x 182.9 cm)
Los Angeles County Museum of Art, gift of Leo Castelli Gallery
and Ferus Gallery through the Contemporary Art Council
M.65.13

Small Torn Campbell's Soup Can (Pepper Pot), 1962
Casein paint, gold paint, and graphite on linen
20 x 16 in. (50.8 x 40.6 cm)
The Eli and Edythe L. Broad Collection, Los Angeles

Flowers, 1964
Synthetic polymer paint and silkscreen ink on canvas
60 x 60 in. (152.4 x 152.4 cm)
The Eli and Edythe L. Broad Collection, Los Angeles

THE BCAM PHOTOGRAPHY PROJECTS

UTA BARTH
Germany, b. 1958, active United States
Untitled, 2007

SHARON LOCKHART
United States, b. 1964
Rancho La Brea Fossils—Late Pleistocene Epoch
Chambers Group, Inc., Environmental Consulting
 Paleontology Team, May 21–25, 2007
LACMA Pit 1, Box 1 of 21 (34.063521 LAT, -118.358590 LON,
 155.7 Feet above Sea Level), 2007

THE CENTER FOR LAND USE INTERPRETATION
Founded in Oakland, 1994
Puente Hills Landfill, Whittier, California, 2007
Azusa Quarry, Azusa, California, 2007
Black Mountain Quarry, San Bernardino County, California, 2007
Fish Creek Quarry, Imperial County, California, 2007
General Iron Industries, Chicago, Illinois, 2007
U.S. Silica Quarry, Rockwood, Michigan, 2007
Bruno Poggi & Sons Quarry, Bagni di Tivoli, Italy, 2007

ANTHONY HERNANDEZ
United States, b. 1947
BCAM #1, 2007
BCAM #2, 2007
BCAM #3, 2007
BCAM #4, 2007
BCAM #5, 2007

ILLUSTRATION CREDITS

Most photographs are reproduced courtesy of the creators and lenders of the material depicted. For certain artwork and documentary photographs we have been unable to trace copyright holders. We would appreciate notification of additional credits for acknowledgment in future editions.

Cover, pp. 231, 233, 235, 237, 239: © Anthony Hernandez
Endsheets: © Chris Burden. Photograph © Erich Koyama
pp. 2–3, 4, 62, 64–65, 67 left and right, 73, 82–83, 87 left and right, 90, 161: Photograph © 2008 Museum Associates/LACMA
p. 8: © Jeff Koons. Photograph © 2007 Markus Tretter, courtesy of Kunsthaus Bregenz
p. 23: © David Smith Estate/Licensed by VAGA, New York. Photograph © Douglas M. Parker Studio
pp. 24, 25: © Robert Rauschenberg/Licensed by VAGA, New York
p. 26: © Jasper Johns/Licensed by VAGA, New York
p. 27: © Jasper Johns/Licensed by VAGA, New York. Photograph by Robert McKeever, New York
p. 28: © Cy Twombly
p. 29: © Cy Twombly. Photograph by Robert McKeever, New York
p. 30: © Estate of Roy Lichtenstein
p. 31: © Estate of Roy Lichtenstein. Photograph © Douglas M. Parker Studio
pp. 32, 33: © The Andy Warhol Foundation for the Visual Arts/Artists Rights Society (ARS), New York
p. 34: © Edward J. Ruscha IV. All rights reserved
p. 35: © Edward J. Ruscha IV. All rights reserved. Photograph © Douglas M. Parker Studio
pp. 36, 251: © John Baldessari
p. 37: © John Baldessari. Photograph © Douglas M. Parker Studio
p. 38: © Ellsworth Kelly
p. 39: © Barbara Kruger
pp. 40, 41, 175: Courtesy of the artist and Metro Pictures
p. 42: © Ross Bleckner
p. 43: © Eric Fischl. Photograph © Douglas M. Parker Studio
p. 44: © Jean-Michel Basquiat Estate/Artists Rights Society (ARS), New York. Photograph © Douglas M. Parker Studio
p. 45: © Estate Leon Golub/Licensed by VAGA, New York
pp. 46–47: © Charles Ray. Photograph © James Isberner, Chicago, Illinois, courtesy of Regen Projects
p. 49: © Mike Kelley. Photograph © Fredrik Nilsen, match print courtesy of Studio P, Los Angeles
pp. 50–51: © Chris Burden. Photograph © Douglas M. Parker Studio
p. 52: © Damien Hirst. Photograph © Randy Boverman
p. 53: © Damien Hirst. Photograph courtesy Gagosian Gallery

p. 54: © Joseph Beuys Estate/Artists Rights Society (ARS), New York/ VG BILD-KUNST, Bonn. Photograph © Douglas M. Parker Studio
p. 55: © Joseph Beuys Estate/Artists Rights Society (ARS), New York/ VG BILD-KUNST, Bonn
pp. 56–57: © Richard Serra/Artists Rights Society (ARS), New York. Photograph © 2006 Lorenz Kienzle
pp. 60–61: © Uta Barth
p. 66: © RPBW
p. 69 left: © RPBW. Photograph by Berengo Gardin Gianni
p. 69 right: © RPBW. Photograph by Christian Richters
pp. 76–81: © Sharon Lockhart
pp. 84, 101, 102, 105, 112 top and bottom, 114, 115, 117 right, 129, 136, 138–39, 147 right, 152, 160, 187 right, 247: Photograph © Museum Associates/LACMA, photographic archives
p. 86: Photograph courtesy of Los Angeles Public Library Photo Archives
pp. 88, 89: Photograph courtesy the Natural History Museum of Los Angeles County
p. 91: © Andrew Dasburg Estate. Photograph © 2008 Museum Associates/LACMA
p. 92: Photograph courtesy of the Academy of Motion Picture Arts and Sciences, Los Angeles
p. 97 left: © 2008 Pollock-Krasner Foundation/Artists Rights Society (ARS), New York. Photograph © 2008 Museum Associates/ LACMA
p. 97 right: © 2008 The Josef and Anni Albers Foundation/Artists Rights Society (ARS), New York/VG Bild-Kunst, Bonn, Germany. Photograph © 2008 Museum Associates/LACMA
p. 99: © Stuart Davis Estate/Licensed by VAGA, New York. Photograph © 2008 Museum Associates/LACMA
p. 103: © David Smith Estate/Licensed by VAGA, New York. Photograph © 2008 Museum Associates/LACMA
p. 104: © Philip Guston Estate. Photograph © 2008 Museum Associates/LACMA
p. 106: © The Clyfford Still Estate. Photograph © 2008 Museum Associates/LACMA
p. 107: © The Samuel L. Francis Foundation/Artists Rights Society (ARS), New York. Photograph © 2008 Museum Associates/LACMA
p. 108: © Frank Stella/Artists Rights Society (ARS), New York. Photograph © 2008 Museum Associates/LACMA
p. 109: © The Andy Warhol Foundation for the Visual Arts/Artists Rights Society (ARS), New York. Photograph © 2008 Museum Associates/LACMA
p. 110: © Claes Oldenburg and Coosje van Bruggen. Photograph © 2008 Museum Associates/LACMA
p. 111: © Ronald Davis. Photograph © 2008 Museum Associates/ LACMA
p. 113: © Chris Burden. Photograph © 2008 Museum Associates/ LACMA
p. 116: © Dennis Hopper
p. 117 left: © Alexander Calder Foundation/Artists Rights Society (ARS), New York/ADAGP, Paris. Photograph © 2008 Museum Associates/LACMA
p. 118: © John Chamberlain/Artists Rights Society (ARS), New York. Photograph © 2008 Museum Associates/LACMA
p. 119: © Edward J. Ruscha IV. All Rights Reserved. Photograph © 2008 Museum Associates/LACMA
p. 121: © David Smith Estate/Licensed by VAGA, New York Photograph © 1965 Museum Associates/LACMA, photographic archives
p. 122: © Franz Kline Estate/Artists Rights Society (ARS), New York. Photograph © 2008 Museum Associates/LACMA
p. 123: © Kate Rothko Prizel and Christopher Rothko/Artists Rights Society (ARS), New York. Photograph © 2008 Museum Associates/ LACMA
p. 126: © Nancy Reddin Kienholz. Photograph © 2008 Museum Associates/LACMA

p. 128: © 1966 Tribune Media Services, Inc. All rights reserved. Reprinted with Permission. Cartoon by Paul Conrad
p. 130 top: © Larry Bell. Photograph © 2008 Museum Associates/ LACMA
p. 130 bottom: © Patricia Faure
p. 131: © Robert Irwin/Artists Rights Society (ARS), New York. Photograph © 2008 Museum Associates/LACMA
p. 132: Photograph © Malcolm Lubliner, courtesy of Gagosian Gallery, Los Angeles
p. 133: © Seymour Rosen Estate, courtesy SPACES, Los Angeles
pp. 134–35: © Craig Kauffman. Photograph © 2008 Museum Associates/LACMA
p. 141: © Claes Oldenburg and Coosje van Bruggen. Photograph © 1971 Museum Associates/LACMA
p. 144: © Asco. Photograph © Harry Gamboa Jr., courtesy Museum Associates/LACMA, photographic archives
p. 145: Photograph © 1974 Museum Associates/LACMA
p. 146: © David Hammons. Photograph © 2008 Museum Associates/LACMA
p. 147 left: Photograph © 1971 Museum Associates/LACMA
p. 148: © Kara Walker, courtesy of Sikkema Jenkins & Co. Photograph © 2008 Museum Associates/LACMA
p. 149: © Kerry James Marshall. Photograph © 2008 Museum Associates/LACMA
p. 151: © Julian Wasser
p. 153: © Richard Diebenkorn Estate. Photograph © 2008 Museum Associates/LACMA
p. 154: © Ken Price. Photograph © 2008 Museum Associates/LACMA
p. 155: © Jonathan Borofsky. Photograph © 2008 Museum Associates/LACMA, photographic archives
p. 156: Photograph by Anne Knudsen, courtesy Museum Associates/LACMA, photographic archives
p. 157: © Vija Celmins. Photograph courtesy of Vija Celmins and McKee Gallery, New York
p. 159: © Barbara Kruger. Photograph courtesy of the Museum of Contemporary Art, Los Angeles
p. 162: © 1980 David Hockney. All rights reserved. Photograph © 2008 Museum Associates/LACMA
p. 164: © Nam June Paik Estate. Photograph © 2008 Museum Associates/LACMA
p. 166: © 2008 Bruce Nauman/Artists Rights Society (ARS), New York. Photograph © 2008 Museum Associates/LACMA
p. 167: © Donald Judd Estate/Licensed by VAGA, New York. Photograph © 2008 Museum Associates/LACMA
p. 168: © Yves Klein Estate/Artists Rights Society (ARS), New York/ ADAGP, Paris. Photograph © 2008 Museum Associates/LACMA
p. 169: © 2008 Willem de Kooning Revocable Foundation/Artists Rights Society (ARS), New York. Photograph © 2008 Museum Associates/LACMA
p. 170: © Chuck Close. Photograph © 2008 Museum Associates/LACMA
p. 171: © Robert Gober. Photograph © 2008 Museum Associates/ LACMA
p. 172: © Jasper Johns/Licensed by VAGA, New York. Photograph © 2008 Museum Associates/LACMA
p. 173: © Cy Twombly. Photograph © 2008 Museum Associates/LACMA
p. 174: © Estate of Roy Lichtenstein. Photograph © 2008 Museum Associates/LACMA
p. 176: © Anselm Kiefer. Photograph © Museum Associates/LACMA, photographic archives
p. 179: © Hans Haacke/Artists Rights Society (ARS), New York/VG BILD-KUNST, Bonn. Photograph © 2008 Museum Associates/LACMA
p. 180: © Mark Tansey. Photograph © 2008 Museum Associates/LACMA
p. 181 top left: Photograph © 1991 Star Black, New York
p. 181 bottom left: Photograph © 1996 Museum Associates/LACMA, photographic archives

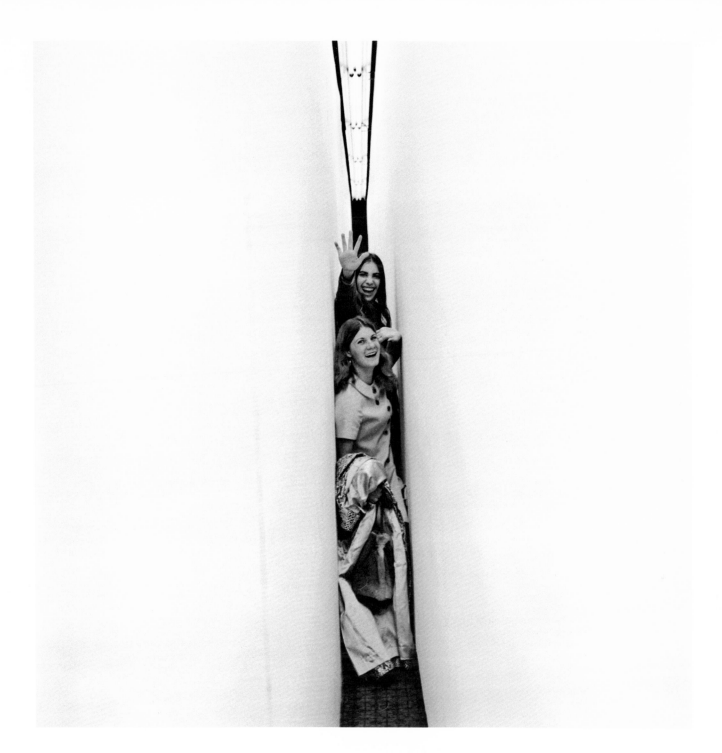

Visitors at *Bruce Nauman*, 1972

INDEX

Note: page numbers in **boldface** refer to illustrations.